CAMILLE

Camille
by Monet, 1866

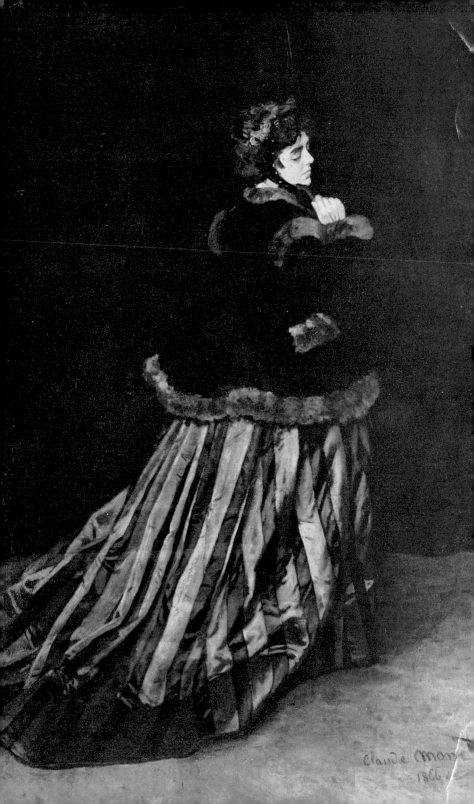

Claude Monet
1866

CAMILLE

A Study of
Claude Monet
by
C. P. WEEKES

SIDGWICK AND JACKSON LTD.
LONDON
1962

Contents

Preface

THIS BOOK WAS FIRST PUBLISHED IN NEW YORK IN 1960. IT HAS SINCE been extensively revised and it is hoped improved by the addition of new material and by corrections and alterations made possible by the comments of friends.

As far as the author is aware the statements made in the original preface remain true: that fewer biographies of Claude Monet have been published than of any famous painter, to be precise, only three in French and not one in English.

It is difficult to understand this neglect, since the story of the life of Monet is often dramatic and always uplifting, a story of courage and determination.

The bibliography lists the sources of statements and quotations but special mention must be made of the kindness and help of M. Michel Monet, M. Germain Bazin and M. Jean Adhémar. Thanks are due to the following for permission to reproduce photographs: Musée du Louvre, Bibliothéque Nationale, British Museum, Kunsthalle, Bremen and Städelsches Kunstinstitut, Frankfurt.

Since the revision of this book was completed an interesting study of Monet has appeared in Paris. It is by the late M. Hoschedé, the painter's step son. When they first met, the boy was ten years old, Monet in his forties. The book therefore deals exclusively with the later years of Monet, when his fame was assured, a period which has been deliberately compressed in the present work. It can be said, however, that the recollections of M. Hoschedé confirm in almost every particular what has been written here.

C. P. W.

Illustrations

Chapter 1
How It Began
1824 - 1856

ANY MONDAY OR THURSDAY OF THE EIGHTEEN TWENTIES OR THIRTIES a small ship could have been seen proceeding unsteadily down the Honfleur side of the Seine estuary towards Rouen at the river's mouth. Every Wednesday and Saturday the same ship could be seen on its way back to Honfleur. The same ship, because the rolling gait was unmistakable: when the estuary was like a millpond the little vessel behaved as though it were staggering through a storm; in the usual choppy sea it bucked and reeled alarmingly; in dirty weather it was almost indistinguishable from the water milling round it.

If a stranger asked anywhere along the coast the name of this apparently unseaworthy ship he would be told with a smile that it was the Polichinelle. After half a lifetime in other men's ships Captain Boudin had picked up the Polichinelle cheaply because of its antics. He used it to carry cider from Honfleur to Rouen, empty barrels from Rouen to Honfleur and, off season, any cargo he could coax out of the trustful.

The Captain was as individual as his ship. He was a tall man with narrow shoulders which spread into vast hips and belly. His face was

dominated by a bulbous red nose. Long wispy brown hair floated from each side of the wide forehead and two eyes of clear blue shone mildly out of the tan. The people of Honfleur lingered over their jokes; the Punchlike waddle of the Polichinelle was amusing them to the point of hilarity ten years after Captain Boudin had bought her. Her owner merely smiled his gentle smile and glanced for the thousandth time with amiable pride over his purchase.

The Captain's happiest moments followed the birth of his son Louis-Eugène. Only forcible objections by Madame Boudin frustrated a hazardous delivery at sea, and soon after his birth in 1824 the boy was hauled on board on every slightest pretext, permitted only the most rudimentary of educations, and finally whisked away and on to the Polichinelle soon after he had gone ten. For good, Captain Boudin thought; beginning as ship's boy as he had done, Eugène would take over as master in due course whilst he took his ease on the cliffs regarding the wallowing Polichinelle under his son's command.

This harmless wish was not to be granted. The boy enjoyed life afloat as much as even his father could desire. Why he enjoyed it was another matter. He would stare by the hour at sea and sky noting every change of mood in that most changeable of waters. As the good son of his father he could have been estimating wind and tide. He did in fact soon know every wind, its force and probable duration, like an old tar. But his ambition was not to use this knowledge to improve navigation when his time came to take the tiller, it was the queer one of somehow conveying it to paper.

For Eugène clung to one piece of learning, a few drawing lessons. As the ship elbowed its way down the estuary he stood on the bridge apparently dreaming, then would suddenly dash into the little cabin to try to draw what he had seen. His father's few books and charts were soon covered with these trial sketches, the rigging of their tiny ships correct to the last detail, the waves corresponding to the clouds in direction and extent just as he had seen them a few minutes earlier.

How Captain Boudin would have dealt with this seaman's lore gone astray remains a mystery. Before admiration at his child's gift with a

pencil could give way to bewilderment at this peculiar use of a born nautical eye, before Eugène had reached his eleventh birthday, the Polichinelle herself cut short any possibility of a second Boudin as her master.

One fine day Eugène was in his usual place when work was done, hanging over the end of the bridge intently regarding the play of light on the water. In one hand was a piece of paper, in the other a crayon. To his right stretched the low cliffs of the Honfleur shore. To his left ran the far green stretch of the Le Havre coast with the masts and smoke of the big port rising thinly. Few could have made out those masts from such a distance but the boy's eyes were blessed with the seaman's sight of his father. All was peace: the sea shone, a fresh wind whipping it into white wavelets, fleecy clouds scudded across the blue sky, the green arms of the estuary slowly came together as the Polichinelle rolled towards Rouen.

Suddenly and for no reason at all the ship gave a more than usually violent lurch. Eugène lost balance, grasped vainly at the rail, toppled over and plunged into the sea. His father down below heard and saw nothing, but one of the crew, meditatively smoking aft, heard the splash. He acted promptly, threw over a lifebelt and followed himself. The boy, who could not swim, was pulled out before being swept away.

Eugène recovered quickly but the incident could not be hidden from his mother when the ship returned to Honfleur. Marie-Félicité was a sharp little woman who ran the Boudin home with decision. She did not like the sea. As Mademoiselle Buffet she had served as stewardess on the ship which crossed the mouth of the estuary from Honfleur to Le Havre. She had been thankful to marry Captain Boudin and let him do the sailing. She had not wished her son to follow his father but had bowed to tradition. Now she put her foot down; Eugène was not to become a sailor. She met little opposition. The boy was more anxious to watch and draw the sea than earn a living on it. His easygoing father was too shocked and guilty to question seriously the decision which ended his hopes.

The fond and anxious discussions which followed led to a printer's

and stationer's shop in Le Havre where Eugène was apprenticed. The reasoning which brought him there was typical of the parents he was lucky enough to possess: he was devoted to the making of sketches, he had to earn a living, so what better place to earn it than a shop in which paper, pencils, crayons and all the rest of the paraphernalia were free to hand?

It would have been hard to disapprove of the diffident boy with the hesitant voice and shy blue glance and his master was far from disapproval. A more uncommercially-minded young man than Eugène would be difficult to find, but customers liked him, liked his politeness and patience. If, when sent on a errand, he was found hours later rooted to the harbour quay watching ships and men and water, he never deliberately played truant and his confusion and penitence were so unfeigned that everyone from the master downwards hastened to forgive him. Besides, the sketches soon to be found in every corner of the shop were, the master thought, remarkable for a selftaught boy. He surely had a future. In his way the man contributed to this future; after a year or two he presented the young Boudin with his first box of paints.

Being what he was, Eugène stayed peacefully in this haven until he was eighteen. Though he spent all his free time sketching on the waterfront, in the meadows behind the town and along the estuary, he had too little confidence in himself to make any move to further his gift. When at last he left the shop it was to open a similar shop in another part of the town. Nor would he have taken even this mild step had it not been suggested to him by the foreman printer, a man named Archer, who offered him a partnership.

Eugène Boudin was a happy young man comfortably installed in his shop in a street which looked straight across to the water. The shop soon offered him joy of a deeper kind. He made one concession to his growing passion for everything to do with the making of pictures; stirred to action by the discovery that no frame-maker existed in the town, he whipped himself up to an uncharacteristic show of energy and persuaded his partner to take on the work. This led to unexpected and, for Boudin, gratifying developments. Normandy was then

becoming a favourite summer centre for painters from Paris. Leaving their studios when the city heat grew unbearable, they visited Le Havre, Honfleur and all the coastal towns nearest to the capital. Amongst them were the then great academicians Isabey and Couture, painting smooth seascapes which the *nouveaux riches* would gobble up as profitable investments, and Troyon making his equally sought after studies of cows in the lush Norman fields.

All three painters noticed the neat and centrally-placed little shop. They came there to buy canvases and paper and, seeing Boudin's notice, asked to have their work framed. All three were charmed by Boudin and suggested that he show this finished work in his window. He agreed eagerly, flattered to have anything to do with real painters, as he thought of them. They were too grand for him to mention his own efforts but one day Millet turned up. Millet painted after Boudin's heart, he was poor and had struggled and he showed it in his face and manner. He too had his work framed and asked if it might be put into the window. The very way he paid for the framing told the sympathetic Boudin everything, there was no careless tossing of coins on the counter like the great Parisians but an anxious counting of small change. To Boudin, spending every spare copper he possessed on drawing and painting materials, Millet appeared a fellow spirit. He one day summoned courage to show him some of his own things.

Millet looked through the notebooks filled so painstakingly, studied the sketches. He saw that Boudin lacked faith in himself—all the work was timid, tentative—but thought he discerned a true talent. He gave the young man his first lessons. He also spoke to the wealthy painters. They too looked at Boudin's work. Troyon, who had long forgotten anything he knew of hardship, flew into a passion of enthusiasm and told Boudin to abandon his business at once, go off to Paris and devote his life to painting. This lighthearted advice caused Millet, who remembered only too well the misery ahead of most professional painters, to throw up his hands in despair with a "So you want to do the same with him too!"

Modesty, his timid nature and a strong love for the Normandy coast saved Boudin from Troyon's flattery. He stayed where he was

but worked ever harder. Two years later action was forced on him; he was called up for national service, drew an unlucky number and was faced with seven years on a warship. This opened his eyes; he knew at last what he must do with his life. Horrified, not so much by the idea of the years at sea as by the loss of precious painting time, he bought a substitute. He had no spare money, all had gone on paper, paints, brushes and pencils. To raise the large price, 2,500 francs, he had to sell his partnership in the shop. He did not hesitate, and closed with the first offer.

He was left penniless and without an income. His father could not help him; the Polichinelle had finally come to the end she had always promised and Captain Boudin lived penuriously in Honfleur watching other men's ships with a melancholy eye.

So Boudin had to fend for himself. He knew only one way of earning money, to sketch and paint and try to sell what he made. He worked every day from dawn to dusk on the beaches, the quays, in the fields. Taking a leaf out of the book of his famous patrons, he persuaded Archer to put one or two of his things in the window. When lucky he got as much as a franc apiece. He hawked his little sketches round the port where his friends the ship fitters and stevedores sometimes took them for a few sous; they thought nothing of the sketches, much of their maker, he was a man after their own heart, looking like a seaman and behaving like themselves.

Two years passed. Boudin became a town mystery. How did he live? the Havrais asked one another, watching the tall, stooping, bearded figure bent over his sketching block. The mystery led to an unexpected development; one or two curious men, influential in the town, persuaded the town council to give him a three year grant to study in Paris. They pointed to the town's meagrely stocked art gallery. A dozen or so specimens from this local product, specimens with all the Paris slickness but not at Paris cost—this, they argued, would do credit to Le Havre and reward a man who at least worked hard.

Boudin found himself in a quandary he had not the character to deal with. He gave way and reluctantly went off to the great capital.

There all his fears were realised. He loathed every moment of his three years, loathed the time-serving atmosphere of the Beaux-Arts, the emphasis on cleverness at the expense of sincerity, the bad manners, the frightful unconcealed fight for survival. He was utterly miserable. He learned some elements of drawing, he learned how to drown his sorrows at the bistros. That was all.

He came back to Le Havre in disgrace. Instead of the expected baker's dozen of glossy, well-finished pictures for the art gallery he brought copies of two unfashionable painters—"because he liked them"—and one still-life. The town council was much displeased. "They imagined," Boudin ruefully said, "that after three years of studying I should come back a phoenix of art. Actually I returned more perplexed than ever . . . If Corot with his immense talent had all the difficulty in the world to make a name, what must we suffer, we learners? My *peinture grise*, my efforts to render the soft colours of sea, mist and cloud, wasn't appreciated, my seascapes were specially thought to be right out of date What could I do, I who had heart only for one style of painting? It was necessary to retire to one's province and wait for better days."

Typically he said "wait." In fact, though he had lost his one chance of powerful help in the town, though he was regarded almost everywhere as a hopeless waster, he worked like a man possessed. He grew gaunt, his bony face so thin that the eyes dominated it, two enormous globes of blue. He lived in the port, he slept in the fields and barns. He made an occasional sale, he was given an occasional crust or free meal by his poor friends. He no longer looked the seaman, he looked what he was, a desperately poor artist. He began to get a bad reputation: a disgrace to the town, said the respectable when he passed them haggard and ragged; a man who doesn't know his job, said the local art snobs looking distastefully at his precise sketches and subdued colours, his deliberate lack of finish.

The years dragged on. Somehow he kept himself alive. His nature remained sunny. He was trying to do what he knew he must do, he had stout supporters in the harbour and in Archer, and when he most despaired of reaching his goal he comforted himself with the thought

7

that one day a better man than he would carry on where he left off, a man whom he might perhaps even help over the first stages. He was always looking for a sign of this successor, and one day in 1856, an historic day in the annals of painting, he thought he had found him. He noticed in Archer's window, some framed, some laid under glass just below his own studies, a group of caricatures of certain Havrais. They were bold, they were amusing. They were not at all what Boudin might be expected to appreciate but by some miracle they held his attention. He saw that they were priced at twenty francs, twenty times what Archer asked for his own work.

He did not waste a moment bewailing the disparity in price. He went into the shop and asked who had made the caricatures; he saw talent there and would be happy to meet the man.

"Man!" said Archer with a smile. "Why, those were done by young Claude Monet."

Chapter 2

The Monets

1840 - 1857

CLAUDE MONET'S FATHER WAS A GROCER IN RUE LAFFITTE, PARIS. IN the apartment over the shop the first Monet son, Oscar-Claude, was born on November 14, 1840.

Rue Laffitte was to become famous in the history of art, but to Monsieur Monet it signified only personal failure. Soon after his son's birth the business began to disintegrate. There were two relations of the Monets in the grocery trade, one at Nantes, the other at Le Havre, and in 1845 M. Monet gave up the fight in Paris and moved to Le Havre where he went into partnership with his brother in law. This brother in law, Lecadre by name, had a nice little business in rue de Fontenelle. He did not rely on over the counter transactions, he went into the port and won contracts for supplying some of the ships. M. Monet was soon able to dismiss the anxieties which had made Paris unendurable. He decided to settle in Le Havre for life.

His small son quickly forgot the few memories he might have had of Paris. His thoughts were all of Le Havre, that paradise for the growing boy, with its wide sea front, large port, quays crowded with exotic produce from far countries, friendly sailors of all nations, ships

large and small, above all its wide and changeable skies and the water which ranged in a few minutes from storm-whipped greeny-gray to calm and placid blue.

The boy was fascinated by the town and the Seine estuary at the head of which it stood guard. He hung about the quays, wandered along the shores of the estuary, lay ecstatic in meadows swayed by sea winds. When he was sent to school he took French leave day after day, lingering by the sea or strolling off into the country. He did not consciously see what he had played truant to see, yet the mind and heart of the future artist were absorbing all. To the boy this was obscured by a dream of vainglory. He could think only of Claude Monet the great caricaturist.

For, bored, he occupied his token appearances in school by drawing in books and notebooks, on anything which came to hand, caricatures more or less irreverent of unpopular masters and of schoolfellows who did not please. He had attended the drawing lessons with some profit, learning just enough to develop a natural talent.

His school companions were carried away by his daring and skill. There, unmistakably, was Monsieur Ochard, the drawing master with his famous monocle. Yet this was an Ochard sufficiently absurd to puncture all dignity, to arouse howls of delighted laughter from all who knew his ways. The dark young Claude, image of his Lyonnaise mother, would dash off with an air another clever-cruel likeness of some common enemy. The crowd around him crowed with delight, called for more. He did more. He felt a power. All were at the mercy of a quick brain directing agile fingers.

By the time he had arrived in his early teens he had won a reputation in school and out of it. He was not so much admired as feared. He was, said one of his schoolfellows, "turbulent and irreverent, his chief pleasure to strain every nerve to play the *enfant terrible*. In the drawing class his lack of discipline became notorious. With his liveliness, his black hair, olive skin, and brilliant dark brown eyes underlining by their extreme changeableness his exuberant character, he was truly the wild street arab of the school."

Monet, looking back, saw himself as "undisciplined from birth;

from my infancy, no one was able to make me submit to any rule. The little I learned, I learned off my own bat. School always seemed to me like a prison and I was never able to bring myself to endure even four consecutive hours there when the sun shone invitingly, the sea looked beautiful and I could enjoy a good run on the beaches in the fine air or splash about in the water. Up to the age of fourteen or fifteen I lived this irregular but healthy life to the great distress of my parents."

He blamed himself excessively to shield his mother and father. In fact, his father was a weak man, as his retreat from Paris and reliance on his brother-in-law showed. Neither he nor his wife could deal with their strong-willed son so, like all weak parents, they let him have his way and complained about him in the same breath.

"I was born," said Monet, "into a business environment in which it was the thing to parade a contemptuous disdain for the arts." But he mistook a natural wish to put him into the business for an implacable hatred of art. His parents, his father especially, ran down a career as painter purposely to elevate a career as grocer. He and his wife were, besides, respectable, timid people. The word *artist* automatically suggested riotous living. They wished to protect their son as well as themselves.

But the tradition of art in France was too strong and long-rooted for the Monets to despise it. Nor would they, for they knew, and were proud of it, that a successful Paris painter was affianced to a cousin, one of the Nantes Lecadres. And nearer at hand, in their house, in their very blood, lived an enemy to trade—Madame Lecadre, the boy's aunt. Madame Lecadre had artistic leanings, she made a studio out of her attic, she painted and sketched a little, patronized the local artists; she even had ties with a real painter in Paris, the young Armand Gautier. She was also childless and made a pet of Claude as far as that offhand young man permitted. In her fluffy, breathless way she was determined that her "lamb," as she incongruously called the strapping boy, should develop his artistic impulses and escape from debasing trade. She permitted him free run of the studio, talked to him about art and artists, tried to give him lessons in technique.

To keep a lively and self-opinioned boy within bounds in the face of such support was quite beyond the powers of Claude's mother

and father. They insisted on calling him Oscar, but this was their one triumph, their one assertion of common sense over art. For the rest they looked on helplessly, if not always wordlessly, while their son lived his own life. What, after all, could they do when complaints from school poured in? The boy was too big to flog even if they could have nerved themselves to it. He had a vociferous defender in his aunt. And the complaints from school were not of his stupidity. On the contrary it was clear even to the perplexed parents that he fled from school time and again not only because he panted for the freedom of the quays and beaches but because he was ahead of many of his companions and had nothing to do. Could they conscientiously punish a child for superior brains?

When his caricatures began to catch on, in his fifteenth year, his aunt's pride was stupendous. He was encouraged to use the attic for his work. And he had much to do. In time the admiring and gleeful cries of school friends had turned from a demand that he demolish enemies into a "Do me!" then "Do my sister, my father, my mother!" Moved by a mixture of vanity and contemptuous generosity, he "did" them all. But no longer with the savagery of his first efforts. He now made likenesses with just enough of the caricature to raise a fond smile.

The result astonished him. Within the space of a few months he found himself quite a notable figure in Le Havre. His fame as portrait-caricaturist ran over town. He was besieged by offers. Everyone wanted to be "done."

At this point the scornfully rejected Oscar raised his head. He was not his father's son for nothing. Realizing that what had been begun in pique could be continued as a profitable side line, he began to charge from ten to twenty francs apiece. In one month the number of his customers had doubled. Again he showed himself a true Oscar: thriftily he gave most of his profits to his aunt to keep, holding back only enough for pocket money. Still his orders rolled in. Greatly daring, he raised his price to a uniform twenty francs. To his astonished delight the orders continued at the same speed. "If I'd gone on in this fashion," he said afterward with a smile, "I'd have been a millionaire today." He was preserved from that fate by a rare stroke of good fortune. He met Eugène Boudin.

Chapter 3

Caricaturist

1856 - 1857

THE YOUNG MONET'S MAIN SOURCE OF SALES WAS ARCHER'S SHOP. HIS caricatures were put into the window and sold well, so well that Archer was ready to take all he was offered.

In front of this window, his face pressed closely to the glass, was to be seen almost every day throughout 1856 and the early part of the following year a tall, broad-shouldered young man with a shock of black hair in great disarray and deep brown eyes glowing out of an olive skin. This was the caricaturist in person. He looked eighteen but was in fact two years younger. He stood there partly because he could never tire of contemplating his cleverness, partly because he had often to call at the shop to collect his share of the spoils, but most of all and most enjoyably to hear the comments of other window-gazers. For many people stopped, looked, pointed, and cried, "What a beauty!" "Isn't that funny!" and other exclamations of a similar nature. And listening to these compliments, the silently gloating youngster who looked so much older "nearly burst himself with pride."

One thing marred this daily orgy of self-congratulation. His work was not always alone in the window. Only too often, displayed just above the caricatures, were one or two little pencil and wash impressions of the sea and port—a fully rigged ship, a sunset over the sea front, the *plage* with bathers, the lighthouse.

With all the comprehensive and facile disdain of the schoolboy, Claude used to stare at these paltry sketches—not even dignified by frames or a sheet of glass like the caricatures—which had the effrontery to compete with his original and popular work. True, the despised sketches were marked at no more than a twentieth the price of his caricatures, but even this sop to vanity could not entirely soothe his displeasure. He noticed with enormous satisfaction that other men and women stopping to look into the window never had a good word to say for the little sketches. How he agreed with them! How he disapproved of the work of this Eugène Boudin—for the fellow even had the cheek to sign his daubs!

One water colour, typical of so many, was a sunset seascape in which the maker had conveyed the very hush of the hour and the calm of a darkening but still brilliant sea of a blue seen only at that particular time of day. It was the work of a man who had lived with the sea, who knew its every mood, who had really used his eyes. Yet this, like all the rest, roused nothing but disgust in the boy who patronizingly gazed with a frown on his strong, square forehead. "To my eyes," he wrote in recollection, "familiar as they were with the arbitrary colouring, false notes, and fantastic arrangements of the modish painters who were all the rage, the small, sincere compositions of Boudin with their little, correct figures, their well-rigged ships, their sky and water so exact, uniquely drawn and painted after nature, appeared to me to be utterly inartistic and their truthfulness the most suspect part of them all."

This disapproval of a man who was not only plainly going the wrong way but also daring to challenge his monopoly of the shop window led to its inevitable conclusion. "This work filled me with a frightful aversion, and without even knowing the painter I took a dislike to the very idea of him."

14

Archer, an amiable man, had been trying for some time to bring his two local clients together. "You ought to meet Monsieur Boudin," he told young Monet again and again. And when he saw the boy's face, he added defensively, "Whatever one likes to say about him, he knows his job. He has studied in Paris, in the studios of the Beaux-Arts. He could give you good advice, help you to get on."

The well-meant suggestion was rebuffed. "Whatever one likes to say about him." Claude fastened on this. Though he did not know Boudin he knew of him; he was notorious. Ever since his childhood Claude had heard stories of Boudin loafing about the port trying to peddle his sketches. Nor was this the worst of it. The man was little better than a beggar and, like so many of his kidney, when he was given a few sous he straightway poured them down his throat. The tipsy painter was a town joke.

Yes, he knew all about Boudin and felt a special antipathy and anger toward him. He typified the man who brought art low, who made the Monet parents set their faces against their son's wish to become an artist. To Claude, whose idea of art was an activity in which one made just as much money as running a grocery shop, a reputation into the bargain, and remained eminently respectable, the Boudins of the art world were anathema; he despised Boudin's work and resented the man.

So Archer's attempts to introduce man and boy met with one repulse after another. But in his pleasant way Archer was obstinate too. No doubt he wished to give the cocky boy the thrashing of his life, but Claude was too big for this and too profitable a client. Yet this was not all. In spite of his arrogance and respectability, the young Monet possessed even then a something which denied everything he said and apparently was. Archer divined dimly the existence of this something. He was one of the numberless figures who live on the outskirts of art, figures who are lucky if they receive a mention in art history. Yet they play their part as he played his. He persevered: did Claude know that Boudin had been praised by those famous academicians from Paris, Isabey, Couture, and Troyon, men who had made a fortune from their work? Did he know that Boudin's teacher

had been no less a man than Millet, who had been captivated by the sketches Claude complained of?

To all this and more the boy turned as deaf an ear as he was able. Boudin might have made the most honest of partners to Archer; he might, by some strange miracle, have bewitched the painters from Paris. But that was long ago. The present told another story, with his only patrons a few ignorant deck hands who had nothing better to do with their odd sous than to buy cheap sketches from a scarecrow.

And when, as a would-be conclusive argument, Archer told Claude why Boudin had left the partnership, the response was worse than he could have imagined. If ever Archer lost all faith in the young Monet it was when he saw his reaction to this story of sacrifice for art. What boy who believed himself talented in the arts would not thrill to this living example of a dedicated man? The answer was too plain for words—Claude Monet. To Claude patriotism came a long way before art; patriotism and the romantic glory which he associated with that emotion. All Archer did was to convince him that Boudin was outside the pale. The scrounger, tippler, prideless ragged wanderer, maker of useless scribbles, disclosed himself as a physical coward too.

So Claude's reactions, never of the politest, to these persistent efforts to lead him to his destiny became increasingly brusque. He made one excuse after another, he spoke bluntly, he was downright rude. "I refused time after time," he said regretfully years later. " 'What good could it do me to know such a fellow?' I asked." But rudeness, arrogance, evasion were all in vain. Even Boudin had money to collect occasionally from Archer. Sooner or later they were bound to meet.

The day came when, cornered in the shop, Claude found himself face to face with a tall, round-shouldered man and looked into eyes which belied the weather-beaten cheeks and brown mustache curling into pointed beard—the eyes of a seaman, mild, blue, farseeing, the eyes of a child who knew no evil, the eyes of one possessed. The worn face spoke eloquently of suffering and want, but the eyes glowed with a pale fire. "Monsieur Boudin," the delighted Archer was saying, "allow me to present Monsieur Claude Monet."

Chapter 4

Boudin and Monet

1857 - 1859

TO BE SPOILED AT HOME IS BAD ENOUGH. WHEN, IN ADDITION, A BOY
finds that he has a gift which, easily applied, brings in plenty of money
and makes him, at fifteen, "a personage in the town," he is likely to
behave badly. As Claude Monet did. He was overbearing, curt to
everyone he considered his inferior—which meant almost all—and
arrogant. He was suffering from what he himself was to diagnose as
"a bad case of swollen head."

So when at last he found himself cornered in Archer's shop early
in 1857, soon after his sixteenth birthday, an explosion of rudeness
was to be expected. He, the son of a grocer who had managed to set
up his seaside villa at Sainte-Adresse with the rest of the prosperous
Le Havre businessmen, to be obliged to speak to this down-at-heel
waster! The town's great caricaturist to be taught by the maker of
those daubs in the window!

Yet the expected did not happen. Face to face with the despised
Boudin, Claude proved for the first time that his overweening air
was skin deep. He proved, moreover, that for a boy of his age and
upbringing he was perceptive. If he opened his mouth to put the

17

painter in his place, the words were never spoken. Instead, it was Boudin who said in his low, slow voice, "Ah! So you're the young man who did those little things in the window? They always give me pleasure to look at, they're so clever and amusing. You have a gift."

Boudin, surprisingly for him, did not leave it at that. Some instinct, which was to have a profound effect on French painting, made him go on with a tentative, "But it would be a pity if you stopped there. Why don't you try your hand at painting? The sea, the skies, trees, animals, people are so beautiful seen as they really are." He offered to teach the boy what he could, suggested that they go out painting together.

Monet listened; without pleasure, but he listened. He went as far as to think that Boudin's reputation in the town might be exaggerated; he seemed harmless and even sincere in an eccentric kind of fashion. But the calm assertion that one could not stop at caricature—as though he were the one who was making the money—struck the successful caricaturist as laughable. Besides, though the boy had gone some way towards accepting the man, he had not moved an inch in his detestation of the man's work. Teach him to paint! And paint what? Those wishy-washy daubs without bounding line, striking colour, story or moral—daubs which no one would buy?

He made his excuses, politely for him. He was too busy with orders, homework, he had no paints, etc., etc. They parted.

But as usually happens when two people by chance avoid an encounter for a long time, they began after that first meeting to run into each other frequently. The meetings did not vary, Boudin diffidently repeating his offer, the boy declining it. Six months passed before Monet gave way. It was a hot day, the town was dusty and unattractive, his resistance was momentarily at low ebb. He consoled himself as they went off to choose a box of paints with thoughts of the cool breeze and shady country—for at Boudin's suggestion they were making for the hamlet of Rouelles, a mile or two up the coast.

On the way to Rouelles the elder man—Boudin was then just thirty-three—long arms swinging, body swaying as if they were pacing a deck instead of tramping a leafy lane, talked earnestly about

painting. He told his young friend of his confusion during the years in Paris and the one certainty that had emerged, that landscape and seascape were, if not the painting of the future, the painting for him, and the *peinture grise* the only truthful way of rendering the Normandy scene. And that in any event, this was his joy which neither poverty nor the disdain of his townsfolk could stifle. Whatever happened, he would go on trying to reproduce faithfully what he saw about him.

Monet heard all this with mixed feelings. He saw that from the world's point of view Boudin was a feeble fellow, and with the confidence of the youth who knew his own mind he sensed and despised the man's timidity. All very well, to hang about one's home town playing the painter. If one really, desperately wanted to paint, could one endure the provincialisms, the stupidities of Le Havre or Honfleur? Let him, Claude Monet, be given the chance of Paris, and what a different job he would make of it!

Yet this was not the whole story. The boy was intelligent as well as vain. Boudin spoke about his painting with a humility that made his cocksure companion uneasy. It was clear—even a prosperous caricaturist felt it—that this man of twice his age regarded himself as not differing in essence from the peasant or the seaman; his métier happened to be painting, that was all. For him, painting needed as much pains as coiling a rope or making a splice or building a haystack —as much but not necessarily more. There was no talk of inspiration, none of the affectations expected from the artist.

When they reached Rouelles, unpacked their gear, and Boudin began to work, he explained the beliefs behind this work. "Everything painted directly and on the spot," he said, "always has a strength, vigour, and vivacity of touch that can never be acquired in a studio." And as he painted he repeated time and again his other prime belief, that a painter's first impression is the true one and that he should never allow himself to be diverted from it by secondary attractions.

Monet, struggling with paints for the first time, did not immediately heed this advice. What struck him from the beginning, struck him into silent admiration, was not Boudin's painting but the infinite pains he took to reproduce the scene exactly as he saw it. To the boy,

accustomed to flinging off caricatures in an hour, this dedicated approach touched a chord hitherto silent. He watched Boudin with respect. The respect grew when his own experiments with a brush proved humiliatingly that a painting was a very different matter from a caricature.

At this point Monet first showed the stuff of which he was made. Common sense stepped decisively over his vanity. Common sense and something else, a something dimly awakened when he first put finger to brush. He accompanied Boudin again and again. Before very long the two oddly assorted people were virtually inseparable.

After months of companionship the boy began to realize that these almost unsalable paintings of Boudin's, with their subtle harmonies and delicacy of sure touch, were little works of art. And being at heart a questing, thoughtful person, he saw further than the painter himself, saw that his companion was not primarily concerned with ships and men and cows and shore and sea and cloud, the obvious basis of his work and the apparent cause of the extreme care he took. He realized what Boudin in his simplicity was unable to tell him, the true reason why the landscape painter must work out of doors from first to last and stick to first impressions. Boudin's real concern was with the atmosphere in which the scene was bathed at that particular moment. What the man was trying to do was to paint air, for it was the passing effect of air which gave all the rest of the picture its charm and truthfulness. Omit the air and one was left with a coloured photograph; capture that transient phenomenon and one had at once exactitude and a work of art.

The moment Monet understood what his friend was attempting— and this was half a year or more after their first outing—his mind was made up. He announced that he too was going to be a landscape painter.

His announcement caused consternation at home. His mother had protested many times, always without effect, against his association with Boudin, a man who lived no one knew how, and painted pictures no one would buy. Even given the saving grace of substantial profits, the sale of caricatures had been a serious enough departure from

respectability. What could one say of learning to paint like Boudin, of consorting with a man who was certainly not clean, who might well be vicious?

Monet was not to be moved. He would not give up his friend. And he was equally resolute about his future: he would not be a grocer, he would be a painter. He was supported by his aunt. She lived on the proceeds of a grocery business, but delicately and with a distaste for the mundane. Her handsome, clever, beloved nephew standing behind a grocery counter? Never, if she could prevent it. She had a vision, born of affection, not perception, of Claude as a famous painter. Not a painter like Boudin, certainly, but like Armand Gautier or the local academician, the Ochard her nephew had caricatured during his drawing lessons.

Madame Lecadre was a power in the struggle which developed between son and parents. The struggle lasted throughout the latter part of 1858 and into the next year. Boudin innocently brought it to a conclusion. Towards the end of this period he began to see signs of real power and originality in his pupil's work. He saw it with alarm. He had no faith in himself as painter or teacher, impelled though he was to attempt both. Besides, he saw more than Monet's natural gift; he divined a superior intelligence and will. Where he, Boudin, had failed in Paris, Monet would succeed. He was potentially too good for local teaching, he needed the Paris schools.

The advice was no sooner given than Monet, still a bare eighteen years old, panted to be off. He asked his father to let him study in Paris. He could not afford it, was his father's reply. And the answer to this, provoked by Boudin, was, let his father apply to the town for a grant. His father did so.

This was in the spring of 1859. The Salon opened in May. Monet was determined to see it, the more so since Boudin was to have a picture hung there for the first time. May arrived. No answer from the town council. The boy lost patience. He was going, he declared. His father would not give him a sou and foretold disaster. "I shall manage," answered his son with his usual confidence.

There was, as usual, some reason for his confidence. Afterwards

he explained: "I had begun my savings long before. My caricatures accounted for the greater part of them. It wasn't out of the way for me to make seven or eight caricature-portraits in a single day." The profits mounted. By this time he had put into his aunt's safekeeping no less than two thousand francs. "With this," he said, "one feels rich. I furnished myself with some letters of introduction and slipped my moorings posthaste."

He did not, after all, slip them without permission. His father, impressed by the determination and possibly even more by the two thousand francs, said that he could go to see the Salon and meet Armand Gautier; he paid the fare and made him an allowance. The question of staying in Paris and learning to paint was left over until the town council had made up its mind.

Claude agreed; wild to be off, he would have agreed to anything. At heart he had not burned his boats; he talked largely but his actions showed him still tied in spirit to the grocery store he despised. Oscar Monet was not dead. Though he had spent months with Boudin, though he declared again and again his determination to be a painter, he continued to the last minute to make and sell his caricatures.

Perhaps the town council bore these facts in mind; in a town like Le Havre all was known. A few days after the young Monet had gone off to Paris the council announced its decision. It had studied the still life which he offered as a specimen of his talent as a painter. This, said the report ponderously but with sense, "would have given a poor impression of his talent if this had not already been revealed so fully by the humorous sketches we all know . . . But is there not in this precocious success, in the direction given by so facile a pen, a danger, that of keeping the young artist away from the more serious but less profitable studies which alone have the right to municipal grants? The future will show."

The grant was refused.

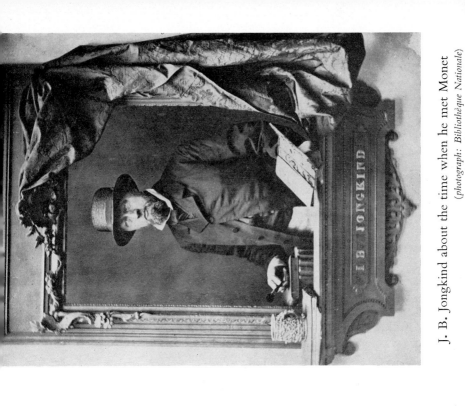

J. B. Jongkind about the time when he met Monet

(photograph: Bibliothèque Nationale)

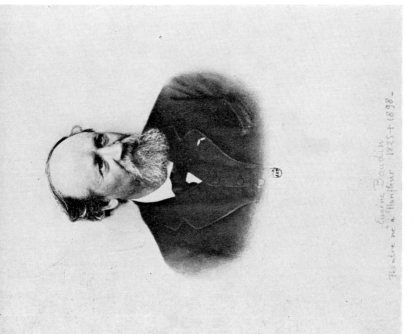

Eugène Boudin in old age

(photograph: Bibliothèque Nationale)

*La Sainte Catherine
à Honfleur*
by Jongkind

(*watercolour, 1864*)

Chapter 5

Oscar or Claude?

1859 - 1860

PARIS IS HEADY STUFF FOR A LIVELY AND CURIOUS YOUNG MAN OF eighteen. For a time after his arrival Monet's behaviour suggested that the turning out of amusing drawings represented his true level. He went often to the Salon and commented freely to Boudin on the exhibits, but his comments were banal. He told Boudin soon after getting to Paris, "In spite of the little time I've had I can see that the landscapists are in a majority," without going into the question of the kind of landscape that was being done then. He had one stroke of foresight. He questioned a picture by Troyon in a single but illuminating detail: "I find a little too much black in the shadows."

This criticism was not only a pointer to the future, it showed courage. For the young Monet, like so many people in France, regarded Troyon as a god. There had been a time when Louis Napoleon, going the rounds of the Salon, had been injudicious enough to say that he didn't understand a Troyon. Not long afterward his Minister of Fine Arts put before him for signature a decree decorating the painter. Louis signed with a smile and a whimsical, "I see that I know nothing about painting!" Louis was in the right, except that

23

Troyon is only too easy to understand, but at that time no one could have believed this and certainly not Monet. He raved about Troyon's cattle and dogs, he found his Salon pictures of that year "superb . . . marvellous . . . magnificent . . . astonishing." When he called at the great man's studio with a letter of introduction from Boudin he was quite bowled over by his reception.

Troyon the man had the same fault as Troyon the painter—insincerity; all his ducklings were potential swans. He spoke—shouted rather—to Monet that he had only to do this and "you'll get there!" This on the strength of two still lifes which the young man had brought to his studio.

Unable to see through the academic polish of Troyon's work to the absence of originality, Monet hung on his words. And these words, hastily passed on to Boudin, were in the main sensible if obvious. "Well, my dear chap," Troyon told him, "your colouring's all right. The general effect of what you do is correct but everything is too slick, it comes too easily. If you want to go in for art seriously you must go into a studio where they do the figure only, academic figures. Learn to draw, draw with all you've got. You can never know too much about it."

This was accepted without hesitation by his young listener who up to that moment had thought his draughtsmanship exemplary. But was he not to paint at all? Yes, said Troyon, "make sketches in the country from time to time. Do some copying in the Louvre. But above all, draw. Then you can go back to Le Havre for the summer, work in the country and come back to Paris in winter to settle indefinitely."

The programme, as a programme, appealed to the boy, though how much of his enthusiasm was for painting and how much for Paris was a moot point. In the letter he at once wrote to his parents he naturally played up his patron, the great Troyon, for all he was worth. They agreed that he should stay in Paris another month or two. To Boudin he wrote confidently that he had been "received perfectly" in Paris, that he had "many small paintings in train and shall any day now begin a large lithograph." And, "I have been to see many

painters. I began with Monsieur Gautier who asked me to give you his greetings and tell you that he looks forward to seeing you in Paris soon. All say the same. Don't stay downhearted in that rotten town."

Boudin did not come to Paris. He did not wish to stand transfixed before his own picture in the Salon—perhaps the only painter who would have resisted that satisfaction—and the "rotten town" was at that moment giving him a pleasure that Monet sought in vain in Paris. He had made the acquaintance in the most flattering way of the man whose name stood highest among the young progressive painters. One day the steps which led to his little studio began to quiver under a heavy tread. There was a thunderous knock at his door. Gustave Courbet stood there accompanied by his friend Schanne, the Schaunard of Mürger's *Scènes de la Vie de Bohème*. In his loud, commanding voice he explained that he had seen some seascapes in Archer's shop, had demanded the name and address of the man who made them. And what was such a painter doing, hiding himself away in Honfleur?

Boudin, unintimidated by the great man's rough and ready manner but quite overcome by the honour of the visit, murmured that if his visitors wished he would show them why he stayed. Courbet stamped about the studio routing out sketches, at which he stared with prominent eyes. He gave judgment: extraordinarily good; a bit wishy-washy, too small in every way, but he would change all that. "Our friend needs a course of Courbet," he announced jovially. The three of them toured Honfleur, the estuary shore, crossed to Le Havre and explored the great port. Boudin took them to all his best-loved places, ending at the farm of Saint-Siméon, halfway up the hill above Honfleur. There his friend Mère Toutain prepared a meal that Courbet smacked thick lips over, and offered soft beds. Outside was the sea and a landscape which cried out to be painted; inside the walls showed that Mère Toutain had a soft heart for painters and let them experiment freely.

Courbet was delighted; with Honfleur, the estuary, Le Havre, Mère Toutain, above all with his new friend's talent. He produced a *bon mot* which pleased him enormously. "What skies!" he cried, after

watching Boudin at work. "You must be an angel, you're the only one who understands the heavens."

The *bon mot* was duly registered by the obliging Schanne in readiness for innumerable repetitions in Paris where every word of Courbet was treasured. He had to store it, for the master was loath to leave either of his latest discoveries, the Normandy coast or Boudin. Day after day they went sketching together and one day ran into Baudelaire. He was staying with his mother in Honfleur and writing an article on the work of Courbet. With his customary roar Courbet told him to drop everything and come to see Boudin's seascapes. Baudelaire came, was ravished by the hundreds of little pastel sketches, and there and then wrote an appreciation of them for inclusion in his notice of the Salon. "These studies of waves and clouds so quickly and faithfully drawn from what is the most changeable, most elusive in form and colour, carry always, written in the margin, the date, hour, and wind. For instance: October 8, midday, wind north-west. If you have at any time had the leisure to experience these climatic beauties you can verify by memory the observations of Monsieur Boudin. Cover his title with your hand and you will still know the time of day, the wind, and the time of year. I don't exaggerate. I have seen."

Boudin could resist the flattery but had not such a good head for drink. A typical notebook entry reads: "Return from Honfleur with Courbet, Schanne. The noise we made was simply appalling. Our overheated brains reel. Our minds whirl. Courbet proclaimed his profession of faith to us in a manner the reverse of lucid, naturally."

This picture of Courbet shouting slogans in the middle of a darkened street remained with Boudin long after the famous painter had gone back to Paris. "Wherever I put myself, it's always good if I have nature under my eyes." This saying, which he took literally, made him love the man. He responded to Courbet's revolutionary talk—why not paint ordinary men and women, everyday scenes?— by making little sketches, exquisitely coloured and wittily observed, of bathers on the beach at Trouville; and he defended these with Courbet-like, "The peasants have their painters . . . haven't those middle class people strolling on the jetty at sunset also a right to be put on to canvas?"

He was less wholehearted about Courbet's admonitions to take his courage in both hands and paint more boldly. The advice—order, would be nearer the mark—was taken gratefully but in his own way; he was not and could never be a Courbet and he knew it. And he did not wish to be. He was soon saying, "Courbet has already freed me a little from timidity; I shall try some broad pictures, some big things more elaborate in tone. Then I shall enter fully into art. Courage. I have seen Courbet at work. He is a brave man. One can take over his broad principle though it sometimes seems to me rather coarse and careless in detail. One can use enough of it without going as far. There is a more truthful, surer way. All the same, this is a lesson. I like to see his strong will, but hasn't he been made self-opinionated by people who love to turn this will into an eccentricity?"

And with this shrewd analysis of Courbet the exhibitionist, the unlearned Boudin continued to plough his own furrow, cutting a little deeper than before. Whether he passed on his judgment to Monet with his news is doubtful. He was too kind to allow criticism further than the pages of his diary. So Monet was left to watch even more eagerly for the great rebel at the Brasserie des Martyrs.

Boudin was writing and not talking to his young friend because the attractions of this "stunning" Paris were obliterating everything, from Troyon's advice to the pleas of the Monet parents. Summer came and went; Claude was still there. Protestations from home were followed by threats. Claude, full jaw set firm, stayed where he was. His father stopped his allowance. Claude wrote to his aunt to send him some of his savings.

This obstinacy of purpose was not so single-minded as the boy would have it appear at home. For a while the budding painter seemed likely to be submerged by the pleasure-loving youth set free in Paris for the first time. Claude Monet was charmed out of his usual robust good sense by the appeal of city life. For a long time his main haunt was not the studio but the famous Brasserie in rue des Martyrs. There he sat for hours at a time, watching, listening, drinking, and making his caricatures—for he had discovered that they could earn money in Paris too.

The Brasserie was the headquarters of revolt in the arts. In its two packed and stifling rooms were found on most evenings dissenting painters and poets, from the lone wolf Baudelaire to the strolling player Glatigny, from the nonsense rhymer Silvestre to the rotund Banville talking nineteen to the dozen in his high voice. Monet gathered without difficulty that the revolt, in poetry as in painting, took the form of a violent reaction to the romanticism which had come to its head in the thirties. By the time of his arrival the poets had reduced this reaction to the aim of "impassibility," an aim which Banville summarized from time to time in an ecstatic, "Art is my religion!" ringing through the café like a war cry. And though the poets were almost as varied as the painters, they were moving towards the group expression of the *Parnasse Contemporain* of six years later: art for art's sake, avoidance of personal feeling, the expression of truth and feeling through impeccable form.

This much an intelligent man—and the young Monet was not dull —could extract with patience from the babel. But to discover a common purpose in the painters was another matter. All had much to say and their literary supporters even more, but it was a saying confused by many things, by lack of seriousness not least. All were in revolt against instruction at the Ecole des Beaux-Arts by a rota of teachers appointed by the all-powerful Academy of Fine Arts. The dutiful student was taught to paint in the manner approved by the Academy, correct, finished, lifeless. If he were talented, his work would in course of time be selected by a Jury (also appointed by the Academy) to be shown at the Salon. And as the Salon was the only way of placing one's wares before the public, he would receive the attention of the critics, would be granted honorable mentions, decorations, and perhaps, finally, admission to the Academy. All of which insured a market for his pictures.

The painters at the Brasserie loudly deplored this state control of painting. All panted after an alternative means of making a name and sales. The grievance and the difficulty provided fine excuses for uproar. And that was about all, for not only had the young men no idea how to market their work, they could not agree about the work

itself—they championed a dozen disparate methods of painting. There were Ingristes, followers of Ingres who preached the all-importance of drawing and the superiority of line over colour. There were Coloristes, followers of Ingres' great rival, Delacroix who preached the virtues of action, colour, imagination, with drawing as secondary and the slogan "Line is Colour." There were Couturistes, followers of the most popular painter of the day and one of the most powerful teachers at the Beaux-Arts, whose motto was "Ideal and Impersonality." There were Réalistes, followers of Courbet, who at the great World's Fair four years earlier had put up his own pavilion to show works whose purpose was "to interpret the manners, ideals, and aspects of my own time." There were Fantaisistes, followers of the Barbizon group who painted after nature in Fontainebleau Forest. There was even an accasional voice raised in favour of one or other of the rustic painters, Corot, Millet, and Daubigny.

The confusion of thought, the absence of true aim, the obvious love of argument for the pleasure of hearing one's own voice—all this gave the listening boy a first-rate excuse for simply enjoying himself. Which, having made the motions of studying the Salon, obtained Troyon's advice, and taken up his introductions, he did.

Later in life he looked back at this period with extreme distaste. The months at the Brasserie, he said, "lost me a great deal of time and did me a lot of harm." He spoke of the "bad characters" he met there, and included himself among them. But this judgment was altogether too severe. The wonder is that the hot-blooded young provincial did not put himself out of action for years.

In fact, for a few months he revelled in the Brasserie, went there day after day. He could not tear himself away, so much did he enjoy the sense of good fellowship, the lively atmosphere, the thought of men of the arts mixing freely and discussing their difficulties. This, after Le Havre, seemed the height of civilization.

For a while it was congenial. But only for a short while. Monet was as typical a Norman as any man born there. The magic soon passed. He had not reached his nineteenth birthday before he noticed that the rival groups mingled indiscriminately, were often more

interested in the prostitutes who abounded at the tables than in their arguments, and were most interested in the argument as a means of personal aggrandizement.

Disgusted, he tried to forget his disgust in drink and women. But that, too, palled. If he talked little, he thought much. About Courbet, for instance. Courbet's "paint what you see" was a clarion call in an age when most men painted only what they or their clients wanted to see. Monet admired him tremendously, was too shy even to approach him when he returned from Normandy. Sitting in the midst of the painters at the Brasserie, he thought back to those days and weeks and months of working and talking with Boudin on the shores of the estuary. Contrasted with the thought of Boudin quietly working, the rowdy young men lost something of their charm. Yet Monet was young as Boudin was not, ambitious as Boudin was not. He had no wish to go back to Le Havre. With all his reservations he was enjoying his life. So he called on Boudin again and again to join him in Paris. The call was not answered as he wished. Boudin had not the fare to Paris, he had not the desire to go either. He knew that his young friend was being unrealistic. Monet wanted the best of both worlds, the gaiety of the cafés, the truth of his master. They did not mix.

So Boudin did not join him and Monet soon began to show his hand—surprisingly soon for so young a man surrounded by many attractions. First, he took a strong line about the Beaux-Arts. He had long since asked the advice of Troyon and others: where should he go for tuition? The answer was unanimous: to Couture, the best teacher at the Beaux-Arts. But Monet did not like what he had heard of Couture, an envious, spiteful fellow. He defied the advice of his betters and got himself into more hot water at home. There, the natural wish was that, if the son must try to be a painter, he should go to the Beaux-Arts, since only thus could he become a painter who made money. But Monet not only did not care for Couture or his work, he remembered Boudin's experience at the Beaux-Arts. He refused to go. When his father continued to cut off supplies he called on his aunt to send more savings. He also refused to go home. He stayed in Paris.

By the beginning of the next year, 1860, he was telling Boudin that "an exhibition of modern pictures is open here which puts the works of the 1830 school in their right place and proves that we aren't so far gone in decadence as is sometimes said." This exhibition, the first of its kind, was held on the Boulevard des Italiens, all the pictures being lent by private collectors. Monet haunted the place. The conventional comments of the previous year began to rise into original remarks as he allowed his eye to do its work unimpeded by the glamour of a great city or of great names. Portraits of this time show him as he was when he walked eagerly down the hill from his room in rue Pigalle. A black cloak swirled about his tall and sturdy figure, the square face was framed in a mass of black hair worn to the neck rather like the feminine "bob" of later days. Yet there was nothing feminine about the young Monet; he was the essence of virility. The hair, though thick, was never allowed to droop over the fine wide forehead, it was brushed back firmly. The cheeks were still a little puffy with youthful fat, heavy eyebrows shielded those bright all-seeing eyes.

Down he came from Montmartre, two or three young painters trying to keep up with him, day after day. He did not talk much but, the day's sightseeing over, he would write an account of his impressions to a Boudin who still resisted every plea to come to Paris. There were eighteen "splendid" canvases of Delacroix. In contrast, he found the Troyons "impossible to compare" with either the Delacroix or the Rousseaus—a big step forward for the Troyon admirer of a few months earlier. Couture he described as "thoroughly bad." Corot and Millet, he says with equal significance, have "brilliant" things at the exhibition.

In the same letter he answers a question, and mentions another name to be significant to him, with: "The little Daubigny in question belongs absolutely to me. It is hanging in my room." This remark had a history. Some time before he left home Monet, cleaning up his aunt's attic studio, found "in the midst of the rubbish jammed into the corners" a little painting of a *vendange*. He was struck at once by it, begged it from his aunt, and found as he had suspected that it was a Daubigny; at which "my joy was great, not so much at possessing a

work by a painter already celebrated but because I had discovered all by myself a work of the master. It was a testimonial to my eye."

As it happened, he had no sooner reassured Boudin that he had the Daubigny than he was parted from it. He and the young friends he had made arranged a party. At the last moment all found themselves out of funds. Monet, the most generous of people, did not hesitate when he saw his companions' downcast faces: "It was good-by to my Daubigny." He and his friends toured the shops in a cab—a typical gesture of these impecunious young men. "There weren't many picture dealers then," Monet recalled, "and they were all very suspicious. All except one refused my *Vendange*. They smelt the canvas, turned it round and round, sniffed contemptuously and conducted us politely to the door. Our laughter grew strained. The cab fare mounted . . . Then at last, in rue du Bac, a man named Thomas— I shall never forget that name—offered four hundred francs for the picture. Yes, but wait a moment, on condition that we supplied a note from Daubigny himself attesting that the picture was genuine."

"For the moment" Monet lost heart—the qualification is significant; he never lost heart for long—but one of his friends had less reverence for a great painter than he. He would beard him, he said, if they would go with him. Daubigny "recognized his child" at once and signed a paper declaring that he did so.

Monet drove off to collect his four hundred francs and, more important, to remember with pleasure and gratitude a man without airs or false pride, a man whose work he had already admired.

For the last two or three years Daubigny, who lived by the Oise at Auvers, had painted river, river traffic, and shore from midstream. On a rowing boat he had had built a kind of crude studio open at both ends. Here he could paint sheltered from weather and obtain without distraction only the restricted view he required. This curious-looking boat was called *Le Botin*. It and his work caused much amusement in the cafés, and his pictures at the Salon when not rejected were regularly and severely criticized. Even the friendly Théophile Gautier complained that Daubigny could never finish a picture, that what he submitted were "nothing more than rough drafts or very slightly

32

developed rough drafts." He was, he said reprovingly, "satisfied by an *impression.*"

Monet did not join in the laughter. He realized that Daubigny was of the mind of Boudin and himself in wishing to paint direct from nature. His spotting of a Daubigny in a rubbish heap and the master's man to man friendliness had confirmed an instinct of the truth, that Daubigny was "a chap who does good stuff, who understands nature!" as he had told Boudin after the Salon.

For Monet was already attacking landscape problems. "I am surrounded," he tells Boudin in February, "by a little group of landscape painters all of whom would be happy to know you." He was working regularly in the studio of one of them and he was drawing hard, wisely combining Troyon's good advice with native instinct.

His instinct was less sound in another direction. He informed Boudin that "the only good seascape painter we possess, Jongkind, is dead to art; he is absolutely mad. The painters are clubbing together to give him enough to live on." And he tried to tempt his friend to Paris with this news, saying, "You can only gain by coming. There's a good place ready for you to fill."

Boudin had more sense, or less confidence, and stayed where he was. So Monet, whose news, fortunately for his future, was much exaggerated, continued working with his group of friends. None of these companions was to make his mark in painting; they are remembered now, if at all, because of this brief association with a famous painter in his calf days. They added nothing to Monet's stature, nor did they influence him. He it was who, remembering Boudin and drawn to Daubigny, kept his eye firmly on landscape and—a notable example of will in a much flattered young man—applied himself to his drawing. "As for me," he reassures a Boudin grown anxious by the long stay—close on a year—in Paris, "I find myself pretty well here. I go on steadily at my figure drawing—there's nothing like it. For the rest, there are only landscapists at the academy; they begin to realize that this is the best line to take."

"They begin to realize": revealing words. For this provincial boy

of not much past nineteen was in process of imposing his enthusiasm not merely on his two or three painter friends who considered themselves experienced Parisians, but on a whole body of older men with whom he worked at the "academy."

This "academy" was not the Beaux-Arts his parents never ceased to press him to enter, but an ancient building on the quai des Orfèvres known to painters as the Académie Suisse because of the former model, Père Suisse, who ran it. No tuition was available, simply the use of models. Many painters came there to draw. Amongst past pupils were Courbet, Manet, and Pissarro. And while Monet was working there in the spring of 1860 Pissarro looked in to see friends working there still.

This momentous meeting was not then seen as anything more than two landscapists getting together. Monet liked Pissarro immediately. Camille Pissarro was then just on thirty, a big man with a bushy beard and large, lustrous brown eyes. He had a curious history. He was the son of a Creole woman and a French Jew who had a hardware store in the Danish West Indies island of St. Thomas. Camille was sent to school in France. There he was lucky enough to meet a sympathetic drawing master. By the time he had to return home, when he was seventeen, he had developed a passion for art. For five years his father disregarded the boy's obvious talent and ambitions and made him work in the store. Camille spent every spare moment sketching in the island's little port. There he met a Danish painter. When the painter moved on to Venezuela, Camille moved with him.

Shocked by this escapade, his father promised that he should study painting, and with a very slender sum in his pocket the young Pissarro arrived in Paris just in time to see the great exhibition of painting at the World's Fair of 1855. He saw also Courbet's defiant private show in his "Pavillon de Réalisme." He was impressed, like Monet after him, by Courbet, and also by Delacroix, Daubigny, Jongkind, Corot. He studied under various masters but abandoned one after another. Finally he decided to rely on his own instinct allied to hard work at the Académie Suisse. Such painting as he had done before the meeting with Monet showed the influence of all his favourite landscape painters

but of Corot most of all. And it was to Corot that Pissarro went for advice.

This showed courage, of which he had plenty. Corot was frowned on by almost all authorities: Couture used some of his choicest witticisms to ridicule him, Ingres declared that he couldn't draw, critics dismissed his figure work as "wretched" and taunted his few followers as "those who, having no flair for draughtsmanship or gift for colour, look for glory without effort under his flag."

Undeterred by these criticisms, Pissarro put his faith in Corot and the few words of encouragement the master gave him. He painted on and with apparent success; only four years after his arrival in Paris he had a landscape accepted by the Salon jury. This was 1859, the year of Boudin's first showing there and of the young Monet's visit to study the paintings.

This early triumph did not inflate Pissarro, who combined a passion for painting with a disarming modesty. He returned to Corot. Corot was a difficult, unsociable man. He did not accept pupils nor did he talk readily, but he received Pissarro with unusual warmth and repeated advice given the first time: above all to study form and values; colour and execution were secondary merits. "You're already an artist," he said after examining Pissarro's work. "You don't need any more guidance except to remember, always study values. You and I don't see the same things, you see green where I see grey and gold. But that's no reason for you not to work at values which are at the bottom of everything. However one feels and whatever one's means of expression, good painting is impossible without this." And before they parted, he reiterated his favourite slogans—"paint what you see, choose subjects which harmonize with your own impressions, never imitate."

All this Pissarro passed on to Monet in those first days of friendship in the spring of 1860. The bumptiousness of the Le Havre caricaturist had not been extinguished by Paris, merely covered over. In the months before meeting Pissarro, when Monet found himself the natural leader of the younger men at the Académie Suisse, it had begun to spring up again. As in the old days, everything seemed a little too easy.

But though one could laugh at Pissarro's appearance and manner, that of a battered Jewish prophet, respect followed hard after. He was both fervent and diffident; his devotion to painting came transparently through this beguiling mixture of ferocious words and mild manner. Monet listened. The advice of Corot touched a chord; Boudin in his hesitant way had said much the same in those early days at Rouelles; Courbet trumpeted it in the Brasserie.

And when he looked at the landscapes which the older man offered for inspection with an apologetic growl he was immediately moved to try to imitate. This attempt to see nature as it was, disregarding the parrotlike dicta of the academic painters—every object must have its distinctive contour, every detail must be finished, nothing must be left to the imagination—appealed at once to the young man. With his usual impetuosity masking determination, he offered to accompany Pissarro who "was working tranquilly in the style of Corot." Monet's "The model was excellent. I followed his example," is a typical understatement. Conquered by the man and his work, he went with Pissarro to make studies by the Marne.

They were not to spend much time together then, but the importance of the brief intimacy to Monet's final advancement could scarcely be overestimated. He had been advised soundly by Boudin, but without confidence. In Paris, Boudin's advice was not so much forgotten as snowed under by the horde of impressions. For a time Monet hesitated. The suspended judgment of the town council of Le Havre hung in the balance—would he be serious or no, was he Oscar or Claude?

Then came the visit to Daubigny, a small incident but significant. And before the effect of this hint could fade, Pissarro, and through him, Corot, followed to urge him to throw aside convention, to be fearlessly himself.

Monet, strong, determined, needed strong leadership. He received it from Pissarro. Pissarro had the strength of conviction; he himself was nothing, his art was a lion. His life was given to his painting. There is no greater force than the dedicated man. Monet's road ran clear ahead.

And having glimpsed the way, he was immediately carried from it.

Chapter 6

Jongkind

1860 – 1862

THE MONET PARENTS HAD BEEN WATCHING THEIR MASTERFUL SON'S prolonged flirtation with art with mixed feelings. He was still managing to exist on his savings. He remained impervious to every suggestion that he return home, even if only to discuss his future. In the Le Havre grocery shop pride, bewilderment, anger, all gave way to the comfortable belief that Monet sense must bring this youthful fling to an end.

They waited in vain. Then another element entered into their calculations. As the year advanced their appeals died away. Their son was approaching his twentieth birthday and military service. This, they reckoned, would cure him of romantic hankerings after the life of a painter.

The time arrived. Like Boudin before him Monet drew an unlucky number. He was faced with seven years in army or navy. His father, who had no wish to see the boy spend so long a period away from them and in rough company, at once offered to buy a substitute for him. There was one condition, that he abandon painting and come into the family business.

Monet refused. The refusal was not unexpected at home; his father's offer was half-hearted, a last effort to accomplish the improbable. Then came the real offer: Monsieur Monet would buy him out if he agreed to study at the Beaux-Arts and take up the career of painting in a businesslike way. The boy replied to the ultimatum with "a superb gesture of indifference." One of his Paris acquaintances had been called up earlier and drafted into the Chasseurs d'Afrique based in Algiers. This youth wrote enthusiastic letters to Paris. Monet, "inspired with a love of adventure," answered his father by another act like the departure for Paris; he applied to be put onto the strength of the same regiment. He was accepted and sent to Algiers.

This episode, which might have put a quick end to Monet the painter, demonstrated that the painter was still far from fledged. He said later: "The seven years which appalled so many were filled with attraction for me. Nothing lured me so greatly as the idea of the endless cavalcades under a blazing sun, the pillaging incursions, the crackling of gunpowder, the sabre thrusts, the nights in the desert." The attraction to a strong, full-blooded young man with his fair share of romance is easy to understand. Nevertheless the town council might well have raised eyebrows with a "What did we tell you?" For it was not the act of the painter born, the man determined to sacrifice everything for his art. Boudin had done much for the boy, Pissarro had pushed him further along the road, but another and decisive influence was still to come.

So Monet disappeared from view for the last part of 1860, the year of 1861, and for months beyond. Boudin worked away in Le Havre and Honfleur. The attentions of Courbet and Baudelaire had changed his work—he was painting with more confidence—but had not changed his circumstances. He was soon writing, "I literally can't find enough to live on here, I shall have to try somewhere else." This was not due entirely to the hostility of his townsfolk but to the fact that he had linked his life with that of a young Bretonne, Marie-Anne Guédes, who had posed for him in his first Salon picture. He was happier but poorer than ever. And when in 1861 a sculptor friend in Paris replied to his despairing letter with a "Come, my dear Boudin,

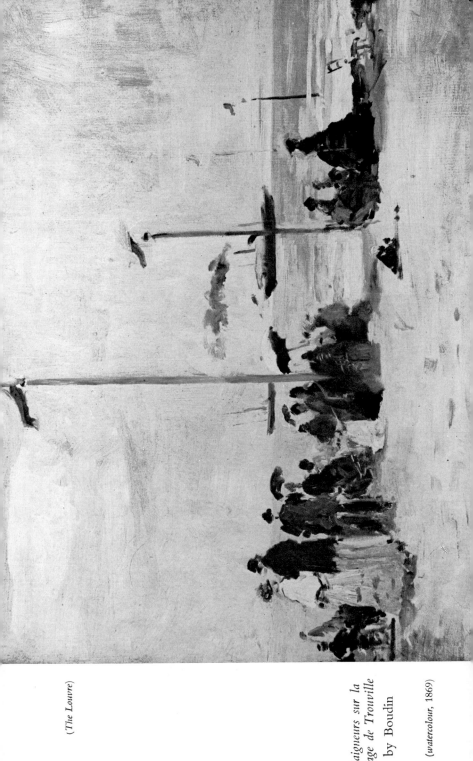

(The Louvre)

Baigneurs sur la
Plage de Trouville
by Boudin

(watercolour, 1869)

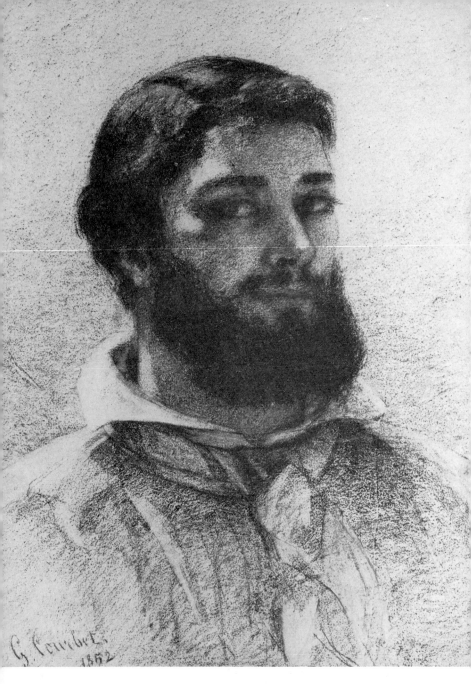

Gustave Courbet
self portrait, 1852

leave that infernal dead and alive little hole of a town inhabited entirely by idiots, your place is here," he gave way.

Paris treated him little better than Le Havre. Troyon had promised to find work for him but this brought him in very little and was not permanent. Eventually he was driven to turn out little sketches for a dealer at seventy-five francs the dozen. "It's frightful," he exclaimed of this prostitution, "but permits one to live."

To live and to hope; for he could never bring himself to believe that the bad days would not pass. He had one great satisfaction; he met Corot, who after examining his work called him "the king of skies." This apart, all was frustration and failure. Paris was a hard place for the unconforming painter in those days; to get on one needed more than talent, one needed personality and drive, In these Boudin was singularly lacking. His drooping, shabby, sailorlike figure standing apologetically at dealers' doors, his slow, gentle voice asking diffidently if they could sell his work or use him in any way, were out of place in brisk, businesslike Paris. They asked for the expected rebuff.

The life of the *petit maître* is often unsatisfactory. During these months Boudin demonstrated in person why his work, original though it was, and full of charm, could no more capture Paris than he could finally convince Monet. Had he been another man his pupil would have thrown caricature overboard in the first few weeks, would have attacked Paris seriously, would not have rushed off to Algeria.

Towards the end of the year Boudin and his "comrade," as he affectionately called her, were forced to walk back to Honfleur where they scratched out a living. In 1862 Boudin tried another means of raising money; an auction sale at Caen. With another painter he walked the forty miles burdened with canvases. After prolonged efforts to whip up interest in the town, they persuaded six people to attend. Boudin, roused for once, stopped the sale which showed signs of turning into a farce. He and his friend, penniless, walked all the way home, their canvases still on their backs.

While Boudin was away on this disastrous venture, Monet returned unexpectedly. He was on sick leave. The longed-for Africa had given

him a serious bout of fever. His bronzed face contrasted strangely with a haggard expression and wasted body. He fell at once to sketching and painting round about the town.

In after years Monet maintained that the period in Algeria was vital to his art. "The impressions of light and colour I received there contained the essence of my future work," he said. But though the hard, pure light of the south has astonished many northern painters and inspired one, it was wasted on an eye above all gifted in discovering nuances of light and shade.

The value of the African break consisted, like so many holidays, chiefly in emphasizing the less obvious beauties of home. Monet roamed about the estuary shore and climbed slowly to Mère Toutain's farm, from which lowly eminence the whole mouth of the Seine opened out under ever-changing skies. He walked out to the lighthouse on the tip of Cape Hève above Le Havre.

One day not long after his return he was trying to paint in a field close to a farm behind the lighthouse. He wanted to paint a cow in the field but no sooner had he set up his easel and taken out his paints than the beast, uneasy perhaps at the painter's stare, became restless. Though outwardly stolid, Monet had a fierce temper. He was beside himself with fury as the cow, sampling every brand of grass in the field and settling to none, roamed back and forth, head now turned his way, then slowly switching her tail. He might have ended by stamping on his canvas or ramming it over the cow's horns, but just then a man walking along the nearby lane stopped, grasped the situation, came into the field, approached the animal, and after some efforts succeeded in anchoring it to one spot near the painter.

The grateful Monet attempted to express thanks which were waved off by the stranger. He turned out to be English and a painter. He sat on the grass and watched Monet begin work. They talked desultorily. At last the Englishman said, after they had both agreed in a love of landscape painting, "Do you know Jongkind?"

"No. But I've seen his work."

"What do you think of it?"

"Admirable."

"You're right," said the stranger. Then, calmly: "Do you know he's here?"

Monet's exclamation was reply enough. His new acquaintance said, "Yes, he's at Honfleur," and asked: "Would you like to meet him?"

"Would I not!" cried Monet. "Is he a friend of yours?"

"I've never seen him in my life but the moment I heard he was here I sent him my card. That was just to broach the subject. Now I'm on my way to invite him to lunch with us."

The Englishman was as good as his word. The next Sunday he and Monet were sitting under the trees outside the town eating an alfresco lunch with Jongkind himself, the man whom Monet had announced as completely mad and done for two years earlier.

Superficially, the Dutchman appeared another Boudin. He had a similar gangling figure, walked with a similar seaman's roll, had similar clear blue eyes. There the resemblance ended and ended startlingly. For Jongkind at first presented an alarming sight. The only disturbing feature of Boudin's tanned face was the signs of years of semistarvation. Jongkind's long and bony face was dead white and ravaged by drink and nerves. His hands and arms were not merely clumsy, as though they scarcely belonged to him, but twitched distressingly. The glances of his restless eyes were suspicious and scarcely sane. His speech was laboured and almost incoherent, as though he had an impediment.

Jongkind was then forty-three and had been in France for sixteen years, painting landscapes wherever the mood took him. Although he revisited Holland from time to time he never dreamed of staying there and in the great exhibition of 1855 described himself as a Frenchman. His life had been ruined by hallucinations and brainstorms. Persecution mania grew to such a pitch that he lived in perpetual dread, believing that enemies were about to carry him off to be guillotined and that so-called friends were trying to poison him. Attempts to drink himself out of the horrors led to worse when he ended with *delirium tremens*.

His tragedy was heightened by the fact that he was intrinsically a good and gentle man. He clung to the society of children, simple

people and animals and was loved in return: to see him playing marbles with the guttersnipes in the rue Chevreuse was to see a happy man. His studio there was like a farmyard, with pigeons perching on the easel, hens pecking around his feet and a bird nestling between jacket and waistcoat as he painted. He never travelled without his favourite turtle dove and partridge. In Normandy the peasants had already become fond of him. He talked to them by the hour and he told them stories. In Le Havre and Honfleur they called him Jonquille.

When Monet first wrote about Jongkind two years earlier, after admiring his work in the 1860 exhibition, the Dutchman was in what seemed to be the last stages of alcoholism. He had been given up by most of his friends. At that moment, a Dutch painter in Paris, Madame Fesser, came to the rescue. This middle-aged woman was herself something of an oddity; very short and white-haired, she had a thick white mustache and looked, one of the Paris wags said, "like a *vivandière* of the Imperial Guard."

She was not a *vivandière,* however, but a kind and firm woman. Deeply sorry for her unhappy countryman and admiring his work, she attached herself to him and refused to be discouraged by suspicions, insults, and ferocious drinking bouts. Gradually she won his trust, persuaded him to drink less, and calmed some of his worst imaginings. She finally won him over after his landlord had threatened to turn him out or destroy his fowls or both, because the birds were soiling the floor. She devised tiny baskets which she fixed under the tails of the birds. The floor remained clean, the landlord satisfied, and Jongkind, convulsed with laughter at the sight of his pets strutting about proudly waggling their unusual decoration, became her somewhat difficult slave.

By the spring of 1862 he had grown, if not normal, tolerable to live with and was again working hard and well. As in Paris, the local people laughed to see the couple walking down the road, Jongkind's long body rolling along beside the tiny little woman. But Monet was instantly attracted to the Dutchman who, speaking atrocious French in a heavy Dutch accent, quickly showed himself anxious to help anyone interested in landscape.

The young man noticed that the moment Jongkind began to talk about painting he lost all trace of hesitation, spoke clearly and decisively and with an irresistible enthusiasm. He was as devoted to landscape and seascape as Boudin, but to Monet, listening on this first day, he attacked the problem in a quite different spirit. Boudin was concerned to render exactly what he saw at a given moment; everything had to be in place, the rigging of a ship as much as the whirl of a cloud. That there could be gradations in the value of accuracy he did not or would not see; that a million men could render rigging as well as he and none but he portray the very breath of a north wind suggested nothing to him. That was his mind. But to Jongkind, as simple a man, the problem appeared quite differently. He wanted to render a scene as that scene struck his imagination. Literal accuracy was of no moment beside that greater accuracy, faithfulness to one's inner as well as outward vision.

So the Dutchman, sitting on the grass munching bread and cheese, declared with an attractive grin, rather like that of the bad boy in a model class, that for him "the horizon was never horizontal." And he repeated impishly yet with immense conviction his reproof to a correct painter friend: "You pose yourself at random like a fly on a muck heap."

Monet revealed his true self by unquestioning acceptance of this fine artist and good man who could so easily be dismissed by the intolerant and superficial as a laughable spectacle. Jongkind's attachment to the young man of half his age and so different in nature, character, education, and class, was an even greater compliment. Up to that moment a spectator of Monet's life might have been excused for wondering, with the town council, exactly how serious he was. A would-be painter who could meet and work with Pissaro, then rush off to "adventure" in the army raised many doubts. Was he an Oscar, was he a Claude? His recognition of Jongkind's stature and Jongkind's of his answered that question once and for all.

Monet was never to forget how Jongkind "asked to see my sketches, invited me to come and work with him and explained to me why he worked as he did." He accepted the invitation eagerly, coloured with

pleasure when his new friend showed interest, hurried to introduce Boudin as soon as Boudin returned, and went out painting daily with the two of them.

To hear Jongkind talk about painting was an experience, to watch him at work was a revelation. Monet was startled, thrilled by the change in the man. Talking about art, Jongkind shed all mannerisms, but making art he was a man transformed. He wielded brush or pencil—he made water colours and sketches—with a kind of exaltation. The clumsy, trembling hand became firm, direct, sure. Bringing with him a native strength of fist unknown to French artists, he sketched out a subject with quick, powerful strokes. Familiar from youth with the low skies, magnificent cloud effects, and water studies of his own country, he responded immediately to the seascapes of the Seine estuary. If Boudin, sitting patiently beside him by harbour or shore, was a master of atmosphere, he was undisputed king of reflections. But more than this, much more, Monet felt, watching him; this man was imposing himself on the scene as Boudin, faithful copyist, was incapable of doing. Jongkind used his imagination; his water colours and sketches represented an individual emotional re-action to nature in which line and luminous colour were used with instinctive and unfailing skill. And above all, controlling all, giving unity to his work, was the superb draughtsmanship, bold, dashing, impressionistic, economical, of this poet of suggestion. "Precise improvisation," Monet was splendidly to say.

Boudin, dreamer but no poet, soon took the lead in enthusiasm for Jongkind's work; he who could portray as no other man the atmospheric turmoil when sea and land meet, whose winds billow on the canvas as in sail or skirt, knew that this new fellow spirit was his master. Day in, day out, he sang his praises to Monet. As for Monet, he was in an ecstasy of admiration for the man whom he was to call "the father of the landscape painting school." He was attracted to both his companions; he always acknowledged his debt to Boudin who had first opened his eyes, but he recognized in Jongkind the vital influence: "He completed the teaching I had already received from Boudin. From that time he was my true master. To him I owed the final education of my eye."

Day by day, week after week, the strange trio painted in the harbours, the fields, and on the shores of the estuary. They became a familiar sight: the tall, thin, stooping Boudin with ruddy cheeks and sailor's pointed beard; the shapeless long-armed bulk of Jongkind rolling along with a gait that appeared a travesty of the seamen of Honfleur and Le Havre; the twenty-one-year-old Monet, thick black hair recovering rapidly from army scissors, square face filling out in the sea air, deep brown eyes alight with enthusiasm. And in the rear, bearing the provisions she could scrape together—for all were desperately hard up—came the small, masterful figure of Madame Fesser.

Monet was never to forget these days of good health, good companionship, good work. For the first time he felt the stirrings of a true power. He had far to go, but he acknowledged his goal and had faith in his ability to reach it. Caricature, Brasserie, soldiering were all thrown behind, seen for what they were worth. He was on his way and would not turn aside again.

When he sat munching bread and cheese washed down with Norman beer, the wind ruffling his hair, and listened to the slow and gentle voice of Boudin, the comical Dutch-French of Jongkind, the occasional martial interpolations of Madame Fesser, he seemed to be in very heaven. And when, having watched his friends at work, he attacked his own canvas with youthful ardour and saw emerging from the brush strokes some faint suggestion of the vision his eye had perceived, when Boudin, bending over his shoulder, smiled encouragingly, and Jongkind gave him a clumsy slap on the back he felt proud, excited, invulnerable.

Happy days, but days which had to end. As the weeks turned into months, three elements combined to force him from his friends. The first element was the imminence of Algeria and the Army. His six months of sick leave were nearing their end. Horrified by the speed with which time rushed by, he fought as hard to avoid the army as he had fought to get into it two years earlier. He was seconded by an obliging family doctor who shook his head gravely at the mere mention of five more years under an African sun.

The second element, his aunt, was torn between concern and wounded pride. Even less than his parents did Madame Lecadre want him to go back into the army, a step she had always opposed. That he had a gift as a painter she never doubted. She was equally sure that this gift would be squandered and he become a waster if he continued to roam about with Jongkind and Boudin. She prided herself as an artist on her freedom of mind. Whom her nephew walked and worked with was of no moment, she told herself with perhaps unnecessary vigour, what he did was everything. And what he did appalled her.

Monet not only had far to go as painter but as man; with his family he remained the cocksure boy. He was short with his aunt, tactlessly laughed off her remonstrances, praised his new friends to the skies. She was deeply hurt. She had backed him against his parents for years. She had watched and encouraged his interest in art. When his savings ran out she had supplemented them from her own money. His ingratitude shocked her; his insistence, made with youthful thoughtlessness, that he had discovered the perfect teachers, made her bitter.

She wrote to Armand Gautier to ask his advice. Her nephew's sketches, she said, "are always rough drafts like those you have seen already. When he decides to finish something, to make a complete picture, the sketches turn into dreadful daubs. He preens himself when he looks at them and even finds imbeciles to compliment him on them. He pays no attention to what I say. I am not up to his level. Now I have retired into the most profound silence."

Gautier replied to this letter of a hurt and perplexed woman with a decisive: "Monet ought to return to Paris immediately."

By a different route Monet's parents, the third element, had come to the same conclusion. They had heard the doctor's report with consternation. They had also listened to the reports of another kind, from neighbours who had seen their son walking and working with the disreputable Boudin and a half-crazed Dutchman. He was making himself the talk of the town.

Monet was himself the innocent agent of their final decision to send him off. Annoyed one day by a timid protest against the company

he was keeping, he retaliated with a demand that Jongkind should be invited to dinner. He knew the Dutchman to be good, he trusted his parents to perceive this against all outward evidence.

Jongkind and Madame Fesser were duly invited. They arrived and sat themselves down to table. The meal had scarcely begun when Madame Monet said to her son, "Pass this plate to Madame Jongkind."

Jongkind, freshly washed and on his best behaviour, thought this an excellent joke. He roared with laughter. " She's not my wife!" he shouted gaily. " She isn't my wife, she's an angel!"

His explanation left the Monet and Lecadre families unappeased. Horrified glances shot over the table. Monet cursed his ill luck in failing to think of and guard against this obvious calamity. The thought that they were entertaining an unmarried couple to dinner reduced the Monets to stricken silence. Even Jongkind at last realized that something was amiss. He decided to explain the position. He described himself before the advent of Madame Fesser. He omitted nothing, exaggerated much in his anxiety to do his angel full credit.

The silence at table grew even more marked. The evening was irretrievably ruined. Madness, perpetual insobriety, and now flagrant immorality! And their son hanging on to the man's every word, never leaving him. The Monets and Lecadres all failed to see the real joke: that their visitor was telling the truth. That possibility their pure minds could not encompass. Jongkind and Madame Fesser lived under the same roof; that was evidence enough for them. That they could be good friends and no more did not occur to them.

From that moment their son's days were numbered. He had no money and his aunt refused to stake him further. Neither Boudin nor Jongkind had a spare sou; they could not help him beyond an occasional bottle of wine and stick of bread.

Monsieur and Madame Monet could not bring themselves to let their son be sent back to Africa. Nor was this solely because of their fear that he might die on service. They had been impressed against their will by his devotion to sketching and painting since he had been invalided home. Never a day passed without his working and rarely a night. That he was in bad company was certain; that he must become

a painter seemed as sure; they no longer had the heart to hold out against his obvious passion for it. They were French, after all, grocers though they might be.

For different reasons, then, the Monet parents and Madame Lecadre united in wishing to see Claude parted from his immoral "imbeciles" and back in Paris. Claude was presented with an ultimatum. His father would buy him out of the Army and he would be staked in Paris if he left at once and promised to study under a recognized teacher.

Sulkily, he was driven to surrender. His friends could not help him, he could not help himself except by returning to caricatures. This he would not do.

In November, sadly, he said farewell to Boudin and Jongkind. The train steamed off, leaving them disconsolate on the platform, fiddling with unaccustomed hats. Madame Fesser unashamedly wept. Claude Monet had grown up.

Chapter 7

Gathering of the Clans

1862 – 1866

"THIS TIME YOU ARE TO WORK IN EARNEST. I WANT TO SEE YOU IN A studio under the discipline of some well-known master. If you go off on your own again I'll cut your allowance at once."

Monsieur Monet's parting words were becoming familiar. His son nevertheless thought it wise to heed them for a time. Before, he had been sure of his aunt's support, moral and financial. Now Madame Lecadre's attitude remained uncertain. Hurt feelings and jealousy of Boudin and Jongkind had made her touchy and undependable.

Monsieur Monet cast round for a firm Parisian eye to be kept on the young man. After a short but stiff struggle with Madame Lecadre he passed over Armand Gautier, who had obviously been unable to control him the first time, and fastened on the relative painter, the glory of the Lecadres, Toulmouche, then married to a cousin at Nantes. Toulmouche would look after the headstrong boy, Toulmouche would lead him into the proper paths. Profitable paths too.

For Toulmouche was famous in his way. He was typical of the successful painter, safe, sentimental, correct, false. The revolutionary critic, Zacharie Astruc, described one of his much admired and high-

priced child studies as "pretty, charming, nicely coloured, delicate. It is also frightful. The children look like tarts. Monsieur Toulmouche helps them to look like tarts. Is it worth the trouble to lavish so much talent on this?"

That was Toulmouche, affable, helpful, kind, and with no artistic conscience whatever. He made the young Monet welcome, asked him to paint something for him. And when Claude had done his still life Toulmouche, making polite faces of admiration and doubt, said in cousinly fashion, "It's good. Yes, it's good. But it's too clever. You must go to Gleyre. Gleyre is the master of us all, he'll teach you how to paint a picture." And Monet, with a shrug of broad shoulders, went off to Gleyre.

Gleyre was the nicest of the well-known teachers at the Beaux-Arts and had set up his own studio to provide pupils with consecutive training in addition to the official rota of lectures. His own work was academic to a degree, without life, with little charm, very sentimental, very literary. "Your bacchantes," said Théophile Gautier, "have been drinking philosophical wine." He was a devotee of the antique. As a man he was generous, charging his pupils less than any other master and leaving them much to their own devices.

He did, however, from time to time examine and comment on their work, and the comment was almost always unfortunate. At the end of Monet's first week, on a Monday, he went the rounds of his studio. Monet had made a study from the nude. Gleyre "sat down and, firmly seated on my chair, looked carefully at my work. Then he turned to me and said, leaning his reverend head to one side with an air of self-satisfaction, 'Not bad, not at all bad. But the chest is too heavy, the shoulders too strong, the feet too large.' "

"I can only draw what I see," replied Monet.

Gleyre shook his head reproachfully. "It follows the model too faithfully. You see a stocky man, you paint him stocky. He has very large feet, you paint them large. But that kind of thing is very ugly. Praxiteles selected the best parts of a hundred imperfect models to create a masterpiece, so remember, young man, when you execute a figure always think of the antique. Nature, my friend, is very beautiful

as an element of study. Outside that it's of no interest. Style, believe me, is everything."

Monet's disgust was barely concealed. Nature of no interest! He thought back no more than a week or two to a Boudin industriously rendering the vagaries of a north-wester, to a Jongkind striking out a sketch, a little miracle of emotional truth. His impulse was to walk out of the studio. It was, in any case and as he had always heard, a disorderly, nonserious place. The room was jammed with students, from graybeards to schoolboys. Scarcely one of them had talent, most of them were merely idling their time. And, which was even more infuriating, they occupied themselves by making it difficult for others to work. The noise was deafening. Dirty jokes flew about, practical jokes were the order of the day. Scarcely an hour went by without a scuffle. It was a bear garden.

To Monet, serious at last, the combination of Gleyre's antediluvian advice and the roughhouse atmosphere of his studio was almost too much to be borne. Yet he did bear it, much as he had borne the school at Le Havre; that is to say, he rarely put in an appearance. Gleyre made absenteeism easy; the Monday inspections comprised the whole of his tuition. So Monet attended on Mondays with a sketch or two for Gleyre to condemn, and on other days when he felt like it. His father's threat to withhold supplies was still too recent to be defied comfortably. Besides, amid the riffraff of the studio certain like-minded students had already caught his eye.

He took almost at once to a tall, slender, aristocratic young man whose languid movements and indolent tone contrasted oddly, and to the placid Monet pleasantly, with the general vivacity. He introduced himself as Frédéric Bazille from Montpellier. He was supposed to be completing his studies in medicine while "looking in" at the Beaux-Arts with the approval of parents prepared to indulge a whim. He did not care for Paris. He was suffering, he said, "from an indigestion of streets and walls." This led to accord with Monet, who was missing his sea air.

More important, it led to landscape painting which Monet's purposeful enthusiasm fostered rapidly. They were soon planning a

painting holiday when winter drew off and began to anticipate it by spending days in the country within walking distance of Paris. During these walks and talks Monet first began to show himself a born leader. Bazille's southern blood emphasized a natural laziness. He had thought it work enough to treat Gleyre's teaching with an amusing contempt, but he had met his match in this Norman friend; neither drawl nor slouch could save him. He had to listen and to understand the truths learned at the side of Boudin and Jongkind. He soon found himself talking landscape, looking long at the work of a few admired land-scapists, and practising it whenever possible. Deferring gracefully to the experienced Monet, his attendance at the studio became sketchy. He listened politely to Gleyre, ignored what he said. With Monet he worked hard to improve his drawing.

They were joined after a time by two more students. Monet's attention was first drawn to one of them, a thin, fair-haired, rosy-cheeked youth of twenty-one, by a short but piquant interchange between him and Gleyre. After a disapproving stare, Gleyre said sarcastically, "I suppose you're painting to amuse yourself?" Auguste Renoir—for that was his name—looked seriously at the master. "Of course," he answered. "If it didn't amuse me I shouldn't paint."

In a place where students were either wasting their parents' money for want of something better to do or plugging away distastefully at a boring routine in the hope of a safe future, this answer fell on the studio like a bombshell. Gleyre merely sniffed and moved away haughtily; he had been cheeked, that was all he could see. Monet and Bazille pricked up their ears. The young man's moral courage stirred the one and his lighthearted attitude encouraged the other to approach him sympathetically. The three of them were soon almost inseparable.

Renoir had come from much the same social milieu as Monet. His father was a poor tailor who moved from Limoges to Paris when his son was four in an effort to make ends meet. He was so far unsuccessful as to be obliged to apprentice his son at the age of thirteen to a maker of china. There, in rue du Temple, Renoir sat day after day for four years painting designs on the china. From a child he had shown a

craving for drawing, and his job with the china maker was the nearest thing to the work of an artist that his father could manage.

When the hand-decorated china business collapsed because of competition with machine-made work, the seventeen-year-old moved on to other, similar kinds of livelihood. He painted designs on fans, copied heraldic arms, painted blinds with imitation stained glass. He even decorated the walls of a café with murals. In all this he had an object, to save enough money to educate himself in art. In his spare time he had discovered some of the great artists in the Louvre and conceived a passion for the eighteenth century painters. He made up his mind to be a painter. By 1862 he had saved enough to enter Gleyre's studio.

The fourth member of the little band of rebels looked as French as Renoir looked English. Yet the tiny, dark, dandyish Alfred Sisley was the English one of the four. Born in Paris of English parents, he was twenty-three, one year older than Monet, two years older than Renoir and Bazille. His father was a prosperous dealer in artificial flowers, then very much the rage in Paris. Sisley had been sent early to England to learn the language and business. He had learned the language but instead of learning the business he tried to learn how to draw and paint the artificial flowers. He entered the studios of several English painters, found the tuition antipathetic, returned to Paris and asked to be allowed to study painting there. His parents agreed and put him into Gleyre's studio. Already an ardent admirer of Corot, he regarded the formal exercises and chilling aims of the aging Gleyre with unconcealed aversion.

Although all four students deplored the academic tuition, although they sat and worked together, neither aims nor actions always coincided. In spite of their criticisms Sisley and Renoir continued to work hard and to attend regular classes at Gleyre's and at the official Ecole. Renoir, the only one of the four who had to pay his own way, knew that if he did not attend the Ecole classes and sit for the periodical examinations he would lose his chance of the Prix de Rome, the five-year scholarship which was regarded as the entrée to a distinguished and profitable career. His criticisms took second place to his business-

like wish to make the most of his money. The arguments of Monet and the sceptical smile of Bazille left him unmoved.

Sisley, too, had his eye on the Prix de Rome. But unlike Renoir he had not to worry about money. Unlike Renoir, too, he was a born landscape painter. In the case of Renoir, who simply wanted to paint whatever caught his attention, it was as much what Monet was as what he said that won admiration. With Sisley, Monet's words touched a real gift.

Bazille was too lazy to do anything by wholes. He wavered between allegiance to the meticulousness of Boudin, the poetry of Jongkind, and the supposed realism of Courbet, which last supplied a titivating contrast to the grace and wealth of the Bazille home in the south. He planned a summer of outdoor painting with Monet, walked, talked and listened to Monet. He also copied with Sisley and Renoir at the Louvre. He remained conscious, as they did, of a need for tuition, much though he disliked both what he was taught and the effort involved for him. Yet how paint landscape if he could not even draw? Caught up in this quandary, he made the best of both worlds with an ever charming smile and gracious manner.

Only Monet, who had met some of the well-known painters and could talk glowingly of his months with Boudin and Jongkind, felt sufficiently secure to shun the Ecole classes and shirk all but a handful of Gleyre's. Only he was unenthusiastic about copying the old masters in the Louvre. For he alone of the four was certain of his aim. All talked of the charms of landscape painting but he alone never flirted with anything else. Possessing the strength of singlemindedness as well as the prestige of experience, he naturally took the lead. At twenty-two he had his own little school.

His chief lieutenant was Bazille, whose easy-going ways were congenial to him. At Easter of 1863 they spent a painting holiday together at the village of Chailly on the edge of Fontainebleau forest. They worked out of doors making studies of some of the huge trees there. When Bazille had to go back to Paris to put in an appearance at his medical school Monet could not tear himself away. He continued to paint.

In Le Havre his aunt, hearing from Toulmouche, conscientiously watchful, that her nephew had not returned from his Easter break, wrote anxiously to him and his cousin. She feared a repetition of the summer of the previous year and the emergence of more bad companions. Monet did his best to explain. "I simply couldn't resist the temptation to stay on. It's so beautiful in spring with the grass coming up and the weather so wonderful."

Madame Lecadre remained unconvinced. For her the only place to learn was in the studio. Her nephew tried to put his point to Toulmouche. "She tells me that I absolutely must not stay in the country, that it is above all a grave fault to have given up the studio so soon. But I hope you'll understand me. I haven't abandoned the studio at all. I found a thousand attractions here which I couldn't resist. I've worked hard and you'll see that I'm going to take up drawing again. I haven't given it up, not by any means."

This satisfied no one but he held to his way. It was true enough that he continued to draw but the heresy of open air painting could please neither aunt nor tutor. For him this first experience of new country, a country made famous by the Barbizon painters, was overwhelming. If he had doubted at all of his course these spring weeks would have convinced him that he had chosen rightly. Even Bazille had been moved to write home about the wonderful forest and the sound advice of Monet, "who is pretty good at landscape."

Monet made a few diplomatic visits to the studio before classes broke up for the summer, then went home for a season of really hard work. Whatever his aunt might say—and she said much in her anxious-fond manner, of the way in which he spent his time, and more particularly with whom—his devotion to sketching and painting was undeniable. Even his mother and father looked on with unwilling admiration.

He painted all round the estuary; at Honfleur with Boudin, at Saint-Siméon and Le Havre with Jongkind, and along a hundred different sections of the coast by himself. Even at this early stage he did not cling to his teachers. He admired them and took what he could from them, but he had a vast pride, a vast common sense.

Before his twenty-third birthday he realized that although Boudin and Jongkind could teach him to use his eyes, he had to go the rest of the way alone. What that eye saw and how to transfer that unique vision to canvas was his problem.

Relapsing from time to time into the spoiled boy of the caricatures, he raged against the difficulties of this task. He who had whipped out seven or eight portrait-caricatures a day at twenty francs apiece was four years later unable to reproduce more than the merest of approximations to the nature all around him. He had not earned a franc since abandoning caricature and seemed unlikely to earn one for some time. He became familiar with the ecstatic beginnings when a scene struck his imagination, the gradual suspicion that once again he had failed to grasp the nettle, the final admission that what he had painted was not at all what his eyes had seen, was conventional, inadequate, pitiful. But despite explosions of rage and despair he stuck grimly to his purpose, singleminded to a degree that amazed his parents and Madame Lecadre when they thought back to the self-indulgent youth of not so long past, the youth whose tastes and temper veered with every breath of wind.

Both families had prospered and had built their summer villas at Sainte-Adresse at the tip of the Le Havre promontory—the chic beach of the town—and there every now and then Claude would visit them. But they saw little of him for he was out at dawn and invisible as long as light remained.

Late that autumn of 1863 he went back to Paris apparently little wiser than before and not sorry to resume the role of great man amidst his group of four. The one painting which has survived, of a Normandy farm, is a thickly painted canvas in which the mature Monet is scarcely to be seen.

The farce, for Monet, of official tuition came to an end a few months later, in the first part of 1864, when Gleyre closed his studio. Freed from the necessity of obliging Toulmouche and calming his aunt and parents, Monet joyously carried off his three companions to Chailly as soon as spring was in the air. Not two miles through the forest was the village of Barbizon, headquarters for the past twenty years of a

landscape group with Rousseau and Diaz as the leading spirits. Corot, Millet, and Daubigny had all spent time there. The four young men met Diaz and heard a great deal about the others. There was some hero-worship; Diaz with his wooden leg and surface roughness of manner was a kind and heartening man. The three novices showed signs of succumbing to the fascination. Monet remained adamant. The teaching of Boudin held firm; it appealed to every natural instinct in him; paint what you see and on the spot.

For this, as Monet quickly discovered, was just what the Barbizon painters did not do. They had returned to nature, they tried to paint nature as it was, but their theory broke down in the studio. For they did not paint before their subject; they made only rough sketches out of doors; the finished canvas was done later, in the studio. And as each painter had his own idea of finish, the original impression became overlaid by last minute "improvements" away from the motif. Of all the painters who had worked in the forest only Daubigny worked directly from nature from start to finish, and even he at times, looking again at his canvas in the studio, gave way to the temptation of, as Baudelaire put it of Millet, wanting "at all costs to add something to it."

Monet half-sternly, half-jokingly forbade his little group to add anything, insisted that they paint in the open and let the first impression stay. He repeated Boudin's advice time and again and added the lesson he had learned from Jongkind, that the landscape painter must use his imagination, impose his own vision on the scene: exactitude was immaterial beside the overriding truth of that personal impression. "Paint what you see when you see it," he said firmly. And such was the conviction of his manner that despite the reverence which the other three felt for the painters of Barbizon, they tried their hand time and again at forest studies, never moving from the scene. Evening after evening they carried back their canvases to the rough and ready but friendly painters' inn, all dissatisfied with what they had done, but happy and determined to have another shot the next day at the seemingly unobtainable.

On wet days they trooped over in a damp but contented body to

the Marlotte inn of Mère Antony where they flirted with her daughter, added to the frescoes left on the walls by other painters, swallowed the plain food like nectar, and returned to Chailly to sleep the sleep of the just.

This near-idyllic existence was brought to an end by lack of money. Bazille, generously subsidized from a wealthy home, contributed more than his share, but Renoir and Monet both felt the pinch. When Bazille was forced back to Paris to take his finals at the medical school, all left with him.

Monet retired to Normandy after extracting a promise from Bazille that he would follow. He stayed briefly with his family, then took rooms over a baker's shop at Honfleur, where Bazille joined him. Boudin and Jongkind were introduced to the southerner and all four worked together.

Bazille was ravished by the scene and his company. "The country is heavenly," he told his family. "You couldn't find richer meadows or more beautiful trees. There are horses and cows grazing everywhere. The sea—that's to say, the Seine estuary—provides the mass of green countryside with a wonderful horizon. We eat at the farm of Saint-Siméon up on the cliffs a little beyond Honfleur and work and spend the day there. The port of Honfleur and the clothes worn by the Normans with their woollen caps interest me a great deal . . . I get up every morning at five and paint the entire day until eight in the evening."

Monet asked him to lunch at Sainte-Adresse with his parents. Matters between him and the family were moving towards a crisis. His failure to sell anything and his refusal to place himself with another teacher in the Beaux-Arts seemed to them stupid obstinacy. If he had no further need of training, why was he not making money? He spoke vaguely yet determinedly of perfecting an individual style before the question of sales could be considered seriously.

This lofty enunciation of principles failed to convince the Monets. The idealist had been seen frequently in the company of the disreputable Jongkind and Boudin. What had these rascally loafers to do with principles?

Relations were at a delicate stage, with Monet fearing every moment that his allowance would be withdrawn, when Bazille arrived. His appearance caused relief in the Monet household. Here was no ragged painter given to the bottle, but a well-to-do young man with charming manners who had taken a fancy to their son. So Claude had not entirely wasted his time in Paris! Vastly encouraged, they laid themselves out to be pleasant. Successfully, too, for Bazille, who was given neither to criticism nor to analysis, found them "charming," their house "delightful." Flattered by his attentions and anxious to preserve him as counterweight to Boudin and Jongkind, they responded, but in vain: "I had to refuse their hospitable invitation to spend August with them," reported Bazille, who was due home for the summer.

All too soon he left the earthly paradise of Normandy and the Seine estuary for Paris and the gloomy though unsurprising news that he had failed his medicals. He had neither heart nor money to return. He went back to Montpellier to confess and to try to turn the far from stony hearts of his parents towards painting as an alternative career.

Monet kept him in spirits and bolstered him in the struggle by writing painterly letters from Honfleur. He was alone. Boudin had gone with his newly married Marie-Anne to Trouville to make his charming water colours of holiday-makers on the beach, the wind filling out the picturesque Empire clothes. Jongkind had roamed off after leaving vivid memories, from the scores of domino games played with abandon in the Saint-Siméon of an evening or wet day to his descriptions of the value of painting the same motif in different seasons or at different times of day, an idea taken from Boudin and expanded. He had made studies of Notre Dame at dawn and at sunset and invited Monet to observe the difference in detail—a lesson Monet remembered. For the moment he had his own absorptions, as he told Bazille. "It is adorable here. Every day I discover the most beautiful things. It's enough to drive one mad, for I want to do them all." But the beautiful things resisted him; he could not do one as he wished, let alone all, and he continued woefully: "It is decidedly, frightfully difficult to make a thing that's complete in every respect,

yet I can't be contented with anything less. I must struggle, scrape off, begin again. One can only make what one sees and understands, and my failures prove that it's no use just thinking about it; it's by strength of observation, of reflection, that one finds what one's after; so it's sweating, sweating all the way."

The struggle absorbed him so much that when Boudin, who had managed to sell some of his water colours, urged him to come along to Trouville and try his hand at figure work against a background of sky and sea, he refused. "It's so beautiful here at the moment," he wrote, "that I must make the most of it. I would have come to see you already if it had not been for this latest burst of hard work. And besides, I'm terribly anxious to make enormous progress before going back to Paris."

The progress, visibly at least, was far from enormous. Yet it was something; compared with the work of the previous summer and autumn a personal view and personal treatment of landscape were emerging. He stayed on and on, struggling to discover the secret of nature painting. His hopes rose and fell. At one moment he would write: "Boudin and Jongkind are here; we are getting on wonderfully well. I'm awfully sorry you aren't here; there's a great deal to be learned in such company, and besides, nature is growing even more lovely as the colours begin to change." Then, Jongkind and Boudin off again, and the family attitude stiffening, he had glimpses of the true future and wrote soberly.

Before leaving for Paris he tried to prepare himself for the struggle by sending three canvases to Bazille. He asked him to try to persuade a neighbour, a patron of Courbet, to buy them and provide him with a little capital against any attempt by his parents to force him to toe the academic line. The effort failed; the man was not impressed. The one point of moment is Monet's claim to Bazille when sending the pictures that he painted them "without any painter in mind." So far had the twenty-four-year-old painter progressed in confidence by the end of autumn. When he sat with Jongkind before the same motif —the lighthouse of Honfleur—his sketch for a painting was as unlike

the older man's as possible—cruder, more obvious, faulty in many ways, but his own.

This painting and another he carried back to Paris late that year, leaving a flower study in Le Havre. In January, 1865, he joined Bazille at the latter's studio at 6 place Furstemberg behind St. Germain des Prés. From this studio two years earlier they had watched the ailing Delacroix painting in his garden shortly before his death. Now Bazille rented the studio again. He was in high fettle, having won over his family to painting, but, being a gregarious young man—Monet had already reproved him for his fondness for the company of "playboys" —spent much of the winter enjoying himself in less exhausting ways. Evening after evening he carried Monet off with him, picking up Sisley by the way, to the gatherings at the house of his relative, Commandant Lejosne.

This military man, unlike his kin, was in the thick of the literary and artistic warfare then agitating Paris. His soirées were attended by most of the rebels from Baudelaire to Gambetta, from the advanced photographer Nadar to Edmond Maître, chief worshipper at the shrine of revolution in music embodied by Wagner. A regular guest was Fantin-Latour, painter of *Hommage à Delacroix;* he had taken up Renoir, then trying to make ends meet by portrait painting, and often brought him along.

Here Monet heard all the enthusiasms, from Wagnerism to radicalism, in politics, poetry, and painting. He remained unmoved. Music meant little to him, politics meant nothing at all, and the intrusion of politics into painting made him smile. Yet this was a favourite topic, everyone echoing and improving on Courbet. Even at the Brasserie years earlier Monet had had difficulty in responding to the general clap-trap of Courbet worshippers babbling about the duty of the painter to depict men of every social grade and to rescue the working classes from their lowly role of crowd scenes in paintings of the past. At Lejosne's the argument appeared sillier than ever. How could class or profession give a right to be painted? To Monet, a man's only claim to be represented in a picture was his appeal to the artist as a paintable subject.

In any case he found the emphasis on man more than a little tedious; all he asked was to be put before nature. There he would discover more motifs than he could render in a life-time. So he allowed the surge of argument to pass over him. He put discussion some way below action. As he sat in his corner, black hair flowing wirily almost to the strong shoulders, a young black beard covering the firm chin, he was meditating a painting which would bring him for the first time to the notice of the art world of Paris.

Yet he was not unpopular. He was respected as a single-minded young man who refused to compromise. Not for him the painting of commissioned portraits which were keeping life in Renoir. He would paint what he felt moved to paint, or starve. And such was the dignity of this blunt young Norman that he won more respect from the company than the most talkative advocate of this or that revolt. It was almost as though these people divined that this silent, apparently stolid painter who took little or no part in the hot talk of revolution here, revolution there, was in his own fashion to be the author of the most striking revolution in painting for centuries.

Of course they did not dream of such a thing, they merely reacted unthinkingly to a natural dignity. Nor did he, confident though he could be: he was preoccupied with his new and ambitious project for which he waited impatiently the coming of good weather. He waited, too, for the days when the burly Pissarro came puffing up the stairs of Bazille's studio.

For Pissarro had again met Monet. He had been painting in a different area, his ways and the younger man's had not run together. Each remembered the other with sympathy. Monet knew something of Pissarro's work and had heard more, but Pissarro knew no more of him than he had gathered in their spell together. They had shared an enthusiasm for landscape painting then, but Monet had been a boy of nineteen with many enthusiasms. Now, though as unknown as he had been five years earlier, he remained dedicated to painting and devoted to landscape, and this constancy delighted Pissarro, himself convinced that in nature the painter found his most inspiring model.

Pissarro sometimes brought with him another serious man, a man also encountered in the Académie Suisse. This tall, thin man was at first sight alarming. He wore old, paint-spattered clothes. Not quite two years older than Monet, he looked many more, his fine black hair already beginning to recede from a wide forehead. He had small, glowing black eyes under thick eyebrows. He spoke roughly and with tremendous emphasis in an uncultured Provençal accent, the accent and the lack of culture both exaggerated. "Paul Cézanne," said Pissarro.

Having accepted Boudin and made a friend of Jongkind, Monet took Cézanne in his stride. It was, he realized, easy to make sport of Cézanne, his looks, clothing, accent, his apparently humourless concentration on painting. He had heard of Cézanne's eccentricities and of the way he had been ragged at the Académie Suisse. But Cézanne was in earnest; he did not simply care for painting, it was his life. Monet, dedicated less dramatically, perceived this at once. To judge by the gossip at Lejosne's, Cézanne might have been a crank without gift, but here was Pissarro introducing him, guarantee that he was a serious painter and a good man. Monet made them welcome in his quiet but breezy manner and enjoyed their talks as he did not enjoy the cleverness and facile enthusiasms—so much like the Brasserie of old days—at Lejosne's.

He explained his new plan. This was, to paint in the open air a group composition on a large scale, so that men and women could be caught, like ships at sea or in harbour, in action, as in a photograph and against a natural background. In an age when groups were always painted in the studio with a rural background, if such were required, artificially imposed by the artist, this plan was revolutionary.

In spring he went to Chailly to choose a site and sketch out his picture. He decided to make the subject a picnic, believing that this would give the maximum possible impression of people caught out of pose, the most truthful impression possible of a peopled landscape. He was wild with excitement, telling Bazille, "I can think of nothing but my picture, and if I thought I couldn't make a success of it I believe I'd go out of my mind." Boudin, to whom enthusiastic letters

also flowed, spread abroad the news that "the young Monet has a canvas twenty feet long to fill."

In fact Monet had already come against a snag. He wished to make the figures life-size, and this meant that his canvas would be too big to be moved day by day. He was forced to paint it indoors, sketching it bit by bit on the spot in the forest and transferring his sketches to the final canvas. Bazille came down to pose for him—he took two poses, models being scarce—and the vast picture began to take shape.

It took time. Monet was a difficult man to satisfy, and he had to contend not only with a technique still decidedly imperfect but with weather which, said Bazille ruefully, was "atrocious." Bazille began to fret as the weeks went by and his strong-minded friend showed no sign of letting him go. "I'm at Chailly simply and solely to help Monet," he explained to parents who demanded why he lingered as summer went by. "If it were not for that I should have left for Montpellier long ago and very joyfully . . . Even by hurrying up Monet will need another three or four days; I must therefore with great regret postpone my departure."

He had to postpone it for much longer than that. Outside the inn one evening—they were staying at the Lion d'Or in Fontainebleau— some "clumsy English painters" began to play about with a heavy bronze disc, part of the inn sign. They used it as a ball, tossing it about. Some children tried to join in the game, the disc flew towards them, slipping from the hands of one of the Englishmen, and Monet dashed forward to shield the children. The disc struck his knee and he was carried to bed in great pain. Unable to move and furious at the delay, he lay in the inn bedroom for some days. Bazille, trying to calm him, persuaded him to be used as a model.

Bazille was then very much a painter of promise; his canvas is filled with faults. Nevertheless it is difficult to imagine a better impression of an impatient man than this study of Monet in bed. There are all the signs of a strong will checked and rebelling furiously; brown eyes burning out of the bearded face; the tangible flag of frustration, the one foot thrust out of the bedclothes as though Monet could not endure the discipline even of this symbol of captivity, as

though he thrust everything out of bed that he had the power to move. Less seriously, Bazille's sketch suggests what an impossible invalid this purposeful friend made.

News of Monet's project led to his friendship with Courbet. The great man included amid his many vanities an assumption that no young painter of moment could hope to advance without his blessing and active help. Nor was this assumption, irritating though many found it, entirely without warrant. Monet's great canvas was duly reported to the master who roared out: "What! A young man who paints other things than angels!" and announced his intention of visiting the daring fellow.

This witticism drew the expected howls of laughter and Courbet went off to Fontainebleau forest well pleased. Monet pleased him too, as every popular man is pleased by the rare appearance of an admirer who is not a lickspittle. He hummed and hawed before the beginnings of *Le Déjeuner sur l'Herbe*, reminded Monet that he had already invented the juxtaposition of partial tones to break up the light, advised him rather late in the day not to use white canvas, spoke benevolently and with many a doubtful jest to Bazille, was gracious to Renoir and Sisley who had come across from Mère Antony's on hearing of his presence and who remained dumbfounded in his company, introduced the lot of them to Corot who happened to be painting near, and took himself off at last in a cloud of oaths and bellows after commanding Monet to look him up in Normandy that summer.

Pissarro too came to see the monster canvas—"That lengthy business," as Boudin put it—and admired his young friend's sense of form, the way in which the women's long dresses melt into the snowy cloth spread in the glade, in a picture which emphasized informality. But Pissarro, like Monet, feeling first for landscape, would have eyes for it here. Monet, as Pissarro would have done, was using his picnic party as a design in nature rather than as a group of varied human beings. All was in clothes and attitude, nothing in the faces. And Pissarro's big eyes glistened when he studied the trunk

of the great beech tree under which the picnickers sit and which holds up the entire picture. For here was a study in light and shade and a rendering of nature which hinted broadly that a new eye was at work in landscape painting.

Monet had not fawned on Courbet. He was incapable of fawning on anyone. That formed part of his charm for the famous. But he liked Courbet too, though with typical Norman reservations. Courbet was in painting what Hugo, then retired to Jersey in splendid exile, was in literature, a great poseur, great talker, great vulgarian, great producer, great in talent, fornication, boasts, kindness. Monet saw this, saw too something of the struggle between inborn romantic and intellectual realist which was to cripple the great talent and so often to make the pictures, like the man, fall between the grand and the ridiculous. He had heard the often repeated boast of Courbet: "I am the proudest man in France" with a smile, knowing that this proud man would shout in the middle of the crowded café an unrepeatable anecdote about one of his models, knowing that he had given his picture *Le bonjour de Monsieur Courbet* the subtitle of "Wealth saluting Genius." But Courbet, unlike Hugo, had a certain grandeur of person to carry off his enormities, and if one ignored the fleshiness that was rapidly turning his impressive walk and carriage into a waddle, he could rightly claim that he was big in every way. In generosity especially. The moment he discovered that Monet had a future and would not be bossed into a Courbet-directed version of it, he opened himself to him, pockets and mind both.

Not only the large canvas and the outdoor motif had drawn Courbet to Chailly. Long before the great labour was ended Monet had for the first time won favourable mention in the press as painter; the Salon of 1865 accepted both the seascapes he had painted at Honfleur the previous summer. In the *Gazette des Beaux-Arts* a critic of some repute, Paul Mantz, wrote: "We must inscribe a new name here. We don't know Monsieur Claude Monet, painter of *La Pointe de la Hève* and of *l'Embouchure de la Seine à Honfleur*. These are, we believe, first works, and they lack the finesse that can come only after long study. But the taste for harmonious colour schemes in the play of analogous

tones, the feeling for values, the striking aspect of the whole, a bold way of seeing things and of compelling the attention, these are qualities which Monsieur Monet possesses in high degree. His *l'Embouchure de la Seine* halted us brusquely as we were passing by and we shan't forget it. We shall follow with interest the future efforts of this genuine marinist."

The ninth number of *L'autographe au Salon*, a kind of illustrated catalogue of outstanding exhibits, printed a sketch by Monet of *La Pointe de la Hève* with a frank but flattering comment: "Monet. The maker of the most original, most supple, most solidly and harmoniously painted seascape that has been exhibited for a long time. A little dull in key like Courbet but what richness and simplicity of view! Monsieur Monet, unknown yesterday, has made a reputation right away by this one picture."

These notices did not mean, as the commendation of art critics often implies, that Monet had arrived at a bound. It did mean that his freshness of vision had appealed to men hardened to row after row of academically correct pictures. And although he had not yet thrown off the dull colours favoured by Courbet and the Barbizon painters who lacked sufficient courage to cut adrift completely from the conventional colour schemes of the past, the originality and perception of his eye already promised a rich reward. Had he chosen to continue painting in this fashion he could with little effort have made a good name and income.

He was then in his twenty-fifth year and full of life. He liked his food, his drink, his fun. Above all, he liked the acclamation of men. He was ambitious. He had not forgotten the years when he walked the streets of Le Havre, the famous local caricaturist. Praise was sweet to him and he had missed it badly. Now he had the chance to recapture it on a big scale and to enjoy life in Paris as one of the coming young men.

The temptation to such a man can scarcely be overrated. He put it aside without a backward glance. He was interested in money, fame, good living but he was more interested in the truth. What did he see and how could he represent it truthfully: that was his one

unchanging preoccupation. His successful entry into the Salon at the first attempt, the encomiums on his exhibits, meant, a little natural pleasure apart, one thing only, a favourable reception at home and a continuation of the allowance essential to further researches.

So back he went that summer to a gratified family which passed round the critics' notices with undisguised pride. All were pleased; yet in their pleasure was nothing more serious than the hope that perhaps this difficult and masterful son with his doubtful companions might be turning over a new leaf, might even yet win a medal, be officially honoured, and sell his pictures for large sums.

In his dealings with his parents Monet was handicapped hopelessly as every true artist is handicapped in his dealings with the philistine. The Lecadre and Monet grocery shop was open from eight thirty in the morning to seven at night with a generous two-hour lunch break. As it prospered, assistants relieved the owners of the worst strain; they were able to take an occasional deserved rest. With the coming of full summer all went off to Sainte-Adresse for a month or more to sit in their covered deck chairs on the ridge above the beach or to bathe discreetly and enjoy the feeling that they had honestly won the right to these weeks of sunshine and sea air. "The labourer is worthy of his hire," they murmured mentally as they lay in a middle-aged daze of well-doing listening to the waves splashing on the pebbly little beach.

But when the son and nephew, Claude, got up at five every morning and came home at eight or nine in the evening when the light failed, dog-tired, they said only, "How nice to see the dear boy enjoying himself with his painting." Slave of a fixed idea, they denied all the evidence of their eyes. Worn out though the young man might be, they persisted in the thought that he was busily engaged in a game. A game which must be delightful since he had freely and even violently chosen it. And whoever fought for the unpleasant? That hard work —far harder than the average man would ever endure—was a normal part of the serious artist's life never once occurred to them. What gave pleasure could not be work as they understood the term.

Misreading the physical struggles of the painter as they did, his

mental struggles were even further out of their ken. The ceaseless fight after truth of a man such as their own Claude or the despised Boudin or Jongkind was utterly beyond their comprehension. Claude's face was deeply tanned, healthy; he ate when he pleased, did what he pleased when and where he pleased. What kind of struggle was this? What did he know of trouble beyond an occasional shortage of money which they would make up? Had he ever tried to build up a grocery store from nothing? Their one serious thought, which soon submerged the faint hope that he might be on the way to fame and fortune, was the anxious prayer that when he left the house he would not roam about with a Boudin or Jongkind and set the neighbours to fresh gossip.

This time they were given a new experience, of their son with Courbet. For Courbet was along the coast at Deauville in full blast, demanding Monet's attendance. He was, Courbet announced to the world at large, surrounded by admiring women. "I have," he claimed, "received more than a thousand beautiful women in my studio. In one month I have made thirty-five pictures which have stunned everyone. I have bathed eighty times."

Naturally he was in roaring form. He took Monet under his wing. He would show him how to paint. He would also lend him money. The money changed hands more readily than the lessons. Monet declined stoutly to work on the brown background favoured by Courbet and everyone else. "You can dispose your lights on it," urged Courbet, "your coloured masses. You can see your effect right away." Useless. Monet was determined on the hard way. He worked on white and depended on his visual imagination to fill— literally—the gaps which the ordinary painter feared. He had taken the critic's remarks to heart. His colours were too sombre. The only way to lighten them was to begin on a natural background.

Courbet had better luck with some of his other lessons, especially the ones which were learned without words. Watching him at work, Monet was fired by the virility of his paintings. The "broad technique" that Boudin had regarded with a kind of fascinated repulsion struck a chord in the younger man; he too was powerful, full-blooded, he

wanted to cover a large canvas strongly, even coarsely, using a palette knife after the manner of Courbet and Courbet's broad brush stroke. He tried his hand. His pictures began to show the Courbet influence. But Monet being Monet, he acquired the strength without the vulgarity, the coarseness without the crudity.

Courbet praised his pupil loudly and often. He was a genuine chip off the old block, he declared to all and sundry. As reward he proposed a visit to Dumas Père.

"I don't know him," said Monet, a little hesitant in face of the great.

"Nor do I," replied Courbet airily. "But we'll go just the same."

The poor Dumas, reduced to work on the local newspaper, lodged over a drapery store. His reputation had outlived his income. His novels remained widely known and quoted, but their sales were negligible. But though he had run through all his money he had not lost his pride; mentally he still lived in the days when he was a famous figure in Paris, eagerly sought by the hostesses of the Boulevard Saint-Germain and flinging his royalties away in the grand manner. When Courbet knocked at the door he was told that the great man was busy.

"When he knows who's come to see him he'll receive them," announced Courbet with immense self-importance.

"Who shall I say?" asked the woman.

"The Master of Ornans," said Courbet with tremendous emphasis. Dumas appeared.

"Dumas!" exclaimed Courbet, opening wide arms.

"Courbet!"

They embraced. Monet watched the comedy in silence.

They arranged to dine three days later. Monet arrived on time, Dumas also. No Courbet.

"I have lived with kings," exclaimed Dumas after a few minutes. "They have never kept me waiting!"

Monet went after Courbet, found him leisurely finishing his toilet. "With kings!" he commented contemptuously as Monet watched him putting the finishing touches. "But not with a Courbet."

More than once Courbet remarked that Monet was a very fortunate

young man to have won his special attention and favour. He would add, as explanation of the favour, that Monet was one of the coming men. He may even have thought so. In any case he spoke no more than the truth. Monet's meetings with Boudin, Jongkind, and Courbet were strokes of great fortune, yet not so much as one would think listening to the master. For years past there had been many youthful painters working on the Seine estuary. Plenty of young men were to be found playing dominoes in the Saint-Siméon on wet days and summer evenings. Lots of them had met Boudin and Jongkind and several had been roared at by Courbet, yet these meetings never grew beyond casual encounters. This was not chance, it was for the very good reason that other young painters lacked what drew the older men to Monet. Monet had no special charm of looks or manner; he had no eloquence of speech; his robust figure and squarish face with its mane of strong black hair and steady brown eyes were impressive rather than attractive, his occasional forthright words impelled confidence rather than fascination. But he had that other and more lasting charm, that more powerful eloquence, of will and unflinching sense of purpose backed by unmistakable talent.

Courbet's final stroke was, however, less happy than the influence of his manner of painting throughout this productive summer and autumn. Monet went back to Chailly in high spirits to finish his big canvas. How high was to be seen in the masked ball which he and Bazille organized in their studio in the first month of the new year, with Bazille as *Chasseur d'Afrique* (his costume supervised by his friend) and Monet as a fisherman of Honfleur. The noise annoyed the other occupants of the building; they complained to the landlord and the two painters were asked to find other quarters.

Renoir and Sisley were painting in the forest, too, with their headquarters at Mère Antony's; it was there during the rain of January, 1866, that Renoir painted his group round the inn table while Sisley was making a study of the village street in time for the next Salon. Renoir's now famous painting was extremely Courbetesque. Ironically enough he, more than Monet, had been impressed by Courbet who paid little attention to him.

71

6

All Courbet's attention was given to Monet and the large group. And when Monet proudly showed him the canvas completed at last, Courbet, unable to let well alone, pressed him to make several changes. Monet gave way against his better instinct, feeling that Courbet must know best. He repainted some of it to the tune of the master's approving grunts and Courbet went off highly pleased with himself. But poor Monet, taking a second look and a third at the altered picture, realized that he had made a mistake. He could not submit it as it was, not could he change it back in time for the Salon.

For this was well into the spring of 1866—the picture had taken more than a year to paint. In despair Monet took it off its stretchers, rolled it up and left it in the inn with the rest of his tackle. There it stayed. Unable to redeem it for some time because of shortage of cash, he found when he at last unrolled it that damp had ruined both sides of it; only the centre portion remained.

This tragedy was in the future. In the spring of that year, having rolled up the great canvas, Monet was faced with a very present tragedy, a year of wasted effort; after all he had nothing to send to the Salon.

At this moment occurred the miracle of his life. It was expressed outwardly as always by a painting. He returned to Paris. There he painted in four days the picture which was to make his name and settle him firmly in the company of painters who would give him the support he needed. This one picture, far though it was from Impressionism, was in fact the birth of the movement. It signalized with dramatic appropriateness—for what is Impressionism but a supreme expression of happiness?—the beginning of a magical era in painting.

Chapter 8

Camille

1866

Camille OR *La Dame à la Robe Verte* IS A STUDY OF A YOUNG WOMAN wearing a long black and green striped silk dress with a short black velvet jacket trimmed with fur. She is painted back view, and the dress sweeps away out of the picture. Her head is turned towards the painter, her right hand holding the black velvet strap of a small fur bonnet perched across a mass of black hair. It was painted with a freedom and feeling for colour and texture which struck most of the critics with astonishment. It has the peculiar interest as well as historical importance of being the first view of portraiture by a born landscape artist. All preconceptions are scrapped, and the preoccupation with colour and the effect of light on the dress, to which Monet devoted most of his attention as well as most of his space, gives the face and attitude of the model a curious, remote charm. It was as if he felt a reluctance to press the model onto the beholder; he prefers to indicate her beauty and fragility by contrast and suggestion.

The feeling perfectly accords with Monet's view of the sitter. He rarely spoke about Camille after her tragic early death; he never discussed her while she lived. But he painted her again and again.

Camille's dark and delicate beauty has long since become world famous through these studies of Monet and other Impressionist painters. Monet never failed with her, nor did she fail him.

He met her—she was still in her teens—in Paris late in 1865. They fell in love. After the disastrous ending of *Le Déjeuner sur l'Herbe* the following spring one or other of them (which, may never be known) thought in desperation of a last-minute portrait to take the place of the ruined canvas. Inspired by his feeling for her, Monet painted with uncharacteristic speed and without a single false note. From that moment they lived together.

His parents, hearing of the liaison through Armand Gautier, ordered their son to break it. He refused. His father stopped his allowance. She had no money. With the help of friends, Bazille and Courbet chiefly, they managed to survive precariously until the Salon had opened.

The portrait and a landscape, *L'Allée de Barbizon, Forêt de Fontainebleau,* were both admitted—he was the only one of the Impressionists of the near future to be spared a rejection. His hopes and those of Camille rose at the good news and still more at the reception of the portrait.

Some critics treated the picture severely—Monet's departure from orthodox straight portraiture was too novel for them to accept—but even the most critical was forced to praise the handling of the dress. The favourable critics spoke with unusual warmth. W. Burger said, "Attention! Here is a very young man, Monsieur Claude Monet, happier than he of a very similar name, Manet, of whom we shall speak later. He has had the good fortune to put *Camille* before us, a fine portrait of a woman standing and seen from the back, trailing a magnificent dress of green silk shining like the garments of Paul Veronese. I should like to reveal to the jury that this opulent picture was painted in four days. When one is young one culls flowers instead of stuffing in a studio. The time for sending to the Salon comes, Camille is there, returned from picking violets, her train the colour of grass and her cape of velvet. Today Camille is immortal under the name of *La Dame à la Robe Verte.*" And he added, "The young painter

of *La Dame à la Robe Verte*, Monsieur Claude Monet, has also done his landscape, a night effect with the sun lighting up the great trees. When one is a true painter one can paint just what one pleases."

Castagnary, the foremost supporter in print of the progressive painters, welcomed Monet as "one of the new recruits to the battalion more or less infected with the doctrines of naturalism . . . and all of the younger generation which is both idealistic and realistic . . ."

Still more notable was the writing and publication of a poem on the picture by Ernest d'Hervilly which led to the commissioning of a smaller version of the portrait for the United States.

But the most enthusiastic and longest notice appeared in the powerful and respectable pages of *L'Evénement*. There a young man who was just beginning to make a name as a fearless critic of literature broke into art criticism with a series of reviews of Salon exhibits couched in extremely plain terms. His name was Emile Zola, he was a lifelong friend of Cézanne, and he had already shocked literary Paris with a pungent first novel.

"I declare," wrote Zola, "that the canvas which held my attention longest was the *Camille* of Claude Monet. There is a strong and living picture. I had been ambling through cold and empty rooms without coming across any new talent when I perceived this young girl trailing her long dress and sinking into the wall as if a hole were there. You can't think how good it is to admire for a change when one is tired of laughing and shrugging one's shoulders. I don't know Monsieur Monet and I don't believe I have ever before looked carefully at one of his canvases. It seems to me now that I am one of his oldest friends. And this because his canvas tells me the whole story of vigour and sincere truth.

"Yes, indeed! There is a temperament, there is a man in the crowd of eunuchs. Look at the pictures next to his and see what a pitiful show they make beside that window opened on to nature. Here we have more than a realist, we have an interpreter both delicate and strong who has been able to render every detail without falling into baldness. Look at the dress. It is both supple and solid, it trails softly, it lives, it says out loud what this woman is. No doll's dress there, one

of those chiffon muslins which one wears in dreams; no, this is real silk in the act of being used and which weighs a great deal more than the whipped cream of Monsieur Dubufe."

All these compliments gave great joy to Monet and Camille. Monet knew by experience that words meant little and that a solid mass of conventional painters stood between him and a living from his painting. But seeing Camille's joy he felt it too. He was young, after all.

Practically, one benefit came almost at once. The parents at Le Havre had a change of heart. It was a typical change of heart which could have been matched in any bourgeois home in France. Reading the many lines of praise in *L'Evénement*, Monsieur Monet was tricked into believing that this was a precursor of his son's fame and eminence and, naturally, acquisition of money. He was not to know that Zola was virtually driven from the paper soon afterwards by infuriated lovers of the academic pictures.

Monsieur Monet was fond of his son. He was fonder still of the life respectable. But he was fondest of the moneybags. And like so many Frenchmen, in some mysterious way he managed to equate fortune with virtue. A famous Claude could have his Camille; that was an understood sowing of oats, good plump oats. A needy Claude who was forever writing for his allowance to be sent on time was quite another matter; for him the straight and narrow, and certainly not an acquisition which was not only immoral but an additional expense.

So to the hard-pressed pair in Paris came a sudden restoration of the allowance which Monet managed to keep alive for some months by a promise to come down in the summer and paint. Camille was not mentioned.

A second substantial advantage followed the burst of praise. One of the manifestations took the form of a caricature sketch of the picture by André Gill. Under the sketch was the caption: "Monet or Manet? Monet. But we owe Monet to Manet. Bravo Monet! Thanks, Manet!"

This was read sourly by Edouard Manet. A group of advanced

young painters thought him a great painter, the hope of progressive painting in France. The radical critics praised him. Zola's praise—made in the series of articles in which he had spoken so warmly of *Camille*—had broken all bounds; what was supposed to be a general review of the Salon exhibits turned into a long eulogy of Manet as the most important painter then working. This passionate enthusiasm lost Zola his job and made his name. In theory it was gratifying to Manet; he was very gracious to Zola when they met. Yet in practice the praise was so much dust and ashes; the fame that Zola predicted for him was in fact restricted to the unsuccessful painters. As far as Paris at large was concerned he had won something very different—notoriety. No important people thought that he was important; they thought him cheap, vulgar, clever. And to Manet success consisted first and foremost in recognition by the important people.

Unlike Monet and his friends, Manet was not dependent on his work. He had almost all the requirements for success. He had exceptional gifts. He had leisure. He had a generous nature and, in general, an open and attractive manner. He had money. Despite extravagant tastes he had not been able to dissipate all the fortune left him by his father. His time was his own. He could paint what he wished when he wished. He lived well and dressed in what he believed to be the latest fashion. All in vain. His family was undistinguished, his manner lacking in true gentility and most significant, he was, despite himself, too honest a painter to follow the conventional line which would ensure success. In consequence he had not the entrée to society salons as the painter of the day. And without this the adulation of the young painters, the praise of the few nonconforming critics, was small beer.

Nor was this all. He had been the victim of a cruel irony. In 1863, the year when Monet went to Gleyre's studio, Manet's work had been rejected by the Salon jury but hung in the notorious Salon des Refusés established by Louis Napoleon to hush the cries of disapproval caused by the severity of the Salon jury. But the Salon des Refusés, which looked at first sight like a victory for the progressive artists, was quickly turned into farce by the public; incited by comments in the

press, crowds invaded the exhibition which they treated as a form of music hall turn put on by the government for their benefit. And the laughter was loudest and the wildly gesticulating crowd thickest before Manet's main exhibit. *Le Déjeuner sur l'Herbe.* Manet had painted and painted well a subject used already by Giorgione—a picnic attended by clothed men and naked women—but, as one critic unkindly but not untruthfully wrote, "the nude, when painted by vulgar men, is inevitably indecent." The crowd and press agreed; Manet became the butt of Paris.

He also became the hero of the younger school of painters—increasingly being styled realists or naturalists by sympathetic critics —but this honour fell flat. His vanity was tickled by the worship but his reason told him sharply that it was the wrong kind of worship. He had no wish to be thought a revolutionary painter, simply a great one. He did not deliberately choose subjects because they were modern but because they appealed to him; it was his misfortune (in the short view) that he felt himself obliged to paint everyday people as they were instead of romantic and untruthful shadows of people. The same was true of his method of painting. His strong sense of line, his subtle and sharp colour combinations, his ability to use with power and unusual effect black, gray, and white, were not deliberately adopted, they were merely the only way he knew how to exercise his gifts. Yet there he was, accused of deliberately flouting convention in style, treatment, subject—he, the most innocent rebel ever born. And this unsought and undeserved reputation was debarring him from the world and the academic honours he most coveted.

Manet was somewhat soured, a natural bonhomie twisted often into mere sharpness of speech, by the time the 1865 Salon arrived. He comforted himself by indulging a natural dictatorial manner amid the satellites he used to shine on each evening at the Café de Bade. His bitter *bons mots* became known and feared throughout the advanced studios; young painters hungering for the distinction of obliteration by the rapier tongue tried every dodge they could think of to obtain an introduction to the master.

Then came the Salon of 1865. Manet's chief exhibit was *Olympia,* a

picture of a naked woman attended by a Negress, a picture originating with a Titian, but owing much to the great Spaniards. He had high hopes for this canvas and when he entered the exhibition on the opening day his hopes rose; he was greeted by enthusiastic cries of "Splendid, old chap, those pictures of yours!"

That year, in response to criticisms of favouritism in placing, all pictures had been hung in alphabetical order. Stepping briskly forward, Manet found himself confronted by two seascapes signed Claude Monet. The shock threw him into one of his rages. "What creature has done this?" he demanded furiously, scenting a hoax by his enemies. "What is the idea? To take my name and use it to score a success while I'm thrown to the wolves!"

For unhappily, not only had an unknown Monet won an acclaim Manet had worked and waited years for, his *Olympia* caused an even bigger scandal than the *Déjeuner sur l'Herbe* of two years earlier. The critics damned it with one accord; even Courbet, hitherto favourable, said loudly in front of the picture. "I'm not a member of the Institute, but really painting doesn't consist in making playing cards." This witticism, in which there was too much truth, went the rounds of the cafés. At the Café de Bade, Manet, hailed as having gloriously confirmed his place as the leader of naturalistic painting, sat like a thundercloud and his disciples trembled. The fashionable salons remained closed to him. Academic honours were a million miles away.

A lover of good feeling, the poet and advanced critic Astruc, offered to bring the unknown Monet to him. It was his real name, Astruc assured him, and he was a young and agreeable man. Manet refused brusquely. He had already heard that this monstrously named Monet, not content with having stolen his limelight, was in process of stealing one of his titles to make a second *Déjeuner sur l'Herbe*. His fury was assuaged by contempt when given further details, for he had no opinion of landscape.

A little later, Monet managed to get a dealer to show in his window a landscape rejected by the Salon. Short of money, he used to hang about the shop in the hope of a purchaser appearing out of the blue.

All he received were remarks he would have been happier not to have heard. One day Corot, still a god of his, stopped before the window and made every sign of disgust. "What a horror!" he said. Next came Diaz, whose dark and excessively dramatic landscapes of the Fontainebleau forest did not please Monet. Diaz praised the picture to the skies with a, "That young man will go far," and the secret listener was left to meditate on the irony of human affinities.

But this was not all. There walked past the shop a group of four men. Three obviously deferred to the fourth, a man of medium height with a bushy beard of light brown and wavy hair of the same shade. He was dressed very much à la mode, frock-coated to the hourglass pattern, and swung a malacca cane with an air. He was in high good humour, and his companions laughed perhaps a shade too boisterously at his witticisms.

This was Monet's first view of Manet, then a man of thirty-three, eight years older than himself. It was his first hearing of Manet also, and not an agreeable one. For Manet stopped before the rejected picture, stared, then, waving his cane at it contemptuously, cried, "There you are! There's the young man who goes about painting in the open air. As if the ancients wouldn't have done *plein air* painting if they had thought it worth doing!"

However, though vain, Manet could also be generous. His vanity was flattered by the crowds of admiring young men about him and he sincerely wished them well. He expected them to take his advice but if they did well in spite of it he would be the first to admit and praise.

All this he proved soon after the 1866 Salon. For him, this was a year of frustration; all his entries were rejected. He then heard that this Monet person who seemed absolutely to haunt him, had crowned his infamy by having his pictures not only accepted but highly praised at the Salon.

When he saw the Gill caricature and caption he was at first furious. But when he thought about the implications of the sketch with its "Thanks, Manet!" he began to consider in a new light the praise which was being showered on the abhorred Monet. Curiosity got the better

of him. He went to see the much talked of *Camille*. And, standing before the canvas, the better Manet, the great Manet, came to the fore in a rush. The painting owed something to him—he could think that if he liked. Gill had certainly implied it. But the fundamental point was that this painting was good. To his enormous credit Manet not only admitted its worth but was glad. For this was good painting and Manet was a good painter and in the long run personal vanities gave way to the love of good painting even when another man, and such a man, had done it.

Manet began to talk about *Camille* at the Café de Bade, to advise his followers to see it and learn the lessons that were to be learned from it. Astruc, noting the changed tone, repeated his suggestion that he bring Monet to be introduced. This time Manet nodded graciously. Monet was brought. The men met. Manet tried to laugh Monet out of what he chose to consider his out-of-door craze. Monet politely refused to be dictated to. After a spasm of anger Manet accepted the unusual defiance—only Degas with his whiplike tongue had ever got the better of him. The anger turned into a condescending respect for this burly young man of few words who merely smiled pleasantly when ragged and continued to follow his instincts. He gave him open house at the café sessions.

Monet looked in occasionally. He did not seem to have much to gain except the pleasure of foregathering with other painters. Manet himself was not at all his type though he respected his work highly. Nor was Degas. Unlike Manet, Degas came from a family which was not only wealthy but closely connected with the Italian aristocracy (he was born Edgar de Gas) and in speech, behaviour, and clothing he looked what he was, a gentleman. He might have been thought to appeal to Monet; that he did not was due to his dislike of landscape painting and his manner of expressing this dislike. Where Manet laughed openly at the young man's folly in trying to go one better than the classical painters, Degas sneered. He had a command of malicious aphorisms which had long since earned him a general wary respect in the painters' cafés. He set about Monet with a cruel lucidity of speech which reduced the Norman to wrathful silence. A sort of

antipathy grew between the two men, the polished Degas, the earthy Monet, and the younger turned to the only one there of his mind, Pissarro.

And he needed all the support Pissarro could give him, for that summer of 1866 he was subjected to a positive blast of witticisms when news of his latest project leaked out.

Yet it was to be by way of these gatherings that he was to form the group which was to change the face of painting for years to come. There was no talk in those early days of Impressionism. The word "impressionism" was heard often enough, used to describe the work of several painters, Daubigny and Jongkind in particular. Monet, if pressed, would always say, with the teaching of Boudin congenially echoing, that everything he painted was an "impression" of what he saw before him at a certain time; but that this could turn into a world movement was neither in his mind nor in the mind of any other man there.

The painting which aroused such hilarity in the Café de Bade was Monet's *Femmes au Jardin*. Ever since the Salon he had been experimenting, as he said, "in effects of light and colour." His first efforts were to paint, from a balcony on the Louvre, his *St. Germain l'Auxerrois* and *Le Jardin de la Princesse*. In these he showed signs of moving away from the influence of Courbet. Up to then he had used dull colours and had tried to suggest light in the Courbet manner, by opposition of light and dark masses and by efforts to imitate the reflection of light on blocks of opaque colour. Now he began to use bright colours, pure reds, yellows, blues, and lightened his shadows, opposing them to the flat surfaces of the rest of the picture. And he began to change his technique. Instead of invariably applying paint thickly, with quick strokes of a large brush, he experimented with short strokes painted very carefully with small brushes to give an impression of fragility (the leaves of trees, for instance) and of light itself.

He was determined to complete an outdoor scene with figures. *Le Déjeuner sur l'Herbe* had not satisfied him because he was unable to paint all of it on the spot. This meant that he lost much of his first

impression. Now, cheered by the renewal of his father's allowance, he rented a small house and garden at Ville d'Avray near St. Cloud on the western outskirts of Paris and promptly began a study of four women in a garden, a study to be painted from start to finish out of doors. He dug a trench in the garden into which the large canvas could be lowered on a pulley when he wanted to paint the upper half and which gave some temporary protection against rain. Camille posed for all four women.

Courbet, still keeping a weather eye on his protégé, dropped in occasionally to watch the progress of the "monster." He did not always disguise his approval of Monet's use of the long crinolined dresses to provide light against the dark foliage and movement contrasting with the static tree trunk, but, conscious of the need to assert authority, he criticized freely where he could.

And not always the painting. Bustling in one day and finding Monet sitting still, he roared a friendly expostulatory: "What! The moment my back is turned you lie about! Why don't you get on with your precious picture?"

Monet pointed to the clouds obscuring the sun.

Courbet laughed his gargantuan laugh. "Any excuse! What does that matter? What's to stop you from getting on with the background?"

Monet smiled politely but did not stir. How tell the great man that he did not understand the first thing about the principles of *plein air* painting? If one attempted open air painting at all, it must be followed logically to the end. The whole purpose was to create an impression of women in a garden at a certain moment of the day, as if they had been glimpsed for a second or two. What use to portray the trees, women's dresses, and the rest of the scene if the authentic light was absent? Just as well paint the whole thing in the studio.

So, having begun the canvas at a certain hour when the sun was shining, the whole picture had to be painted at approximately that hour every day and in similar conditions of sunshine. In this way, and only in this way, could Monet reproduce exactly and with truth to his eye the precise direction of shadows cast on dresses, path, and

bushes and the precise colour of greenery and dresses seen under sunlight of that particular strength at that particular time of day. Then, to quote the words of his forerunner Daubigny, he would obtain a truthful impression of "the great charm of nature, the diapason of everything that is good and beautiful."

Courbet's mockery was as nothing to the chaff and more than chaff at the Café de Bade. All except Pissarro followed Manet and derided the whole idea of reproducing nature. The way in which Monet was using people as decorations, as incidental to nature, irritated all. None were so hot as the political revolutionaries who professed a love of the common man in the Courbet manner without noticing that Courbet continued to paint after nature in his own way. Manet heard this with a certain distaste, Degas too. Their ridicule of landscape painting sprang from another source; both men, the one aristocratic, the other wishing to appear so, preferred at that time to portray men and women of class and distinction.

In any case Monet was held to be wrong and even idiotic. He remained calm. His restraint was remarkable for a young man of his age (he was still a month or two short of twenty-six) who could flare from despair to ecstasy in moments when painting a picture. His anger when roused could be alarming, but this Café disapproval, like the ragging, left him cool. He respected some of the Café de Bade critics, knowing them far better painters than he, but though incessantly dissatisfied with his own performance, he never once doubted the rightness of his aims.

In the autumn he stopped work on the picture for a very different reason, the reason haunting almost all the serious young painters of the day. There had been another change at home, a change not of heart but of mind. No commissions had rolled in since the successful Salon showing. Monsieur Monet realized that what he read in a newspaper did not necessarily tally with the truth—the truth for him being expressed in tangible rewards. He knew from his sister-in-law, fed assiduously by café gossip from Armand Gautier, that Claude continued to live in sin with the penniless Camille. To the Monets, Camille had to be a fast woman. They were incapable of imagining

in any other guise a girl who knew painters in Paris, posed for them, and eventually slept with one.

The allowance was cut off once more as abruptly as it had been resumed, and Monet and Camille were at once struggling; paints and canvases were expensive, food was not cheap, the rent mounted. Monet had been working hard for months; when he could not get on with his big canvas he worked on a little one. He made dozens but he could sell nothing.

There was nothing for it but flight—to Le Havre in the hope that the quarrel might be mended if the family could be persuaded to meet Camille. He fled in disgrace, owing money right and left. Yet such is the irony of the artist's life, he left behind enough pictures to have made a millionaire of any man who had the wit to hold on to them. He and Camille were forced to travel light. More than two hundred canvases had to be jettisoned. Hating to think that they should fall into unsympathetic hands, he slit them with a knife. In vain, for they were sold by his creditors for thirty francs the bundle of fifty. Little did these creditors imagine that the leavings of the man they abused so heartily and which they disposed of so lightly would, damaged as they were, be equivalent in a few years to pure gold.

Chapter 9

First Struggles

1866 - 1868

At this moment, in the autumn of 1866, when superficially his future looked brighter than before, Monet entered a period of almost unrelieved misery.

As his father had perceived belatedly, the praise of the past two years was, practically, worthless. Claude Monet had not made his name. All he had done was to get noticed favourably by certain critics as a promising young painter. But there were, in the critics' eyes, many promising young painters. There were also many established painters. The critics did not excite themselves about these elder painters because there is no novelty in established fame. But the elder painters continued to sell their work; Monet could sell nothing. He was only promising; he had not arrived. For this he would need more Salon appearances, more favourable notices until, eventually, he might hope to be taken up by a dealer or rich collector. It was a wearisome process.

Somehow he got the huge canvas of *Femmes au Jardin* down to the coast. He began at once to finish it. When the light was not right he turned without a break to other work, to whatever struck his eye.

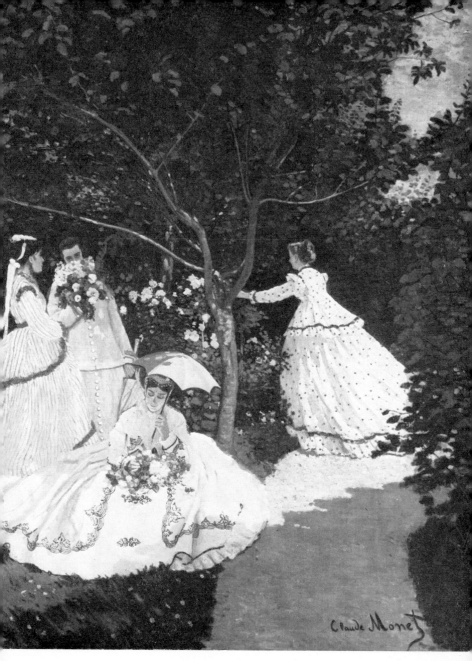

Femmes au Jardin
by Monet, 1866-7

Note: Camille posed for all the figures

(*The Louvre*)

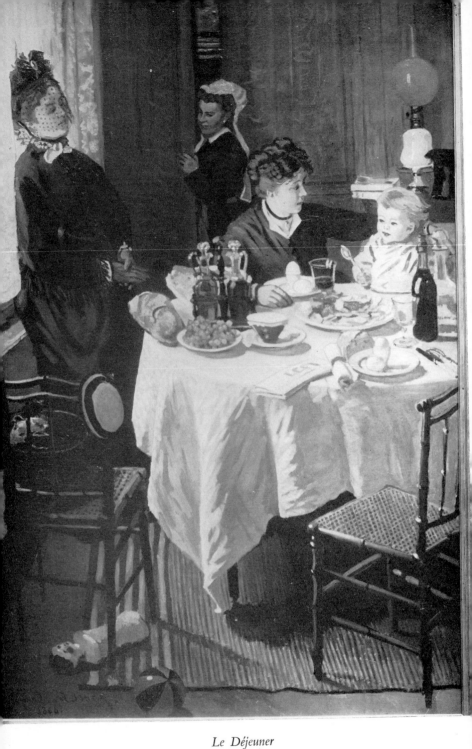

Le Déjeuner
by Monet, 1868
(Städelsches Kunstinstitut, Frankfort)
Note: The Monet living room at Fécamp. Camille and Jean at the table.

He painted *La Terrasse près du Havre, Le Port d'Honfleur, Sainte-Adresse* and a dozen other scenes round about the estuary. In all can be seen the emergence of what was to be known as the Impressionist technique. He painted with an inspired determination. His money ran out; his parents refused to meet Camille, refused to give him a sou as long as he stayed with her. He would not budge an inch. Unable to afford new canvases he sent to Paris for old paintings left with Bazille. He must, he said, scrape them, use them; he could not delay. His eye saw subjects everywhere, his brain was bursting with ideas, he was in a continuous rage to paint.

This was at the end of the year. His affairs were getting worse and worse. The winter was a hard one. He painted one or two excellent snowscapes, but this fresh challenge to the growing powers of the painter was also a challenge to his power of survival. Neither of his friends was there. Jongkind had gone back to Holland on one of his long painting excursions in his native country; Boudin had suffered a calamity, for all his paintings had been ruined by an oil which had gone bad, and he had been forced to go to Paris to peddle paintings in the streets. Monet and Camille were left to exist as best they could. Monet, physically strong and deep in his work, bore privation well. He tried to cheer Camille, who wilted more easily. She did not complain, but her face told its own story. The tide must turn, he said again and again; one, perhaps more, of these paintings into which he had put himself heart and soul must find a buyer.

In February of the new year, 1867, one of Boudin's friends described him in the midst of the struggle, hungry, cold, but hard at work. "Monet is still here," he told Boudin, "working on vast canvases . . . There is one nearly ten feet high and wide in proportion. The figures are only slightly below life size, women in fashionable clothes picking flowers in a garden. The canvas was begun from nature out of doors. It has many fine qualities and the colours are strong but it seems rather dim to me in general effect—lack of opposition, no doubt."

And having dealt with *Femmes au Jardin* which Monet was still struggling to complete in time for the 1867 Salon—the great hope which buoyed him up in his many bad moments—Boudin's friend

reported: "He is painting a large seascape too, but has not got far enough to enable one to judge. He has also made some effective snow scenes." Then came the message from Monet, grasping at every straw. Never had he grasped at a weaker one. However, Boudin was in Paris, all the dealers and probable purchasers were in Paris. So: "The poor chap is most anxious to know what is going on in the studios. He asks me every day if I have heard from you."

Boudin, unable to help himself, could not help Monet. Courbet was the kind of man who made generous gestures when he thought of them; when they were suggested to him he took an altogether different view. No help there. Renoir was as poor as ever. Sisley had just got married. Pissarro and Cézanne were in their different ways almost as embarrassed as Monet. Pissarro, loaded down with a growing family, had settled at Pontoise just outside Paris. He was always short of cash. Cézanne, son of a rich banker at Aix-en-Provence whose view of painting resembled Monsieur Monet's, was given a small allowance on which he could live simply and no more.

Monet never swerved from his determination to paint and to paint well. He expected, as all optimistic young men will, to sell what he painted, but he knew, no one better, that the changes he was making in technique threatened the good name he had won at the last two Salons. He knew this but did not stop experimenting. He wanted to discover a technique for expressing nature as he saw it, and he intended to perfect it. He would not be moved by a hairbreadth. He would not consider any other means of earning a livelihood. Caricatures never even entered his head. A job in shop or office or at the docks would delay his emergence as a fully-fledged painter. He would not endure such a delay; the struggle to become such a painter threatened to be long-drawn enough as it was.

Looking at Camille, cold, hungry, and smiling gamely, a lesser man would have given way. Monet had his own moral code, he was artist first, foremost, all the time. He needed Camille more than he knew. He did not understand all she did for him. But she had chosen to link her life to his. He had left her in no doubt of the dangers and discomforts.

Yet some outlet he had to have. To be within grasp of money at home and have to refuse it, to be hunted by creditors from Paris, to go short of food, fire, comfort of every kind, to feel a power of creation that cannot get itself expressed fully, to watch a Camille loyal but drooping, all this demanded utterance. His sufferings are to be read in his letters to Bazille. Bazille was his one hope of relief. Monet was no more a ready borrower than he was a ready letter writer. He had, like so many artists, the sense that the less creative can best justify their existence by assisting the original artist. But he was bourgeois born and bred, although beyond his petty bourgeois pride he had the vast pride of the man who asks help for something greater than himself.

He begged from Bazille again and again. The appeals led to trouble. Unlike so many of the dilettantes who have rescued the artist, Bazille was a thoroughly nice man with a definite if limited talent for painting. He was kind, good-humoured, well-meaning, sympathetic, admiring; he genuinely believed Monet to be the greatest of the young painters. But his lack of imagination cancelled all these virtues. The old, dreary story of relationship between lender and borrower was repeated.

Bazille was shocked when he received Monet's first letter admitting that they were going short of food. To save his friend's pride he at once made a tactful suggestion: he offered to buy *Femmes au Jardin* for 2,500 francs—a very generous figure—and to pay for it in instalments of fifty francs per month.

The offer was made partly because he was not sure of being able to get hold of the full sum at once. It was also made because he feared that Monet might spend everything quickly if given it en bloc. He did not explain this second reason. but there was no need; Monet, with the abnormal sensitiveness of the borrower, divined it. He was, in short, not being trusted—that was how he saw it. And this was true; even the tactful Bazille, put to the test, could not bring himself to lend money without claiming the right to direct his friend's life, to give advice, in short, to get value for his money. To give and to forget—that was beyond even him.

Monet accepted the offer; he could do no less. He had just had the

CAMILLE

last of his defences stripped away by Camille's news that she was
pregnant. But in his mind remained a tinge of resentment. The
resentment soon had more solid grievances to feed on. Bazille was
unimaginative. He was also lazy. He had never known what it was
to miss a meal, to fear for a roof over his head, to put his hand in a
pocket and find it empty. He was one of those young men who
speak with a grimace of a bank overdraft, forgetting that the less
fortunate cannot afford an overdraft. He complained half seriously,
knowing well enough that rich, fond parents stood behind him.
Gregarious and extravagant, he forgot to send the monthly fifty francs
promptly. Monet and Camille, counting the days, watched for the
postman in vain. At last Monet wrote a furious letter. They were
starving, what kind of friend was Bazille?

Conscience-stricken, Bazille sent the money. Only to forget again.
More angry and reproachful letters arrived from Monet. Bazille
sent the money, but a trifle haughtily. Starving? Really? Repetition
blunted the effect; he could no longer quite believe it. Did people
really starve? Where did Monet get the paper to write on, the
envelope, the stamp? He did not write this, but he thought it. He
sent the money but with a cool letter. The letter brought fresh re-
proaches from the angry man in Le Havre. Monet gave details: he
was behind with the rent, they would be thrown in the street, Camille
was growing paler and paler, he scarcely had strength to hold his
brushes. Pride drove him to exaggerate his woes, to post even angrier
letters to the easy-going man in Paris.

Once Bazille, touched, managed to sell a painting for Monet to
Lejosne. He got two hundred francs for it. He wrote triumphantly,
sending the money. He thought, thoughtlessly, that there would be
a respite. There was no respite; the couple by the sea were deep in
debt. They could not live on Bazille's fifty francs a month; the extra
two hundred melted as they tried to straighten their affairs, as Monet
bought paints and canvases, as they even had a little celebration dinner.

All gone. Another letter to Bazille. He, astonished, was reproachful
in turn. What were they doing with all the money? All!

The sad farce went on. In late spring, Bazille, losing patience, took

matters into his own hands. Without telling Monet he wrote direct to the parents: they could not realize the position their son was in; surely they would help?

Monsieur Monet replied coldly: he knew nothing of his son's sufferings; whatever they might be he had brought them on his own head; he had only to renounce Camille and he would receive food and a bed at Sainte-Adresse; he could no longer be trusted with money.

Bazille transmitted the reply to his friend. Monet's fury, with Bazille, with his father, was past description. He would not listen. The Salon jury was just on the point of meeting; he still had the hope that they would accept his picture and that favourable notices would again soften hearts at Le Havre.

Femmes au jardin was rejected by the Salon jury—his first rejection. The blow was severe. This was the year of the great Fair; Paris was crowded with people and more canvases than ever would be bought by those who thronged the halls of the Salon. Desperate, with Camille expecting her baby in July, he had to give way. He took her to Paris, found her a room, toured the dealers with his work, sold two small paintings, left the money with her and returned to Le Havre so that the pitiful sum should last her as long as possible. He commended her to his friends and believed, for all his anger against him, that Bazille, with need before his eyes, would not fail him.

He went over to Sainte-Andresse and made a sort of peace with the family. He felt bitterness towards his father and mother but knew that his aunt, for all her gentility and conventional gestures, had a heart, had even a sympathy, however reluctant, with his aims. On this he relied to make his enforced stay tolerable to a proud man.

But he was very wretched. In June he put pride aside and wrote again to Bazille. "Ah, my dear fellow, what a painful situation! Camille is a very sweet, very good child and has been so sensible." He recalled with a pang the girl's uncomplaining acceptance of the separation. "Naturally," he went on, "this saddens me even more. I beg you to send me what you can, the more the better. Send it to me here to begin with, for although I am on terms of a kind with my

parents they have told me that I can stay here as long as I like without it costing me a sou, though if I want money I must earn it."

He knew, as did Bazille, what they meant by "earn." He declined absolutely. Yet he must get to Camille. So: "I have a prayer to make. Camille is due to lie in on July 25. It is essential that I get to Paris then and stay ten days or so. I shall need money for lots of things; try to send me something even if only one hundred or one hundred and fifty francs. Think of it, don't forget it, for I shall be in a pretty desperate state without it."

Bazille sent a little money, though not enough for Monet to go to Paris and stay there, and warned him that he might not be able to send more before the first of September. This was bad news; and when Monet failed to persuade his aunt to advance the fare to Paris he felt like throwing himself into the sea. What he actually did, being Monet, was to work harder than ever. He felt the power. He could not be mistaken. He had only to keep on, to face misfortune and master it, and his time would come.

In that belief he worked on under the eye of an approving aunt. "I've about twenty canvases in hand," he told Bazille, "including some stunning seascapes and gardens with figures. One of my seascapes is a regatta at Le Havre with lots of people on the shore and the nearby sea a mass of sails. I'm doing a huge steamship for the Salon; it's rather peculiar."

He worked so hard throughout June that Madame Lecadre, reclining in her beach chair under its bright sunshade, passed from approval to uneasiness and uneasiness to fear. She protested; she could not recognize in this grim-faced man her much petted boy of the agile pencil. Enough was enough; that June proved to be one of the hottest months for many a year; to work in such a glare day after day from sunrise to sunset was to court trouble. He merely shook a dark, determined head and turned back to his easel. She warned him repeatedly; no one, however strong, could keep on at that pace in such weather.

She was right. By the end of the month his head had begun to ache, an ache that grew to blinding pain when he had done the day's

work. In the early days of July he had to put his brushes aside and see the family doctor.

He came away from the interview in despair. "Just imagine," he scribbled to Bazille, "I have lost my sight. After half an hour's work I can only see with great difficulty. The doctor says I must give up outdoor painting. What will become of me if this doesn't clear up!"

Bazille had not replied after a week and Monet, angry, hurt, astonished, wrote again. Bad enough, to be unable to work—his one consolation for the family prison into which he had had to immure himself; but not to know what was happening to Camille, not to be free to go to her, was intolerable. Typically, he did not speak again of his own troubles. "It is cruel of you not to have written. I am terribly worried about Camille who hasn't a blessed sou. And I'm in the same boat. Every day I'm dreadfully afraid she'll have to take to her bed. What a position to be in, the poor creature! I do beg you, my dear friend, to get me out of here. My state of nerves is as plain as daylight to everyone in the house. I must leave in a week at latest. I will bring some studies I've done. If you aren't in funds at the moment, send me the most you can raise. This would at least show good will. I should be horribly unhappy if Camille was brought to bed without any of the necessities, without a midwife, a nurse, without care, even without anything to wrap the little one in. And at all costs I must be there. Think of me, then, and forgive the excessive eagerness with which I appeal to you in my bad moments."

Bazille's reply to this cry of help was like a dash of cold water. He repeated he could not send money. More serious, he did not seem to think that his friend's anxiety about Camille was justified. His view of the girl had always been mixed. He was afraid that she might prove a drag on Monet and prevent him from realizing his talent; he was also disturbed at the thought of being called on to support three people instead of one until such time as Monet's work began to sell.

Monet reacted characteristically to this chilly note. "Send me at once 150 or 200 francs and above all reply as quickly as possible, I beg you. I count on doing what I told you I should do for Camille and the child, and I bank on being in Paris to see them for myself."

His answer to Bazille's doubts of Camille as a mother—he thought her too frivolous—was simply, "When I see the manner and behaviour of the mother I shall be able to decide what I must do."

He broke off to give a piece of good news. "I have seen Guillemet. He is at Honfleur. He was astonished by what I've done here, and I must admit I would never have believed that I could do it. I work all the time. My eyes are getting better, thanks to a run of overcast days which have hidden the sun."

But even his work, pleased though he was about it, could not deflect his thoughts from Paris. He ended with another appeal. "Think of me. This is my prayer to you. I simply must have money. After this I'll leave you in peace, but the child must not come into the world miserably, it must have what it needs. And I only have you to count on. Good-by. Reply without fail by return of post for letters take a long time to get here. I am in a constant state of worry and your reply alone can calm me."

Bazille remained, if not unmoved, insufficiently so to send money. He had sent too much in the past year. He could not believe that Camille was worth it. Monet remained at Sainte-Adresse, raging helplessly. He worked, but wretchedly. The child was born; he could not be there. But at last release came. As the weeks passed his despair was so moving that Madame Lecadre could no longer resist him. All her old fondness returned. Her "lamb" was in trouble; he must have a treat.

The treat was, of course, Paris. She paid the fare. He rushed to Camille and the baby, a sturdy boy; and he deposited at Bazille's flat the result of his work.

Bazille was astonished. The last remnant of ill feeling disappeared the moment they met face to face. He wrote home proudly, "Monet has just dropped on me from the blue with a bunch of magnificent paintings. He'll be sleeping here till the end of the month. With Renoir that makes two hard-up painters I'm housing. It's a real workhouse. I'm delighted. There's enough room and they're both in excellent spirits." The comment was a typical one and expresses Bazille exactly; it was a lark to him and he entered into that spirit of

it with youthful gusto. He knew that Renoir had been moving from one garret to another before he came to him *in extremis*. He knew that Monet had been at the end of his tether for almost a year, but he could not feel it. He saw only two friends who spiritedly cracked jokes and made themselves at home in his apartment. Sitting before his easel he sat for Renoir—a good portrait—but it was precious little sitting before his easel that he did that winter; he was in the grip of his musical craze and was full of his new hero, Edmond Maître. Nevertheless, he was a fine and generous host; he told his friends to make the place their own and meant it. All three discussed their own future with immense seriousness, and they again went over their reactions to the two private exhibitions of a few months earlier—reactions which were to have a long-range effect.

For it was in the spring of 1867 that Manet, rejected once again by the Salon jury, followed the example set by Courbet at the Fair of 1855. He built a pavilion of his own at the 1867 Fair showing a full range of his own pictures—a gesture which Courbet at once echoed. Monet had been there and told Bazille—then in the south: "Manet is in the most frightful state of nervousness. I'll tell you all about it. The opening will be curious." Courbet's attitude, however, was "quite another thing. Imagine, he is inviting all the artists of Paris for the first day. He has sent out three thousand invitations." Nevertheless, when the shows opened Monet was disappointed. He did not think Manet had moved an inch forward and he found the Courbets downright bad. But the private exhibitions had given him an idea.

If further proof was needed that he was steadily launching out on his own, away from the influence of other men, he supplied it during this winter and the early spring of 1868. He demonstrated to Renoir, whose style of painting varied from canvas to canvas, an innovation he had worked out during the months of slavery at Le Havre, Honfleur, and Sainte-Adresse. This was, to apply patches of pure colour to convey the shimmering effect of atmosphere.

And such was the resilience of these two young men living on the edge of starvation that they planned in the heat of enthusiasm to test out Monet's device that very summer by the Seine. How they were

ever to get there or, having got there, live, neither troubled to think. They could scarcely wait for the months to pass.

Monet soon left Bazille's apartment and joined Camille and his child. They existed—one cannot call it lived—in a bare room without a fire. Often enough there was nothing to eat. When the cupboard became empty or his paint supply failed, Monet would make the tour soon to become wearisomely familiar; to Bazille, to Sisley, to Courbet, to every dealer who would trouble to look at his canvases. He could not afford to bargain; he had to take what was offered when it was offered. For a few francs pictures changed hands on which he had spent weeks, sometimes months, of care. Bazille did his best to help, but he had Renoir to keep and was not always able to curb a natural extravagance. The recently married Sisley was in the throes of domestic expenses. Yet the atmosphere in that comfortless room was a happy one. Monet was proud of his child, happily surprised at Camille's response to motherhood, and filled with a certainty that he was on the right road in painting. Renoir, still holding out at Bazille's, would come over, ostensibly to cheer, but more often to be cheered. For he found in the midst of this frightful discomfort and want a united little family. Bazille's fears had not been realized. Camille had reacted to motherhood and bad times with a gaiety and courage which sealed Monet to her for life. Indeed, it was she who kept the household on its feet.

Success seemed far away that spring. Survival itself appeared unlikely. The scenes of Honfleur and Le Havre were being repeated, with the additional worry that there was now a child to feed and clothe, when Boudin sent a message of hope.

Ironically, the ineffectual Boudin and the forceful Monet had begun to change roles in their home towns. Boudin was slowly becoming accepted. Respectable he would never be, prosperous never, but he was well thought of in local art circles and the grace of his work was beginning to penetrate slowly even to the ordinary people. His little studies of holidaymakers at Trouville and Deauville had a charm for many—some even bought them.

So it was Boudin, the man who had been at his last gasp in Paris

not many months earlier, who proudly informed Monet that he had persuaded the organizers of an International Maritime Exhibition at Le Havre to ask him to send pictures along with Courbet and Manet.

The news came as a godsend to the worried man in Paris. He hurried down with Camille and the child, once again forced to leave canvases to fall into the hands of creditors. At the same time he appealed to his aunt. "It is plain," he said, "that someone is trying to blacken me in your eyes." He suggested that she should write to Gautier. He had nothing to feel ashamed about, Gautier knew it and he would confirm the fact that he had been working hard and well.

Gautier's reply was satisfactory and gave Madame Lecadre the opportunity she wanted, of forgiving Claude yet again. It was understood that he did not return to Sainte-Adresse; his aunt drew the line at Camille and the child. But for the rest, as she told Gautier, "I thank you a thousand times for the interest you are still showing in this poor boy who has great need of it at the moment. He is as gentle as a lamb, he admits all his faults. He will listen to all my advice. God grant that this lasts! He is horribly troubled just now. He is being tracked down and hemmed in by creditors who were annoyed when he left Paris. They threaten to seize his pictures at the exhibition."

They did seize them—unhappily they were still there to be seized—and Monet wrote despairingly to Bazille. "I sold nothing at the exhibition. I have been given a silver medal (worth fifteen francs); I've had some excellent notices in local papers and there you are—it doesn't add up to much in food."

There was both better and worse to come. The seized canvases were put up to auction and fetched eighty francs each. Monet, of course, did not get even this money and felt the insult keenly. He was also irritated with his aunt, who refused to pay his debts: "I've had enough of that," she told Gautier. "My intention is to give him enough to live on each day." She steadfastly refused to acknowledge the existence of Camille and still less of the child.

Good of a kind came out of the humiliating auction, which set the whole of Le Havre buzzing with this latest scandal of Claude

Monet. The man who bought the canvases was a wealthy merchant named Gaudibert who lived some miles up the coast in a château at Etretat. He asked Monet to come there to make a portrait of his wife. Monet, at his wit's end to know how to buy food and canvases, was forced to accept. It was his first commissioned picture and relief was entirely swallowed by chagrin at his departure from principle. The work done, he fell into self-criticism. His old fire seemed to have disappeared, he told Bazille. "My painting won't flow and I've absolutely finished with counting on future fame. I'm becoming dreadfully low. In fact I've done nothing worth while since I left you. I've grown horribly lackadaisical, the slightest thing upsets me whenever I make up my mind to get down to work. Everything looks black. And of course I'm always short of cash. Disappointments, insults, new hopes, new setbacks—that's my life, my dear chap."

This reaction to a solitary deviation from his fight to paint according to his lights was reversed for a short time. One visitor to the Le Havre exhibition was Arsène Houssaye, editor of *L'Artiste* and a power in the art world of Paris. He came to see Monet and offered him eight hundred francs for the portrait of Camille. Better still, he "is enthusiastic and says he wants to get me launched." Monet rebounded from despondency to delight; it was the last flicker of the boy. Having given the news to Bazille, he wrote to Gautier, who had also come down for the show. "Since you were here I have made eight hundred francs. I hope that when I can get in touch with more dealers things will go even better."

Direct in speech himself, he trusted others to be the same; he counted on the promised influence of Houssaye and on the forthcoming 1868 Salon to launch him. One or two sales through Houssaye, some good Salon reviews, and he could escape from debts and worries pressing on a mind which should have been given to painting.

He was mistaken on each count. Houssaye had bought and praised a picture which was not typical of the landscapist Monet or of the painter still experimenting with technical novelties. He had far to go before he could accept the things Monet was then painting. He did nothing.

The Salon, on which he was particularly set after his rejection of the previous year, provided another disappointment. With Daubigny on the jury—a Daubigny who believed in Monet more than in any of the young men—he felt sure of success. In fact, Daubigny succeeded in getting almost all his friends accepted; Manet was in, Bazille, Pissarro, Degas, Renoir, Sisley, and the talented young pupil of Corot, Berthe Morisot. Cézanne was again rejected—he had never yet managed to get a picture accepted. Monet had only one picture accepted, his harbour scene at Honfleur, and that only after a great struggle by the loyal Daubigny. Boudin repeated to the old dealer Père Martin, "Daubigny told me that he had had to fight to get even one of Monet's canvases accepted. The one of the ship was taken, but when the next came up in its turn Nieuwerkerke exclaimed, 'Oh no, we've had quite enough of that kind of painting!'"

Nieuwerkerke was the Director of Fine Arts and a convinced adversary of modern painting. He was a man of great power and had a nose for the least hint of revolution. When he said "We've had enough of that kind of painting," he threatened the very existence of the man who dared to continue with it.

Whether Monet perceived the backhanded compliment is doubtful. The struggle to live and to paint was slowly robbing him of his native buoyancy of spirit, his good humour, his optimism. He saw Bazille, whose promise as painter was still largely in the future, and Renoir, who had not developed an individual style, preferred before him. He saw Manet, the one-time bane of the Salons, freely admitted. He was hurt, bitter, difficult to console as all his bright castles fell to the ground and he saw ahead an indefinite continuation of struggle and suffering for himself and Camille.

Yet the fact remained that when Nieuwerkerke set his face plainly and publicly against his work he was elevating Monet into a position he was to be proud to occupy. His ceaseless experiments, his persistence in working against odds, were not for nothing. He who had been regarded as one of the most promising young painters of the Salons of two and three years past was now set aside—the impossible Cézanne excepted—as the most dangerous innovator of all. When

the Salon showed his pictures freely and critics effused, there was something the matter with those pictures; they were Monet, but they were also Courbet, Manet, Corot, Daubigny, Jongkind, Boudin, a tinge of each still unabsorbed by the mature painter. Now the Salon frowned, Nieuwerkerke blustered, and Monet was himself at last.

If Monet did not realize fully what was happening, his companions did. Boudin, who met him at the Salon, was tremendously impressed by his work. He understood perhaps better than his old pupil what the official attitude meant. "He shows us the lesson we all ought to remember," he told Père Martin; "how to stick to one's principles." And he added, "In his work one always feels the sense of a praiseworthy struggle to produce *true tone*. Everybody is beginning to respect his painting." Bazille exclaimed loudly, "Monet is the greatest of us all."

Chapter 10

The Birth of Impressionism

1868 - 1870

EIGHT HUNDRED FRANCS SEEMED A SMALL FORTUNE WHEN HOUSSAYE paid it over in the spring of 1868. By the time Monet had stayed in Paris early the same summer it was on the wane. He retired once again to Normandy where life was cheaper—this time to the inn at Fécamp, a small port above Etretat.

He began to paint right away, a change of scene stimulating him to try to portray this new version of the familiar coast. His contentment did not last long; it was overshadowed, then submerged as always by gathering money worries, by dunning landladies, threatening letters from paint salesmen, by the sight of Camille and the small Jean going hungry.

On June 28 his spirit broke. His father, approached once again, had returned a brusque, "No, not while that woman is with you." His aunt had withdrawn her help, annoyed because he had not returned to her and disappointed by his moderate showing at the Salon. His landlady had told him to get out; she had taken everything he had — canvases, paints, brushes, clothes—to go toward the unpaid bill. He could no longer paint, he could not face the uncomplaining Camille. He threw himself off the jetty into the sea.

This first and last failure of courage passed quickly. The shock of the cold water brought him to his senses. He swam ashore. Ashamed, he went back to the inn to face his difficulties.

The next day he wrote to Bazille, "in haste, to beg your immediate help. I was certainly born under an unlucky star. I've just been thrown out of the inn—and without a stitch of clothing, what's more. I've managed to find shelter for Camille and my poor little Jean for a few days in the country. This evening I'm off to Le Havre to try to arrange something with my admirer there. My family won't do any more for me. Where I shall sleep tomorrow I have no idea."

He signed himself "your most harassed friend" and confessed his weakness of the previous day: "I was so distressed that I foolishly threw myself into the water. Luckily no great harm came from it."

His admirer, Gaudibert, bearded in his office at Le Havre, broke the spell of ill luck. He did not understand what Monet was trying to do in painting and would not have liked it if he had. He did understand sincerity when he saw it, and desperation. It was difficult to look into Monet's eyes without surrendering to the transparent honesty there. The tradition of the art patron is strong in France. Gaudibert was kind—and flattered too. He agreed to give Monet a small allowance until the next Salon, when the painter, whose optimism was strong, firmly believed that his work must be acknowledged: he felt a power, he said simply, he saw it in his canvases—how could others deny it?

Gaudibert, a simple man, accepted this reasoning. Monet went off happily. The allowance was barely enough to live on and still less to paint extensively, but he was not in the mood to be critical. He rented a little cottage at Fécamp and he and Camille and the child settled down to a summer of content.

"The country is superb," Pissarro was to write on his first view of this part of Normandy fifteen years later. "There are cliffs, forests, farms, enough subjects to keep one busy for ever." What Pissarro felt in 1883, Monet felt in 1868. He once more began to paint fast and well, on the beach, in the country and in the home. Life flowed into him. His letters were filled with hope. Never had he done better work.

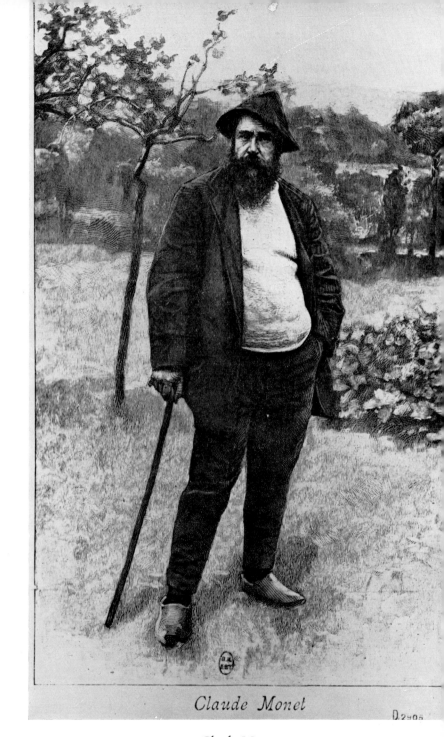

Claude Monet

Claude Monet
woodcut after photograph, 1877
(Bibliothèque Nationale)

(The Louvre)

L'Eglise de Verteuil
by Monet, 1878–9

Note: The Monet cottage
is on the extreme left.

The respite seemed miraculous, and his letters reflected his content-ment. He had the enviable nature of one who looked neither forward nor back when he was able to paint with his family about him. On the rare occasions when he thought of the future, he believed in his heart that in spite of every check he must finally succeed. As summer drew into autumn he expressed this contentment in one of his rare interiors, *Le Déjeuner,* a study of Camille and the child in the tiny cottage living room. He spoke of this to Bazille in a letter of the time. "I'm surrounded here by everything I love," he told his friend. "When the weather is stormy or the boats are putting out to fish I spend my time on the shingly beach. I also go into the country round about which is so beautiful that I'm not sure I don't find it even more attractive in winter than summer. All the time I've been working, of course, and I have good hopes of doing some serious things before the year is out."

Like every artist who has suffered, Monet was enviable, too, in his appreciation of simple things. He who had sat through a fireless winter so chilled that his fingers could scarcely clasp the paint brush, found the homely flame in a hearth a perpetual comfort and joy. "And then, my dear fellow," he went on, "in the evening I come back to a good fire and a loving little family in my cosy cottage. I wish you could see your godson now, how charming he is. It is fascinating to watch this little being growing up. I am very happy to have him. I shall put him into a picture for the Salon—with other figures around, naturally. I want to do two pictures with figures this year; this interior with baby and two women as well as one of some sailors. I want to do them in a really outstanding way."

But this interest in figures did not lessen his enthusiasm for land-scape. He thought of Paris and his sufferings there, of the time wasted in socialities, in the danger of influences, and he burst out into a passionate plea for the retention of the "utter tranquillity" which "the kind gentleman of Le Havre" had given him. "I want to go on always like this," he declared, "working in a quiet and secluded countryside. I don't envy you in Paris at all, I assure you. Frankly I doubt whether one can do anything good in such surroundings. Don't you really

think one does better alone in the heart of the country? I'm sure of it. For that matter I've always thought so and my work in the midst of nature has always been better than in the city. However strong-minded one is, there is always the likelihood in Paris of being led astray by what one hears and sees. What I am painting here has one merit at least, that of not resembling the work of anyone else. That, anyway, is what I believe, because this work is solely the expression of what I alone, in person, feel."

Even this blissful state contained drawbacks. The chief one is familiar to every sincere artist. "What troubles me most of all is that the further I go the more I see and regret how little I really know." As autumn wore on, another familiar problem raised its head. Coal, for instance, had to be paid for, canvases were expensive, paints too.

The deeper he got into winter and the harder he worked, the greater were the demands on Gaudibert's small allowance. Then his dealer refused further credit and he ran out of canvases. An urgent appeal went to Bazille for old canvases. This was not the first time he had been driven to scrape off old pictures; he remembered with horror how the work of months had had to be destroyed because another thought had come to him which had to be put down on canvas. So he asked Bazille particularly for unfinished canvases and begged him to take great care of the finished ones. "I've lost so many," he added wistfully, "that I cling to those that are still left."

The halcyon months at Fécamp spun over into 1869. But Paris would not be resisted. There was news that the Salon jury would be more amenable than in the past year or two. Hopeful as ever, Monet came up in late spring. He had submitted what he considered to be his most powerful and characteristic work to date.

He was not mistaken. His error was in thinking for one moment that his growing technical adventurousness—throwing, for instance, the chief emphasis of one supposed figure study on to reflections in water carried out by tiny dashes and dots of paint—would ever be considered seriously by a jury still governed by academic considerations. All his entries were rejected.

Bazille wrote in high fettle to his family. "What gives me most pleasure is the genuine animosity shown against us. Monsieur Gérôme is at the back of all the trouble; he treats us like a band of lunatics and says it is his duty to do everything he can to prevent our paintings from being shown." He added, "This isn't at all a bad thing." However true in the long run, these were the words of a young man with private means. Besides, for all his martyred air, he had had one canvas accepted, as had Pissarro and Renoir. Manet, the ex-rebel, had both of his taken. Only Monet, Sisley, and the inevitable Cézanne were rejected without mercy.

Monet was by this time in his twenty-ninth year. As far as the sales or even the showing of his canvases were concerned, he had the sensation of going backward. At twenty-six he had been very much better known. Indeed, he was now no longer mentioned. There was no more talk by critics of his great promise. All was silence. He felt the despair of the isolated man, a despair made ten times worse by his certain knowledge that his later works were in another class from those which had won such praise.

Of course he exaggerated. His reputation in the circle of advanced painters gathering about Manet had never been higher. But this was little comfort to a man who had no wish to live on vanity but on money honestly earned. The rejection forced him to try his luck near Paris once again. Whatever he might think and say about Paris (and he had quite lost his feeling for a big city), the only hope of sales lay there, for there alone could he meet men who might give him introductions to dealers and collectors. There too was Boudin's Père Martin who might at a pinch be persuaded to hand out thirty or forty francs for a Monet canvas which he hoped to sell for double the price and which a few years later would fetch fifty times what the painter had been paid.

Putting his pride in his pocket, Monet again approached Gaudibert. The Havrais listened and paid up. He agreed to extend Monet's allowance until he could settle himself and family near Paris. There was no doubt in Monet's mind about the area he preferred; the months at Ville d'Avray in the year he met Camille had given him a love of

the Seine valley between Paris and Rouen which he was never to lose. By June he, Camille, and Jean were in a cottage at Bougival, a little village a few miles further down the river. From there he wrote to Houssaye, recalling his promise of a year earlier. "You advised me," he said, "to come to Paris where it would plainly be easier to make the most of my small talent. My rejection at the Salon has completely made up my mind. In the future, after this blow, I can't hope to make the best of myself at Le Havre any longer. Monsieur Gaudibert has again been kind enough to help me install myself here and send for my little family. Here we all are and I am nicely settled and full of courage for working. But alas, that fatal rejection has practically taken the bread out of my mouth and in spite of my most reasonable prices dealers and collectors turn their back on me. It is especially saddening to see what little interest there is in a work of art that has no list price.

"I have thought, and I hope you will excuse me, that since you have already found one canvas of mine to your liking you might wish to see some other canvases that I have been able to save. I thought that you might be kind enough to come to my rescue, for my position is practically desperate. The worst of it is that I soon shan't be able to work any more.

"It is unnecessary to assure you that I am prepared to do anything and at whatever price to escape from such a dilemma and to make sure, by preparing my next Salon pictures now, that such a situation can't occur again."

This letter brought nothing tangible from Houssaye. It was not that he was unfriendly; he was simply less advanced than the man who sought help. Paris was filled with needy painters and Houssaye was accustomed to appeals from them. He made the mistake of believing that Monet was just such another. He saw the promise but not the fulfilment. He chose for the moment to ignore his own encouraging words at Le Havre the year before.

His polite, noncommittal reply shocked Monet. There he was, installed but with no funds. Within a week or two he had reached the state dreaded by every painter whose head teems with ideas. He

could no longer paint; all his colours had been used up, and he had no money to replace them.

Frantic, with motifs on every hand he yearned to put on to canvas, he implored Bazille to send him some paints.

Renoir, who had retired penniless to his mother's little house at Ville d'Avray, walked over frequently to Bougival. He had never forgotten Monet in the Gleyre studio firmly telling his companions to be done with the useless tuition. He remembered with admiration the Monet of Fontainebleau forest insisting that they all paint directly from nature. The weeks with Monet in Bazille's studio were still fresh to him, weeks of encouragement from a man who seemed to have no future and certainly no present. Like all who flourish in joy and sink under discouragement, the happy-go-lucky Renoir leaned heavily and gratefully on Monet's solid sense and strength of character. And like those who dissipate their gift for want of a guiding principle, he found most inspiring Monet's purposefulness and certainty that he was on the right road.

So over he came, glad to be away from the home atmosphere with its side remarks on the steady money he used to earn painting pots and blinds. And he brought with him a perky cheerfulness of speech and gesture—he deliberately emphasized the gamin in himself—which the too grave Monet relished. His admiration came as a boon to a man who felt himself abandoned and his talent going into thin air. And his eagerness to experiment in *plein air* painting often exceeded Monet's.

No two men could have differed more. Renoir, thin, nervy, with wiry hair, thin black mustache and snatch of beard on the pointed chin, soared from a cheerful burst of gutter slang to abysmal misery of silence. Monet, now heavily bearded, squared-faced, steady-eyed, appeared the last word in reliability. They went well together, complementing each other. Together they made tolerable and constructive a summer and autumn which could have been unrelieved suffering and gloom.

Renoir was little better off than his friend; he had shelter and food at home but no money. He could not even afford to buy a stamp for

a letter. Bazille had sent a few paints, Renoir brought a few over to Bougival, somehow work went on.

There were no sales. Nothing happened. Bougival might have been in a desert for all its nearness to Paris meant. Monet could no longer find the small fare into the city. He was completely cut off, Renoir his only link with painting. Even Bazille wrote to say that he could do no more for the moment. He had exhausted his allowance; he had had to pawn his watch to keep going.

By the beginning of August the little Monet household had reached rock bottom; they were out of food, coal and wood for their stove, oil for their lamps. Renoir kept them alive; he stuffed his pockets with bread left over from his mother's table and hurried across to the Monet cottage.

"Do you know the state I'm in?" Monet demanded of the silent Bazille. "How we've been living during the week since I last wrote? Just ask Renoir who brings us bread from his home so that we don't die of starvation. For a week no bread, no wine, no wood for the kitchen, no light. This is frightful! It's really too bad of you to forget me since after my last letter it was easy to see what would happen. And when you've read this one you can't help but see what's in store for me. I haven't the heart to say another word to you."

They were not yet out of paints, however, and despite his words to Bazille, Monet put such a bold face to the situation that Renoir became quite gay. "I'm almost always at Monet's where, by the way, one gets a bit worn—we don't eat every day," he wrote to Bazille, adding, "but all the same I'm contented because Monet is such good company when it comes to painting."

And in spite of everything they worked on. Bazille, shamed into action by their letters, did what he could when he could and when he remembered. It was little enough and the inhabitants of Monet's cottage went hungry with frightening frequency. But the men's hunger disappeared when they sat before their canvases in the open air. Day after day they went out. And it was Monet's persistence in *plein air* painting which literally made them as painters and saved them as men. Their favourite spot was the bathing place of La

Grenouillère on the river near Bougival where they found congenial subjects seen from the restaurant terrace overlooking the water and in one place actually built over it. The proprietors, the Fournaises, looked with a kindly eye on the two painters, the solid, earnest, black-bearded Monet and the lively, slender Renoir. They not only allowed them to put easels on the terrace—which had a certain advertising value—but the kindhearted Mère Fournaise fed them and, discovering that there was want at home, sent them back in the evening with precious leftovers from the day's food.

From the painter's point of view Monet and Renoir, perched on the terrace, found themselves in an Impressionist paradise. Facing them was all the gaiety of a Parisian summer, the river crowded with boatloads of men and women in bright clothes, picnickers spread over the islands and banks, bathers by the score. It is one of the feats of the Impressionist painters that they discovered beauty in everyday things no one had thought paintable. It is another feat that their paintings reflect nothing of their private lives, all of their outer vision. Like all that Monet had painted and was to paint, the present work showed no trace of the stresses of his life. Impossible, looking at them, to think that the painter was hungry, harassed, uncertain where his next sou was coming from. His canvases are serene or happy as if, when he got a brush in his hand, material things vanished from his mind.

Nor was that all. Impressionism was not born when Monet and Renoir sat on the terrace of the Fournaise restaurant in 1869. Yet at La Grenouillère, painting the river scene from a similar viewpoint, they put Impressionism on to canvas five years before the name was even thought of. They were Impressionist not only in choice of subject and in the happy view of this subject, but in technique too. Their aim, following Boudin and Jongkind, was absolute truth of vision. They wanted to reproduce exactly the sense of activity and gaiety. They realized—and the "they" was usually Monet—that the only satisfactory way of conveying this human bustle was to give a similar impression of liveliness in the natural surroundings: the sparkle of the river water, the reflections of the sun on tiny waves, the glistening beads of water dripping from an oar, the very vibrations

of light in the air. And to do this they made numberless tiny dashes and dots of colour with a small brush, all done very quickly and with pure bright colours. Bounding lines disappeared, the whole surface of the painting was built up out of these tiny dabs of paint. Their *La Grenouillère* were historic canvases.

The work was not done easily or quickly. The joyful canvases give no inkling of the struggle that went not only into the painting but into the struggle to be able to paint. "I do practically nothing," Renoir was telling Bazille later in the summer, "because I've so little paint."

Before the end of September the little had become none and Monet was writing desperately to Bazille, "Here I am halted for want of paint! This year I—and I alone—shall have done nothing. This thought makes me furious with everyone. I become jealous, mean, half out of my mind. If only I could go on working, everything would come right, I'm sure of it. You tell me that fifty or a hundred francs won't get me out of this mess. You might be right. But if I look at it that way I might just as well go and smash my head against the nearest wall, for there's no hope of a fortune suddenly descending on me from the clouds." He went on, "I have a dream in my head, of a picture of the bathers at La Grenouillère. I've made some poor sketches for it but it remains a dream. Renoir, who has been here two months now, also wants to do this picture."

The picture was done. In spite of Bazille's temporary withdrawal —a Bazille tiring for a while as before of constant appeals—Monet kept on. In spite of a halfhearted Renoir—"no fighter" as he himself said—who in weak moments urged him to throw in his hand and take work that would bring in money, Monet kept on. He, the only one of the three who had absolutely nothing, no money, no helping family, no foreseeable future, not only insisted on painting what he wanted to paint but compelled Renoir by sheer force of character to do the same. Renoir was to remember these moments with gratitude; his admiration for the man whom nothing could crush or turn aside from his purpose rose into near idolatry. "If I remained a painter," he said, "it is thanks to Monet. But for him I should have given up."

The picture was done and many more besides before, in October, the friends parted. The weather was closing down and Monet felt that he must make one more effort to come to terms with his family. He begged the fare home from Boudin. Boudin would give his last sou to help the pupil he believed to be on the verge of greatness. He scraped the money together and sent it off with an encouraging message via his old dealer in Paris.

Monet went first to Gaudibert's château at Etretat. He was frank with the Norman openness that gained him the respect of all. Gaudibert was sympathetic. He agreed to give Monet an allowance until the next year's Salon. The Monet parents were less generous. Camille was a persistent thorn in the flesh, and their son's equivocal reputation in the town distressed them scarcely less. Mistress and debts were alike painful to these unimaginative people. Their terms remained as ever, the dismissal of Camille, and as ever Monet refused them contemptuously.

He returned to Paris the next month, November, and again moved a little down river, renting a cottage at Saint-Michel a short distance from Bougival. Renoir had joined Bazille at the latter's new studio in the Batignolles but Monet still had company close by, and company of an inspiring kind. A few miles away, at Louveciennes, Pissarro had settled with his Julie and young family. Pissarro could not virtually live with Monet as Renoir had done, but they saw much of each other, taking turns in walking over. The change from disciple to fellow spirit was welcome to the younger man. Renoir had been gay, charming, amusing; he was far from being always serious and his enthusiasms were liable to disappear the moment he got outside the range of the stronger character who had inspired them. Pissarro's enthusiasms were by comparison stability itself. A born landscapist, he was excited by Monet's technical innovations and had made innovations, not less important, of his own. He had long since abolished black, bitumen, sienna, and ochre from his palette. His canvases were lighter than those of any other man painting and, as his rejection of black indicated, he had discovered that there was no such thing as a black shadow. A shadow was merely composed of

colours less clearly seen by the ordinary eye. He preached year in, year out, "paint only with the three primary colours and their derivatives."

For a man so extreme in conversation—he demanded, for instance, that all art galleries be burned—he remained in practice the essence of reason and generosity. He preached the virtues of landscape painting but insisted that his pupils go their own way. He could only point the way, he would say again and again, waving large arms; each man must portray what he sees. He deplored linear form, pointing out that form could be achieved much more satisfactorily by colour. But always he ended every exhortation with his famous: "Your only master is nature. Consult her always."

This new intimacy—for by chance these two men with so much in common had rarely spent much time together—gave Monet one of his happiest winters and springs. During the hard weather he and Pissarro made several snowscapes, a subject for which he was to show particular flair. His work improved as he lightened his palette still further. Above all, his many conversations with this excitable, lovable man with the patriarchal beard and large liquid eyes gave him the sensation of progress. Together they began to thrash out a definite technique for landscape painting. If it is true to say that Impressionism was first shown in action on the La Grenouillère canvases of the autumn of 1869, its technical outlines were established that winter and spring of 1870. In each case Monet played a vital part.

Much of the two men's conversation naturally concerned the 1870 Salon. Though more fortunate than Monet, Pissarro was nevertheless always struggling; the few pictures he managed to sell went for ridiculously low prices. He and his growing family were forever in debt, often uncertain of the next meal, and he, like Monet and Renoir, was frequently hard pressed to obtain canvases and paints. Only a few months before this fresh intimacy with Monet, he had been driven to imitate the example of the young Renoir and paint shop blinds for a living.

Of the two, however, Monet was by far the worse placed, as the generous Pissarro was the first to admit. His indignation on his friend's

behalf often rose into a frenzy, beard waving, eyes gleaming, like one of the avenging prophets of old. For Monet, once so favoured, had had only one picture accepted at the Salon in the last three years. This, with the Salon as it still was, the only serious means of selling a picture at a reasonable price, was a catastrophe. Monet felt that 1870 was a vital year. He could not hope to keep Gaudibert's interest alive with further promises if he was again turned down; his only chance of getting into the good graces of his aunt—and possibly of his parents —was by an acceptance and good critical notices.

He worked like a demon throughout the dark months preparing for the lighter days. And when these came he was out from sunrise to sunset, short of food, short of paint, but never short of determination. He felt the greatness in himself. He had a power. He could not be kept down.

He sent in his pictures in May. From the first moment it became evident that there was a general determination to reject Monet as the special favourite of Daubigny. The previous year's debates and Nieuwerkerke's intervention had not been forgotten. The history of the previous year was repeated exactly: Manet, Degas, Renoir, Pissarro, Sisley—all except Monet and the ultra-rebel Cézanne were accepted. All Monet's entries were turned down.

These rejections led to an unprecedented scene. When Daubigny —who had been elected to the jury with more votes than any other man—realized that nothing he could say in favour of Monet would be listened to, he promptly resigned. "I liked this picture from the first moment," he said of the first of Monet's canvases. "I'm not going to have my opinion contradicted in this fashion. They might just as well say outright that I don't know my trade."

He stormed out. Corot followed him, equally disgusted. Monet was left, when the news reached him, to grasp what comfort he could from Daubigny's championship and public defiance of the jury. But the net result was as ever; once more he was not to be seen in the Salon; for another year he would have to struggle, beg, endure.

Mercifully perhaps, his bitterness was suddenly broken into by a general catastrophe—war.

Chapter 11

The End of the Beginning
1867 - 1872

THE DECLARATION OF WAR BY FRANCE ON PRUSSIA ON JULY 19, 1870, not only broke into the life of Monet, as of every other painter in Paris, it scattered a group which was to make Monet's name.

The origin of this group, from Monet's point of view, dated from 1867, the year of the World's Fair. This was the year in which all the progressive painters except Degas and Berthe Morisot were rejected at the Salon, the year in which the disgruntled Courbet and Manet showed their work in private pavilions erected in the Fair grounds.

Monet, ever the practical one, brushed aside his friends' grumbles after their rejection; action was needed, and the private pavilions had given him an idea. The first time Courbet built his own pavilion, for the Fair of 1855, he lost a great deal of money. For the 1867 Fair he did differently, as Monet told an absent Bazille at the time. "His intention is to preserve the building, where he has already had a studio made for himself on the first floor, and next year he will let his hall to anyone who wants to hold an exhibition." The permanent building and Courbet's sympathy fired Monet. "Let us work, then, inscrutably," he declared, "and find ourselves in the hall with faultless things to exhibit."

114

Monet's idea was amplified by his customary mouthpiece, Bazille, in a letter to his family. They were all, he said, "a dozen talented young painters," tired of submitting their works to the Salon jury. Their chance of being shown, and their very livelihood, was decided by "administrative whims." Besides, even if they were to be accepted by the Salon jury, they were limited to three pictures. And as no independent dealer existed who had the means or the courage to make an exhibition of their work, they planned "to rent a large studio every year in which we can show as many of our pictures as we like. We shall invite painters we admire to send canvases. Courbet, Corot, Diaz, Daubigny, and many others you don't know, greatly approve of our plan. With these folk and Monet, who is stronger than us all, we are sure to succeed. You'll see—we'll be talked about."

Apart from showing accurately the high reputation Monet had won among the young painters—a reputation due as much to his character as to his painting—this plan led to nothing. It collapsed quickly and for a familiar reason. Bazille was soon sadly admitting: "By bleeding ourselves to the last possible drop we succeeded in raising the sum of 2,500 francs, but it isn't enough. So we are forced to renounce our scheme."

In addition to Monet and Bazille, the little band of painters who collected this quite substantial sum after many sacrifices included Renoir, Sisley, and Pissarro, whose youthful enthusiasms counted him among "the dozen young people" of Bazille's letter. With Pissarro came his old pupil Guillaumin, Cézanne, and Guillemet, friend of Cézanne and Zola and an old habitué of the Académie Suisse. Renoir brought in Fantin-Latour. One or two more who, like Fantin, were not to stay the course, completed the dozen.

This group, which was in fact no more than a few dissatisfied and penurious young men, was to lead directly to the Impressionists of seven years later, yet none would have thought such a development less possible than the young men themselves. They in no sense formed a true group; they had no corporate unity or belief; they were united only in dislike of the jury system. Had admission to the Salon been free to all, no more would have been heard of revolt. These youngsters

—Pissarro excepted as to age—were also completely without power. They had had one or two pictures accepted at the Salon and that was all; they remained unknown.

It is possible that they would have remained unknown in their own day but for the involuntary assistance of Manet and his gatherings at the Café Guerbois. Manet was a figure even in those early days. Though the senior of all but Pissarro, he was nevertheless young enough to be attacked by the authorities and conventional painters as a dangerous rebel. Unlike the members of the Monet group, he was known: to the general public he was notorious as the painter of *Le Déjeuner sur l'Herbe* and *Olympia;* to all progressive young painters he stood next in line to Courbet as the hope of modern painting. To the revolutionary critics, he was the means of demonstrating their theories of realism or naturalism.

So the gatherings which Manet had begun some years earlier at the Café de Bade and which he transferred to the Café Guerbois in the later sixties became the heart of what was to reveal itself later as the Impressionist revolt. Anyone less anxious to head or even support such a revolt than Manet would be hard to find. In his heart, as Pissarro was to discover, Manet "had a petty side, he was mad to be recognized by the official authorities, he believed in success, he longed to win decorations." Could he have been another such as Couture he would have been contented. He was saved from this petty side, as Pissarro called it, by a talent and nature which could only express itself by antagonizing the authorities he longed to appease.

His gatherings, then, were very much second best for him; a means, very largely, of building up an *amour propre* wounded by savage public and official criticism. At the Guerbois, a tiny café in the avenue de Clichy, two tables in a corner of the room were always reserved in the evenings for Manet and his friends and admirers. Here evening after evening Manet, a shade too carefully dressed, shoulders very square, waist very narrow, held court. He had a reputation for the *bon mot,* he had charm and, when not roused by opposition, made an attractive leader. He did in fact meet opposition from Degas. There were high words often enough across the marble-topped table

at which the great men sat. Manet sometimes swirled out of the glass-paned door in dudgeon while Degas sat chuckling, small eyes creased into the long face. Less often Degas would snap angrily in his high voice, as when Manet, declaring that it was an insult to his wife, cut the profile of Madame Manet from a canvas which Degas had painted and given to him. But in general Manet accepted the quips and stings of Degas. Degas was well born and had to be allowed special license. He was truly witty as Manet often acknowledged. He was a magnificent draughtsman for which he earned Manet's ungrudging respect. And he was by and large of Manet's mind, that the making of portraits of friends and relatives was the civilized use of the painter's art.

The Guerbois gatherings might have degenerated into a mutual admiration society with Manet as presiding genius. That they did not was due to three latecomers. Zola began to drop in. He made his presence felt. He had become a fanatical admirer of Manet but not an uncritical one; he admired what the painter was scarcely conscious of, his realism. To Zola, the romantics with their false emotion were as abhorrent as the academic painters harking back to forgotten ages, teaching smug moral lessons, trying to live in a cloud-cuckoo-land. He extolled Manet for painting living people of his own age. He was, he said, the one honest painter and his work possessed the one worthwhile beauty, the beauty of truth nakedly told.

Zola found allies beyond the flattered but slightly uneasy Manet. He found, in addition to the other realistic critics, Castagnary, Duranty, and Astruc, an unexpected supporter in Degas. All Degas' social inclinations were aristocratic, as his portraits showed. But they showed something else too; a lively curiosity. In his notebooks he had jotted down the limitless possibilities of models seen from unusual angels, the fascination of subjects hitherto regarded as below the painter's notice—musicians and their instruments, locomotives, factory chimneys, steamboats, laundresses. He had done nothing about it but the inclination was there.

Then Pissarro was invited to the café. Though a landscape painter, Pissarro was a radical socialist in politics. He jumped at Zola's realistic doctrine, he encouraged the inventive side of Degas. The common

man, he declared, not only gave the painter a truthful model since he was present in the studio and not simply in the artist's imagination, he offered a new and superior form of beauty, the beauty of everyday life. He took the argument a stage further. Why stop at men? he asked; everyday things, the humblest utensil, the supposedly ordinary view, were also proper objects of the painter's study; beauty was where the painter found it, in the gutter as much as in the palace.

Pissarro was extending a doctrine already trumpeted by Courbet but he raised the question to a new level. It was, he said, not simply a matter of painting what one saw instead of what one felt one ought to see, or what the purchaser would like to be seen. There was the deeper question—how to paint what one saw; how to convey the truth of vision.

It was at this point that the Guerbois gatherings were enlarged by the group of young painters headed by Monet. They did not come in a body but one by one, Cézanne with Pissarro, Renoir with Fantin-Latour, and Monet last of all.

Monet did not come often until the winter of 1869–1870, when Bazille took a studio only a stone's throw from the Guerbois. It was a roomy, handsome studio. Bazille, enchanted, made a study of it which has since become famous. The picture shows Manet regarding the canvas with Bazille and Astruc looking on, Maître playing the piano, and Monet and Renoir talking close to the staircase. This studio not only provided Renoir with a winter home in which he completed his Salon offerings for the next spring, it was big enough to give Monet a bed and painting room. The temptation to come into Paris whenever possible was considerable. Monet loved the river valley but felt cut off there from all chance of making a sale. Even to show oneself to a dealer occasionally, to let him see one's latest work, was a form of publicity which, in those days of many struggling painters and short memories, was essential for the poor man. Yet only a loan from Bazille or Sisley could get him there; his small allowance from Gaudibert was entirely swallowed by food and fuel and painting equipment. To their honour they did not forget him; nor did his neighbour Pissarro when he made one of his rare small sales.

Once at the studio Monet used to spend several days there. He had not only to search out the dealers, he had to pay his respects to possible collectors he had met at Lejosne's and to critics such as Houssaye. He detested these business visits and did not shine at them, but he relished the talks with Bazille, Renoir, and Sisley. And these talks spilled over naturally into the Guerbois. It was a simple matter to stroll along to the café when the evening closed in and painting came to a stop. As they did.

The coming of the young painters raised the question of ways and means. Since the abortive attempt at a show in 1867 they had never been able to muster sufficient cash to rent a place to show their pictures. The problem remained, how to sell their work. Even when they had had a picture or two admitted at the Salon, the pictures were always badly hung and went virtually unnoticed. All remained desperately poor, Monet and Pissarro worst of all. Fortunately for them, this question interested Manet too. He lived lavishly, overspent his good income, and was as eager as the poorest to find some way of showing and selling his work. No reputable dealer would take them up, only the revolutionary and suspect critics would notice them.

No solution appeared. What did appear, though none noticed it, was a sense of unity in adversity. In 1869 Fantin-Latour expressed his admiration in a group painting. This painting showed Manet at his easel engaged in making a portrait of Astruc. Watching him, Fantin brushed in the figures of many Guerbois habitués including Monet, Renoir, and Bazille. Fantin called his picture *A Studio in the Batignolles Quarter* and offered it to the Salon. This picture gave the group its name. Hostile critics and painters saw and feared what the Guerbois crowd did not. They poured tasteless scorn on Manet and his followers. "Jesus painting in the midst of his disciples, or the Divine School of Manet" was a typical headline by those who tried to kill by ridicule.

Abuse merely served to unite. The name Batignolles Group took root, helped to bind together the disparate collection of men and gave the young painters headed by Monet a sort of foothold in art. It gave them a public leader in Manet. It gave them the quizzical regard of Degas, the one man there with plenty of money.

9

These advantages were for the moment psychological only. Plans abounded for sales; all were demolished. But the difficulty of selling pictures merely increased an appetite for discussing what these pictures should be and how they should be made. When the kind of painting was debated, the landscape painters, Pissarro, Monet, Sisley always, Renoir and Bazille occasionally, Cézanne whenever he was there, tended to form a group within a group—a group which consisted of the leaders of the abortive plan to rent Courbet's hall. They always sat together at the less prominent of the two tables reserved for these gatherings, with Bazille acting as a sort of liaison officer between this and the main table where Manet and Degas and their henchmen sat. For Manet, supported by Degas and many of the company, still professed to regard landscape painting as a joke. He demanded, as he had demanded in front of the Monet landscape, why had not the ancient painters done landscape if it was of any value. Monet listened to this rather tattered remark with an ironical smile, Pissarro would redden and blow into his beard, but Cézanne, who disliked Manet from the beginning, made no attempt to control himself. He rushed out with a snarled: "Dirty cads dressed like lawyers!"

But if the genre of modern painting simply aroused controversy, all could and did discuss with some unanimity the painter's outlook and method. To paint what you see, be it landscape or figure—that was the first momentous step agreed. No more cant, but truth to individual vision.

This taken for granted, then came the method. And it was here that Pissarro and Monet began to take the lead. They made a formidable pair, Pissarro all fire and conviction, Monet solid, calm, immovable. They had to fight. Their theories that there were no bounding lines in nature and no black shadows were resisted tenaciously by Manet and his satellites. But in other directions they gradually won their way—or to be precise, were winning it when all at once the members of what was fast becoming a genuine group of progressive painters with a leader and a programme were scattered to the four corners by war. Manet and Renoir and Bazille joined regiments, Sisley went to England, Cézanne to the Midi, Pissarro back to Louveciennes,

Degas remained disgustedly in Paris to witness the folly of nations at war, Monet retired to Le Havre. Impressionism, which had been coming fast to the boil, sank back into obscurity.

When war became inevitable Monet began to worry in case he and Camille were separated. He hurried to give her the protection of his name in the hope that if anything happened to him his parents would acknowledge her and the child and make provision for them. They were married on June 26.

A few days later they went to Le Havre, then to Honfleur, where Monet promptly began to paint as if no such thing as war existed. As, indeed, it scarcely did for him. He was in another world from the boy of ten years earlier who rushed after "glorious adventure." Like so many Frenchmen, he saw the war as an Imperialist last throw for power; as a dedicated painter, he saw the war as the enemy of art. He ignored it as best he could. Deliberately he painted scenes as far removed from war as could be imagined, including the calm and atmospheric *La Plage à Trouville*.

But war would intrude. The French armies, badly led and equipped, crumpled. On September 2 Louis Napoleon surrendered at Sedan. The republic was proclaimed two days later, but too late to affect the course of the war. The Prussians advanced on Paris and by the nineteenth had surrounded the city.

In Le Havre boatloads of French refugees crossed to England. Boudin went to Brussels with Diaz. At first Monet intended to go with them but changed his mind. Daubigny, he heard, was in London, Sisley on his way there, Pissarro had just escaped the advancing Prussians and was talking of England. Monet decided to follow their example. Boudin, Diaz, and Gaudibert between them raised the fare and a little over to keep him going until he had found his feet. He crossed alone to Southampton, leaving Camille and the child under the eye of Mère Toutain, with a promise from Gaudibert's wife that she would help them if need arose. His family did nothing; no record exists of a meeting between Camille and the Monet parents then or at any other time. Nor, it seems, did Monet see his mother and father

again after leaving for England; this was his last visit to Le Havre for many years. It is possible that if he had been killed during the war his parents would have acknowledged the child. As it was, Monsieur Monet held firm to his word; he would help his son if he separated from Camille. The marriage did not soften his heart or change his resolution; he considered it as even more disastrous than the liaison. All his interest was given to his younger son, and it was through this son that Monet communicated with his parents during the remainder of their lifetime. It is also possible, though no written proof exists, that Monsieur Monet was disgusted with Claude for leaving the country; he could scarcely be expected to place art above patriotism of the conventional kind.

In his first few weeks in London Monet had hard work to survive. Then in January of the new year he met Daubigny and life took on a slightly less grim aspect. Daubigny was glad to see him and treated him with great kindness; above all he introduced him to Paul Durand-Ruel. This advanced young dealer had transferred his Paris stock in the nick of time from the gallery he had recently opened in rue Laffitte to a new gallery in New Bond Street. He knew and liked Monet's work. He at once bought one or two canvases to keep the painter going, and showed one in a French exhibition that year. He paid Monet three hundred francs a picture.

The meeting with Durand-Ruel led to a reunion with Pissarro. All three lunched at the Savoy, Durand-Ruel footing the bill. It was a happy moment for Monet and a sad one too. Pissarro brought bad news from France. Bazille had been killed in November. As for himself, he had only managed to escape from Louveciennes by the skin of his teeth and at a disastrous price. He had had to abandon all his paintings and all which Monet left with him in safekeeping when he went to Le Havre. His house had been turned into a butcher's shop by the Prussians and he feared that all their pictures would perish. With reason, for the Prussians showed their disapproval of Pissarro's art by tearing the canvases from their frames and dipping them in the blood of the animals. They laid the rest of the pictures side by side in the garden to form a path from shop to slaughterhouse. All Monet's

pictures were ruined. Pissarro was to recover only forty out of fifteen hundred. The work of many years disappeared in these few months of bestiality.

Neither London nor the English could compensate Pissarro in the slightest degree. On the contrary. "I'm here for a very short time," he told the critic and sympathizer Duret disgustedly. "I reckon to return to France at the earliest possible moment . . . it's only in a foreign country that one realizes how beautiful, great, and hospitable France is. What a difference here! One is treated with contempt, indifference, even rudeness. Among fellow painters there is the most egoistic jealousy and suspicion. There's no art here, everything is a matter of business." As for his own work: "My pictures don't catch on, not at all."

Pissarro and Monet were unfortunate to find themselves in a pro-Prussian, anti-French London. The poet Ménard was writing letter after letter to the papers to protest against the unfair reports and biased leading articles. Vainly: the English had made up their minds that the clean, orderly Prussians with their well-trained army were worth two of the degenerate little Frenchmen and could be safely trusted to rule Europe. Nor could Monet and Pissarro purchase exemption by the fact that they were peaceful painters. Far from it. With them the English demonstrated their enviable capacity for turning moral somersaults. Incapable of thinking art greater than war, their natural hostility chilled into the contempt Pissarro complained of when they were confronted by two ablebodied men painting instead of fighting. At the best of times they did not think much of the French; when they saw them acting the coward their feelings reached zero.

Neither Monet nor Pissarro could understand such an attitude. With them art came first, before country, wife, child; English moral disapproval struck them as mere boorishness. But even had the English attitude, man to man, been less hostile there would have been no hope of their work being understood, let alone sold. Decades were to pass before England could reconcile itself to Impressionist painting. Duret, joining Pissarro to escape the Paris horrors, found horrors of another kind in peaceful London. "Corot and the other great painters don't

exist for them," he told Manet, dumbfounded by English insularity. "They are where Paris was twenty-five years ago."

The London scene was another matter. Monet, in a room off Kensington, concentrated on studies of Hyde Park and the Thames, Pissarro, in the suburbs, worked contentedly round about Dulwich and the Crystal Palace. Both were "very enthusiastic" about the varying light effects obtained in fog, in snow, and, as the weeks passed, in the changeable spring.

Their visits to the art galleries were rewarding. They studied all the painters carefully. "We admired Gainsborough, Lawrence, Reynolds," said Pissarro, "but were mainly interested in the landscape painters who came closer to us in our researches into *plein air*, light and fugitive effects." Interest did not mean approval. "While they taught us something, Turner and Constable made clear in their works that they had not begun to understand *shadow analysis*. In Turner's pictures shadows are used as an effect only, a mere absence of light." As for his watercolours: "so skilful, so weak and only too often *too truthful*."

Monet, as usual, was even blunter. "This brown thing—this is your great Turner?" This did not endear him to English artists, unused to plain speaking, nor did his comment on a Turner winter scene: "Turner has painted with his eyes open for once." He objected to the "exuberant romanticism" of the English master, a quality remote from his own serene and almost scientific approach to painting.

In general these months in England were wretched for both men. They seem to have seen little of Sisley, and what they did was far from cheerful, for the war had ruined his father. They lunched once with Legros, the French painter who turned British and taught at the Slade, but he could do nothing for them against the prejudice of his new countrymen. They submitted work to the Academy but "naturally we were rejected." Durand-Ruel remained the one bright spot in a desolating sojourn. And although both men continued to work hard they were worried by the separation from their families and depressed by the bad news which continued to come out of

France. The fall of Paris and the subsequent humiliating peace terms were followed in March by the establishment of the Commune.

For a few moments the Commune promised some light relief. Courbet, radical to the last ditch, had thrown in his lot with the Communards and was rewarded with the appointment of Guardian of the Fine Arts. This dictatorial position suited the great man down to the ground and he proceeded with gusto to lay waste all the bureaucratic devices of the diehard painters. He abolished the Beaux-Arts, he wiped out the Academy in Rome, he forbade all decorations for painting, he closed the part of the Institute of France dealing with the fine arts. Finally, he condemned the Vendôme Column as bad art as well as symbolic of the bad old days of Napoleon. The column was blown up with an approving Citizen Courbet standing on a dais specially erected for the ceremony.

This defiant proclamation of the free spirit was Courbet's last public gesture. The last gesture of the Commune, for that matter. The troops of Thiers' Versaillais government stormed Paris in May and the Commune and its Guardian of Fine Arts were submerged in a welter of blood. Courbet, narrowly escaping with his life, was thrown into prison. "Dread and dismay everywhere," Duret told Pissarro. "And as for painters, you would think Paris had never known such a thing."

But even these dismal tidings could not keep Monet and Pissarro in London. Pissarro went back to Louveciennes to try to rescue what he could from the wreck. Monet went to Holland before returning home.

This first visit to Holland was the work of Daubigny whose admiration for Monet's work had been extended to the man after their weeks together in London. He had already shown his appreciation by a generous offer to Durand-Ruel. To encourage the dealer to buy some Monets he offered to replace by his own canvases any not sold. He now sent for Monet from Holland where he was painting, telling him that the countryside was made for his eye and brush. He offered to pay the fare. Monet came, met Jongkind again and was ravished by the tulip fields, the mills, the sky and water effects. He immediately

began to paint. When his money ran out the kindly Daubigny was at hand to buy his *Le Moulin à Zaandum* so that he could work on.

Jongkind made an inspiring guide. Holland under snow excelled Holland in sunshine. Daubigny, seeing the good work Monet was doing, pressed him not to hurry away. Not until the end of the year did he return to France. The Guerbois gatherings were resumed. But for a time a sense of restlessness pervaded them. Paris was a shadow of itself. Pissarro, moving to Pontoise, was soon joined by Guillaumin and Cézanne, who had just had a child by Hortense Fiquet. Degas visited America. Manet went off. All except the true Parisian, Renoir, at one time or another felt the after-war fever of movement.

One of Monet's first actions was typical of the man who did not deny his debts. Courbet was still a prisoner. Condemned to death, he had been reprieved at the last moment but had been seen by none and sought by few. A widespread witch hunt was raging, and, fearful of seeming a Communard sympathizer, the painters who had praised him to the skies in safer days now ignored him. Boudin, meeting Monet in Paris in the last days of 1871, spoke of the old master. They agreed to try to reach him. A few days later, at the beginning of January, 1872, Boudin managed to get a letter to him. "We don't want more days to go by without sending you a reminder in the depths of your prison of the devotion of friends more or less happy. If this feeble witness to our friendship diverts you in your solitude for a few moments we shall be satisfied. Only just back in Paris after a long interval, we hope to be able to shake you by the hand . . . We console ourselves by thinking that your term of captivity will soon be over and that you'll come back to art and to your friends."

Courbet, touched, replied with a warning that he did not want to compromise anyone by a visit to "a man who has been seven months in solitary confinement—and that's no light matter." He was, he told them with a touch of his old manner, in a nursing home in Neuilly where, "after having escaped the firing squad I have to undergo an operation by Doctor Nelaton who will certainly do his best to carry out the work of the postponed execution." But he could not keep it up: "I can't live like this. I suffer without break and I can think of

nothing. So do come to see me one day, you will give me great pleasure. It will be fine to rediscover my friends. Come with Gautier, Monet and"—a flash of the past escaping—"the ladies too if their hearts move them."

The three faithful ones went to Neuilly. Courbet was boisterously glad to see them. He was painting fruit, he told them—that was all he was good for. As Guardian of Fine Arts he would have revolutionized painting in France, all his friends would have been judged on their merits. But . . . And he shrugged thin shoulders.

This harrowing duty over, Monet was lured once more to Holland, to paint it under snow and to record the first of the tulips in flower. He worked hard and well, making one canvas after another. Then, satisfied at last, he returned in summer to a France beginning to find its feet. He went down his beloved Seine looking for a suitable place to settle, found a cottage by the river at Argenteuil and rented it. Camille and little Jean, then five years old, joined him. He settled down happily to work.

At this moment, when the reinvigorated Monet, sure of himself as never before, began the most brilliant productive period of his thirty-two years, Courbet left France. He had escaped the surgeon's knife only to fall under a military court. He was exiled. He went to Switzerland. None but the three visitors to Neuilly saw him go or gave him a thought. Courbet was a forgotten man. A new era in French painting was about to begin. It was no more than justice that one of the three faithful ones should be a moving spirit in this great period.

Chapter 12

The Group Takes Shape

1872 - 1874

THE YEAR 1872 SAW THE BEGINNING OF A REMARKABLE REVIVAL IN
France. Recovering rapidly from the first shock of defeat, the nation
roused itself and turning firmly from war as a means of glory, the
French people marched forward as one man in the pursuits of peace.
They paid off the brutally heavy German indemnity with unexampled
speed. They developed their country in every direction. The peasants
cultivated more land; industrialists built railways and factories; roads,
stores, shipyards hummed with activity; Paris became lively, rich,
fashionable, and once more the artistic centre of the world.

The painters benefited from this resurgence of France. They too
were moved by the feeling of hope which spread through every
section of the country. Their work was the antithesis of war and,
with war out of favour, came into its own. Never before had pictures
been bought and sold in such quantities, even in France. There was
soon plenty of money to spend and the men who were making most
of it, the *nouveaux riches,* sought to acquire and decorate sumptuous
homes. This being France, the decoration had to include original
paintings. Nor was this all. As no man could attempt to climb into

society without a knowledge, however superficial, of painting and painters, the *nouveaux riches* took up the collection of pictures as a social asset as well as a profitable speculation.

Monet entered this period of national prosperity and hard work at a peculiarly apt moment. He was thankful to be back in France and with Camille and Jean. He sensed the new spirit and was influenced by it. He did not need example to make him work, he who had worked for years without reward, but the possibility of recognition acted as spur. Financially he was scarcely a sou better off. He remained, like all the Batignolles painters, either unknown or disliked. But the wartime experiences had brought one great gain; he had met Durand-Ruel. The dealer appreciated his work (he paid him fifty per cent. more for his canvasses than for Pissarro's) and had faith in it. He kept and showed it although he could not sell it. He passed the word round, used his growing reputation as the brightest young dealer in Paris to try to acclimatize his customers to the idea of the new painting.

All this spade work for the future he was able to do because of the after war boom. He made money hand over fist, like all the picture dealers, by selling mediocre work. Unlike others he used it to buy the canvases and encourage the aims of the painters he really believed in. Quite soon, prompted by Pissarro and Monet, he met and bought the work of Sisley, Degas, Manet, Renoir. He had become, before ever the word Impressionist was heard, the Impressionist dealer. His gallery always had its little display of Batignolles painters. Few ever sold but they were seen, they could not be escaped.

The knowledge that Durand-Ruel was behind him gave Monet a much needed sense of security. He knew that the dealer would not let him starve if he could help it. That was all he needed to know; his tastes remained simple. With him the mind was almost all.

And this comforting knowledge came to him at a moment when, as painter, he felt a new power. The return to France and his family, the support of Durand-Ruel, all these things contributed to this awareness of his yet they did not fully explain it. Something must be put down to the work in new surroundings, in London and in Holland.

129

But when all is said, the mind of the artist is incalculable, inexplicable. A time comes with the true artist when he throws aside doubt, when he knows himself. This time had come for Monet. He had never lacked confidence but up to this moment confidence had been difficult to disentangle from the cocksureness of a strong character spoiled from birth. Now he attained self-knowledge. He knew that he was a fine painter. He knew that his role was to lead.

The change was felt immediately by all the fellow painters he met again in Paris. "He seems to have a strong determination to make a position for himself," Boudin told Père Martin. "He is settling down nicely, has brought some very beautiful studies from Holland and is destined, I believe, to play one of the most important roles in our school." At the Guerbois, where the gatherings had come back to normal, Boudin's opinion was a general one and Monet began to assert himself. Hitherto he had sat in the background with Pissarro and the other landscapists. He had not been idle. He and Pissarro had gone some way to hammer out a theory of painting. But he had let Manet and Degas do most of the talking. Now, without shedding his deference to the elder man, he took a firmer and more positive line. He did not hesitate to speak when he felt sure of his ground, and he was heard with attention, almost with an involuntary respect. All knew of his struggles and sufferings. He alone had refused to compromise, he had painted on in his chosen way regardless of comfort, food, future. And now to this knowledge was added that sense, which everybody recognizes without a word said, of a man having found himself. Manet's manner began to change, and Degas, though he did not care for Monet's work or his bluntness, turned his witticisms elsewhere. The rough diamond who used to walk in, as one of them said, "like a breath of sea air," could no longer be accepted as a talented but inarticulate countryman. He could no longer be explained away as the leader of a few promising young painters. He had matured, he was a figure. A portrait painted this year by Renoir shows this strong personality. He sits at a table reading. A pipe is held by strong white teeth, the broad brow is firm, calm, determined, the whole square, bearded face breathes power and certainty. He had

always been handsome. Now he had become something of much more moment, a leader of men.

This change came at a vital moment. The disappearance of Courbet immediately elevated Manet to the unquestioned leadership of the progressive painters. The Batignolles group had up to then been regarded as a kind of exaggerated off-shoot of Courbet. Now, though it and its theories were still detested by the conventional painters and critics, it was becoming difficult to dismiss with a laugh. Wherever painting was discussed one heard talk of it, as absurd, as disgraceful, as a monstrous aberration of art—this and its implication too, that it was a power. All outsiders placed the source of this power in the hands of Manet. Ostensibly they were right. His was the name and experience, his the colourful figure, his the words which were easily repeatable. Yet at this very moment Manet was beginning to realize the new force in the counsels of the big, dark, immovable Monet, and his companions were sure of it. Manet would always be the showman of the group—no one doubted that. The cool common sense and the wealth of Degas would always sway argument. The ardour and selflessness of Pissarro would always carry weight. But in the next year or two the suspicion grew that the true moving spirit was none of these but the quiet, dour man who sat strongly in his seat puffing his pipe and looking steadily ahead with those remarkable brown eyes.

One outstanding sign of the postwar years in France was the high spirits of the people. Never before had a defeated nation been gay, yet a hectic gaiety was the predominant mood. The French were not only working hard and making good money, they felt the need to celebrate the disappearance of Louis Napoleon and the old policy of war and conquest. The thought of years of peace and plenty after years of regimentation and fear spread a sense of exhilaration over the country. Everywhere, and in Paris most of all, one met happy people; the streets and cafés were filled with them, the dancing halls, the circuses, music halls and theatres.

A nation gets the art it deserves, for art is a mirror of the people.

The paintings of Monet, Pissarro, Renoir, Sisley were happy paintings. They might have been made for this moment with their entrancing blend of serenity, high spirits, and perception of beauty in everyday life.

So the times were themselves preparing the way for the reception of an Impressionism which officially had not yet been born. Was there anything in the world that was not paintable? the men of the Guerbois asked themselves. And the answer, in the full spirit of their age, was a triumphant No.

The work of Monet accorded outwardly with the new spirit abroad. For him too these years of 1872 and 1873 were to be in many ways the happiest he had ever spent. He was still very poor but Durand-Ruel had relieved him of his worst worry. He and Camille no longer had to wonder where the next meal was coming from nor, if they were given a piece of meat, how they would get fuel to cook it. They no longer went cold, nor had helplessly to watch little Jean blue-fingered and shivering. They no longer waited for the post in a fever of hope and dread, nor when the postman passed without calling had they to summon every ounce of courage and cheerfulness to wait for the next day. And when a knock came at the door they no longer hesitated to answer, fearing to see a creditor with a dunning letter or a bailiff to carry away their furniture. All this had gone. They could live simply and in hope. Monet could paint in the certainty that his supply of paints would not run out, he could use a fresh canvas when he wished and was no longer forced to scrape old ones.

The change, the contentment, was reflected in his work. Canvas after canvas of the Seine countryside and people conveys peace, harmony, beauty. And his view of the people, as integral parts of the landscape rather than disturbing factors agitating it, was also correct in spirit as it was a true impression of himself as painter.

Drawn to this strong man who knew his way and would not deviate a hairsbreadth from it, Renoir came down as he had come to Bougival. Again he practically lived in the little Monet home, exhilarated by the quiet happiness there. He and his host again painted side by side identical scenes: the exquisite *Prairie* and *Pavots Sauvages* with Camille and her son wandering in the field of poppies near the

cottage, and *La Canardière*, with the brood of ducklings on the pond at the back of Monet's garden, are among their most famous canvases, painted at the same time and from the same angle. And in the garden they made pictures of another kind, Monet making a study of the garden and cottage while Renoir painted him at work.

These pictures are not only charming in their own right; they illustrate perfectly what kind of man Monet was. For while moved to paint what he saw about him, and to express his happiness, he was not content to paint as he had painted in the past. Always he demanded and after a struggle found some extra refinement to bring his finished work closer to the ideal he had formed in his mind. In these years he and Renoir, who adopted his improvements with enthusiasm, painted pictures even more impressionistic than those of Bougival days. They used still smaller brush strokes, mere commas of colour dotted over the canvas. They abolished all bounding lines, abolished all solid masses of colour or heavy strokes of the brush.

For Monet had another and more profound aim than to prove Pissarro's dictum that colour is form. He wanted to reproduce his sensations on observing the scene. And such was the delicacy of his eye that he did not see solid forms alone, nor the more obvious natural features such as sunlight and shadow. He saw the air which surrounded the forms, impinged on them and gave them colour, life, and movement. And he painted this air. He acknowledged no division between air and so-called solidity. To him the shape of things was formed by this ever-changing atmosphere. By this delicate, evanescent technique of tiny brush strokes he succeeded in capturing light itself—or, to be precise, the vibrations of light—and so put on to canvas for the first time a scene as it really was at one particular moment of one particular day and could never again be. As he saw it the subject of a picture— a house, a tree, a figure—was in truth never twice the same because it depended on and included elements which the ordinary person never even thought of and the ordinary painter never even saw. And he was after the truth and would be satisfied with nothing less. In these Argenteuil canvases he at last realized his dream. He became the first great Impressionist.

These successful experiments were carried to the Guerbois where Monet's aim and his method of attaining it caused lively discussion. It formed the first plank in what was soon to be known everywhere as the Impressionist doctrine: sensational truth captured by the use of pure colours applied in dashes and dots. To this Pissarro added the division of tones and the juxtaposition of complementaries—for he at Pontoise had been experimenting too—and the "scientific palette" of the Impressionists was perfected.

Manet, who was absorbed by Franz Hals after a visit to Haarlem, pooh-poohed these experiments. Degas, the great exponent of line, looked down his nose at them. But these two were in a minority; Monet and Pissarro carried the day.

Monet, flushed with success, called for a group exhibition, reviving the old idea of 1867. He insisted that the Salon be ostracized and that they go their own way backed by Durand-Ruel and the one or two men of moment Durand-Ruel had managed to interest, notably the famous baritone Faure, and the rich cashmere merchant Hoschedé. He won his point. All but Manet and Renoir did not submit pictures to the 1872 Salon. In 1873 Manet alone was to be seen in the Salon, furious at being "left in the lurch."

His anger was not entirely appeased by the success he gained there. For the first time he was widely acclaimed as a fine painter. This, he asserted vigorously at the Guerbois, was proof that, if one stuck to the Salon, success and sales must come. His argument convinced none. For the acclamation had not come from the men who had always supported him in the past but from the conventional critics. And the picture which had created such a sensation was a retrograde affair. *Le Bon Bock,* a portrait of the engraver Bellot sitting before his glass of beer at the Guerbois, was influenced to an almost laughable degree by Manet's temporary enthusiasm for Franz Hals. If that was the only way they could secure success at the Salon, by going backwards, Monet and Pissarro argued, then they would keep out of it. Manet's success proved all the more the need for a private exhibition of their group.

Two events strengthened their stand. In 1873 Durand-Ruel pre-

pared for publication a large and sumptuous catalogue of his pictures. The catalogue, in three volumes, contained reproductions of all the painters, except Renoir, soon to be known as Impressionists. It was introduced by a well-known young critic, Armand Sylvestre, often seen at the Guerbois. In his introduction Sylvestre tried to show that what uninformed people thought of as a detestable revolution in painting was in fact a logical development of the work done by Delacroix, Courbet, Millet, and Corot.

This attempt to make the revolutionaries respectable seemed to them a good omen for a public appearance. If Sylvestre stretched his argument a little, his comments on the main painters were sound enough and unlikely to frighten the reader who had been led by hostile critics to think of the Batignolles group as some kind of collection of wild beasts determined to bring French painting into disrepute. Of the three leading landscapists of the group he said: "Monsieur Monet is the most skilled and the most daring, Monsieur Pissarro the most genuine and simple, Monsieur Sisley the most harmonious and hesitant."

Sylvestre also pointed out the pleasures to be had from looking at this painting: "It is above all harmonious. The means of attaining this harmony are very simple ... a very delicate and very exact observation of relationships of tone." And he put his finger on its great charm when he said that "their pictures are painted in a particularly cheerful way. They are flooded by a golden light and everything in them proclaims gaiety, pellucidity, the very spirit of Spring."

His placing of the three landscapists, two of them the leading spirits in the plan to exhibit, was emphasized by one, Pissarro himself. His friend Duret, though admiring the new painting, thought with Manet that the Salon remained the best road to success. He tried to persuade Pissarro of this but tactlessly played on the jealousy popularly supposed to exist between artists. Knowing that Monet was at the bottom of the agitation for an exhibition, he warned Pissarro not to let himself be influenced unduly by that strong-minded man. "You may not have Monet's imaginative eye," he wrote, "but you have what he and Sisley lack, an intimate and profound feeling for nature ... Don't

think of Monet or Sisley, don't worry about what they are doing, go your own way." Unable to let it go at this, he went on to criticize Monet's work. The generous Pissarro burst out with a "Are you sure you aren't wrong about Monet's gift, which to me is very pure, very serious? His is a highly conscious art based on observation and springing from a feeling new to painting. It is nothing less than poetry expressed through the harmony of true colours."

As this rebuff indicated, Pissarro knew the value of Monet's work as well as, and better than, Sylvestre and was as keen as he to form a group exhibition. The Guerbois talks went on, heated at times, with a sulky Manet, an ironic Degas, a disapproving Fantin-Latour and a lofty Guillemet who, steadily making a name at the Salon as a classical painter, was beginning to cut short his visits to rue de Clichy. Zola, who had begun to write the novels which were to make his name, also kept away and said little when there.

All the rest were strongly in favour of a group show. Enthusiasm rose when, in the first month of 1874, Hoschedé held an auction at his department store of pictures by Monet, Pissarro, Sisley, and Degas. The pictures fetched, for then, high prices. This the painters chose to take as a sign that public prejudice was abating. If customers at a store would buy their canvases, why not visitors to an exhibition at a proper gallery?

Any remaining doubts, including the many reservations of Degas, were removed suddenly a month later when Durand-Ruel went into liquidation. The after-war boom had been followed by a slump. This, though temporary, caught Durand-Ruel at an unhappy moment. Unlike the ordinary dealer, he was more enthusiastic than businesslike, and his passion for the progressive painters led him into trouble. He had spent a great deal of money making a collection of their pictures—he bought, for instance, no fewer than twenty-three Manets at one time for 35,000 francs—and lost many customers by his likable but unwisely fervent recommendation of the moderns. The withdrawal of these customers and the tightening of credit caused by the slump momentarily forced him out of business.

His support abruptly withdrawn, almost all the Guerbois painters

found themselves back where they had started. They had a few more sources of possible sales than before, that was all. They had absolutely no guarantee and not a great deal of hope of selling another picture.

Faced by ruin and all the agonies of the prewar years, they acted. The first Impressionist exhibition was arranged.

Chapter 13

The Impressionists

1874

It was one thing to agree that an exhibition should be held and quite another to agree how, where, and in what conditions. The only firm point of agreement was that the show should open just before the Salon. For the rest, the six-man committee that was informally set up had one struggle after another to abolish differences of opinion. The committee consisted of Monet, Pissarro, Renoir, Degas, Berthe Morisot, and Sisley.

The main stumbling block to unity was the composition of the exhibitors. Degas, whose connection with Impressionism was tenuous to say the least, wanted the show to be made as respectable as possible. To do this he proposed to invite several well known Salon exhibitors.

Monet and Pissarro wanted to restrict the exhibitors to those who believed in their new doctrines. They opposed Degas' suggestion vigorously, suspecting with some reason that he was more than a little reluctant to surrender himself, alone, to the tender mercies of painting's wild men. They asked, what point would there be in holding an exhibition without some unity of purpose?

Monet's idea had been to give an exhibition respectability in the

public eye by including older and well known sympathizers, Courbet, Corot, Daubigny. This plan had been killed by the development of the Impressionist technique. The disgraced and exiled Courbet had become a liability as supporter and Courbet had to be forgotten. Daubigny disliked the work of many of Monet's associates, Degas especially. Corot had become actively hostile. "You've done well to escape from that gang!" he told Guillemet when he heard about the exhibition.

Manet, whom all wanted, remained resolutely apart. "Why don't you stay with me?" he said again and again to Monet. "You can see for yourself that I'm on the right track." He added, as additional reason for keeping away, "I'll never allow myself to be shown with that *farceur* Monsieur Cézanne."

His most powerful reason for refusing to lead the revolt was, however, one that he could not explain; this man about town took a sombre, almost morbid view of life. He could not always keep this view out of his work. In his speech and actions it was never allowed to obtrude. But in his heart it was rarely absent and forced him to dismiss his fellow painters as triflers, preoccupied with surface impressions only. He talked about technical differences, he really meant a difference of outlook.

Cézanne almost broke up the whole exhibition. His champion, Pissarro, stated his case eloquently. The committee listened unimpressed. Monet was not enthusiastic, the rest objected strongly. Not only was Cézanne a difficult man, veering between the silent and the stormy, his work was violent, hard to understand, the work of a man still struggling to find himself.

The arguments went on. They were settled finally by two facts with which none could argue, time and money. They were approaching the latest possible date for an exhibition that year and they had found a place in which to exhibit. Nadar, the photographer, one of the Guerbois habitués, had just left his studios on the Boulevard des Capucines and offered them rent free.

The problem of ways and means remained. Only Degas and Berthe Morisot had money to spare after the retirement of Durand-Ruel.

Monet, Pissarro, Renoir were all struggling as in prewar days to keep their heads above water. Degas put forward as additional reason for the invitation of his academic painter friends the unassailable fact that the larger the number of exhibitors, the less each exhibitor would have to pay.

Chagrined, the almost penniless Monet and Pissarro had to abandon their principle of Impressionist painters only. They consoled themselves by insisting on their own nominees. Monet brought in Boudin in an effort to repay the debt of years. Pissarro fought with renewed vigour, and an excellent argument, for Cézanne and the less strongly opposed Guillaumin. If they were to admit right wing painters, he said triumphantly, they must admit the left wing Cézanne as balance. He had his way.

The exhibition opened on April 15. The committee had been unable to agree on a common name; the exhibition was therefore given the cumbersome title of *Société anonyme des artistes-peintres, sculpteurs, graveurs etc.* But no title could have saved it. There were thirty exhibitors, most of them "respectable" friends of Degas, showing a total of 165 works. Of these, only fifty-one belonged to the Batignolles painters proper, but it was on these that public and critical attention fastened. Degas' attempt to distract or soften criticism by inviting his friends failed completely. The general fears about the admission of Cézanne proved only too correct.

From the moment the doors were first opened, the scenes in Nadar's studio revived memories of the notorious Salon des Refusés eleven years earlier. The place was invaded by hysterical crowds come to see the latest joke of Paris; each picture was surrounded by groups of people pointing, mouthing, screaming with laughter. One bright journalist explained that these painters of the Batignolles group had discovered a simple method of filling their canvases: they just loaded a pistol with paint and fired it at the canvas point-blank. His witticism caught on famously. The whole city repeated it.

Cézanne was the chief sufferer; his three exhibited canvases were mocked to the skies. But none of the friends soon to be known as

Impressionists escaped. Scorn and contempt mingled with asinine comment fell on all who had organized what an American visitor reported as a "highly comical exhibition." Among Monet's five paintings were his masterly city scene, *Boulevard des Capucines*, and *Le Déjeuner*, the charming interior done some years before at Fécamp. Both were described by this same critic as "two of the most absurd daubs in that laughable collection of absurdities." Nor were French critics any more discerning or, to put the matter correctly, less prejudiced; they came prepared to find horrors and they saw horrors. Another of Monet's canvases was the exquisite *Pavots Sauvages*, a dream of summer painted with much technical skill. Of this, as of his other work, one of the best-known critics of the day could say only "Monsieur Monet—a more uncompromising Manet—seems to have declared war on beauty."

A painting by Monet, *Impression—Soleil Levant*, made in the port of Le Havre two years earlier, gave the Batignolles group the name which has gone into history. One of the critics facetiously fastened on this title, and dismissed the whole group of exhibitors with a contemptuous "These Impressionists!" The name stuck despite the protests of the painters. And rightly, coined in malice though it was, for it expressed what Monet and his followers were trying to do even though conveying no idea of the full charm of Impressionist work; the delight in everyday things, the feeling of peace and happiness, the high degree of technical and inventive skill. And soon, shrugging shoulders, most of them accepted it.

Not one picture was sold at the exhibition. Monet, Pissaro, Renoir, Sisley, bereft of Durand-Ruel, faced a new future of hardship. There seemed to be no hope.

But there were no complaints. "What I have suffered is beyond words," wrote Pissarro. "What I suffer now is frightful, much more than I did when young and filled with passionate enthusiasm. For now I'm convinced that I've no chance in the years to come. But all the same if I had to begin all over again I don't think I should hesitate to follow the same path."

This was written four years later—so long was this new purgatory

to last—but it represented exactly the attitude of all. At the Guerbois the exhibition was talked over a thousand times. Suggestions poured in. There was some hysteria. In the midst of all Monet remained imperturbable. The man was like a rock. He said simply that he would paint on, that they must have another exhibition, must force the people to recognize what they were doing, that it was good and should be supported. All present knew that Monet had no money, that he would have to leave the cottage he loved so well on the Seine, that he did not know where to go, how to support Camille and the child. They knew, but he said nothing. His few words were all encouragement.

Then, suddenly, came a most remarkable change. Manet saw beneath the phlegm of the big black-haired man who sat so firmly in his chair smoking the pipe that would soon remain empty. For Manet knew what it was to be the laughing stock of Paris. He had visited the Exhibition, he had admired Monet's work. He understood his feelings.

The work and the pluck of the man who had made it and sat there uncomplainingly brought out abruptly all the generosity in the dandified leader at the café. There and then he told Monet not to worry; he knew of a small house at Argenteuil not far from the Monet cottage. He would take it for them. He begged Monet to accept the offer. Monet accepted, not turning a hair.

Nor was that the end of the marvel. Berthe Morisot, who was to marry Manet's brother, defended landscape painting in general and Monet in particular. She told her future brother-in-law that he had no right to condemn unheard. Why did he not see for himself how this kind of painting was made? Her words went home; they were, unknown to her, perfectly timed with Manet's admiration for Monet's stubborn courage. He said to Monet, diffidently for him, that he would like to come down that summer and watch him at work: did he mind? Monet said, "Come."

And that August he came. Monet had bought a small boat the previous year and, with Daubigny in mind, had built a shelter over one half of it. There Camille could rest out of the sun or cold wind

while he—and often Renoir too—set up his easel at the other end and painted river scenes. This studio-boat, as Monet called it, tickled Manet's fancy. He would not be satisfied until he had painted Monet at work in it. He did so, not too seriously, but his treatment of the water was suspiciously akin to Monet's impressionist technique.

Then followed a series of garden groups, Monet, Manet, and Renoir, who had come down to share in the great man's presence, all making one canvas after another in the leafy cottage garden by the river. Manet made a study of Camille and Jean sitting under a tree with Monet gardening in the background. Renoir followed suit, much to Manet's disgust. Looking out of the corner of his eye at the happy-go-lucky young man who had borrowed Monet's paints and brushes on the spur of the moment, he from time to time, as if by some kind of horrid impulsion, walked over to the canvas. He stared at it, then turned away with an imperfectly concealed grimace. He went over to Monet, busy with his watering can, and whispered, gesturing toward Renoir who was busy chatting to Camille as he painted, "That boy has absolutely no talent. You're his friend, for goodness sake tell him to give up trying to paint."

He was no better pleased when Renoir, having rapidly brushed in the portraits at a sitting, announced that he had done, gave the canvas to Monet and was off, whistling. How much of his disapproval was genuine dislike of Renoir's work, how much dislike of his attitude toward painting, remains a question. Certainly vanity played a part. He had not forgotten Renoir at the Guerbois; at the height of an anecdote, the attention of the company seemingly riveted on him, he would catch sight of the young man sardonically smiling and tracing none too polite sketches on the marble table top with a burnt match.

Monet, who had given up watering to make a study of Manet at work on his group, would shrug broad shoulders at the complaints of his impulsive friend. The weather was fine, the garden lovely, the river a dream of delight, they were painters together, they had a superb model and hostess—the shrug said all that and more. And if Manet remained sour, there was always one certain remedy, a trip down river in the studio-boat.

All were, in short, happily occupied, the growls of Manet at Renoir notwithstanding, and all made study after study of Camille. Her delicate charm, her ability to wear every kind of garment with distinction, the fine head carriage, the perfection of figure—all this made her a model in a million. Her husband had painted her time after time, year by year. And not simply, as is so often the way with men who marry models, because she saved the hard-to-find model fees. He had a better reason. He who so rarely painted the figure, preferring pure landscape, was drawn again and again to make her portrait. Being Monet, his eye saw her always as an integral part of her surroundings, but she played a part in his work which no other person played.

For Renoir she was the perfect model and the perfect hostess. He could come and go when he wished, he was greeted always and made welcome. She would pose almost indefinitely with no more than the slightest moue of protest when she tired. This year, with the renewal of the struggle to live, she looked tired for the first time. In one of his canvases Renoir portrayed this first suggestion of haggardness, the first hint of the future. But neither he nor Monet thought it was anything more than weariness from an over-conscientious attempt to keep still when posing for long periods.

Manet had respected Monet enormously at the Guerbois after the failure of his exhibition; his respect turned to affection when he saw him the strong centre of a loving family. Even Renoir, though Manet was more convinced of his inability to paint the more he saw of him, even he took on a certain charm in the Monet home. Manet could not drag himself away. His few days lengthened into weeks. What had begun in joke ended in seriousness. Before at last obliged to keep a promised appointment in Venice he had become an Impressionist painter. The day arrived when Monet, standing behind him on the river bank, saw with quiet amazement that this great man of the Guerbois was painting an Impressionist *plein air* canvas. There were Camille and little Jean by the river's edge, there the yachts at anchor painted so often by Monet and Renoir, there the blue-green water. His *La Seine à Argenteuil* was a fully-fledged Impressionist picture; more brilliantly rendered than Monet's and with greater contrasts, but

with a technique similar in essence. He had not the strength or luminosity of Monet, whose canvases of 1874 were brighter, richer, and more powerful than ever, but he had in those few weeks and at the age of forty-two become a more versatile painter.

Nor was the effect of this visit to fade when he moved out of Monet's immediate influence. He never became a convinced *plein-airist*; he stopped mocking the landscapists though remaining attached to studio work. As always, he painted in a variety of styles, but he came back again and again to Impressionism and his last canvas, *Un Baraux Folies-Bergère,* was to be one of the greatest of all Impressionist pictures.

Of more immediate importance to the struggling Impressionists was the change in Manet's attitude. The change was in the attitude and not in the man; only the greatest of men can change heart in middle age and Manet was not of this calibre. He was won over to admiration for a moral courage he himself did not possess. That was one great gain. He was won over by example to practise, in his way, a form of painting at which he had scoffed. That was a second good thing. But his overmastering ambition remained as ever—the winning of state honours. This neither Monet's courage nor his painting could dislodge.

So Manet refused to join in their plans for a second exhibition, fearful of compromising himself in the eyes of the world by public association with pariahs of art, and still secretly thinking Impressionism trivial, as witness the ease with which he had copied it. He continued to send his work to the Salon in the hope of being hailed as a modern master by critic and public alike. But he no longer tried to dissuade the Impressionists. On the contrary he did all that he could, privately, to help them. He even went as far—a remarkable gesture from a man of his pride—as to hang one or two of their canvases in his studio alongside his own, giving them a chance to be seen and perhaps bought by his many visitors.

Chapter 14

Fight for Survival

1874-1876

THE BOATING TRIPS, THE CHEERFUL PAINTINGS IN THE MONET GARDEN thinly covered the fact that all the original Impressionists—the four landscape painters—were living on a knife edge. Not insensibility but courage and a profound persuasion that their work was right drove them on in the face of one obstacle after another. They had been reviled, ridiculed, denied a living: no matter, they would laugh as well as paint. It was no wonder that Manet marvelled and dropped a facile sarcasm.

Pissarro, absolutely without money, had to leave Pontoise and live with his wife's family. There he had to endure daily reproaches from his wife and her parents: why continue this useless painting, why teach his children to follow his example? Sisley, married, with two children, and with parents now as poor as he, dragged out a miserable existence at Louveciennes. He, like Pissarro, continued stubbornly to paint impressionist pictures and to buy paints and canvas rather than enjoy a square meal. Monet was dependent on the gifts of friends. Of the four only Renoir made a little money, for only he abandoned landscape from time to time to paint figure studies which he managed to

146

sell for pitiful sums. The position was summed up by Boudin, back on the Normandy coast, when he told Père Martin: "One needs a stiff dose of courage to keep on wielding a brush in these days of neglect and indifference."

But help was on the way, though it was to be agonizingly slow in taking effect against the massed opposition of public and critical opinion. It began, suitably enough, in the boat which Monet continued to sail and work in. When he first began to construct this studio-boat he attracted the attention of a neighbour. This man, Gustave Caillebotte, was a maritime engineer by profession but by inclination he was yachtsman, amateur gardener and painter. In person he was small, thin, and shy, living with his mother and meeting few people.

Caillebotte had noticed the sturdy Monet painting by the river and had seen him working in his garden. He was lonely, several years younger than the thirty-four-year-old painter and was attracted to him by the bluff confidence he so much lacked. He did not manage to pluck up courage to speak to him until he saw Monet at work on the studio-boat, just beginning to plan the deck cabin.

This was so much Caillebotte's province—he owned and had built several yachts—that he offered his help without a tremor. The resulting greeny-blue structure in which the Monet family could eat and sleep, and which became a familiar sight on that reach of the Seine, owed much to Caillebotte's advice and active assistance.

By the time the boat was done the men had come to know each other pretty well. Caillebotte, already drawn to Monet, was further impressed when he found that they had so many interests in common. They began to sail together, they talked over their gardens and they discussed painting. Caillebotte fell immediately under the sway of the strong painter who made works of such calm beauty. He did not question the impressionist technique, he admired instantly and begged Monet to instruct him. He was a promising painter, learned quickly, and was soon painting with Monet on the river.

The two men fell gradually into a close friendship. When Renoir came down—and not many a week passed without his descent from

Paris—Caillebotte took to his birdlike charm and much admired the way in which he would brush in a painting in an hour or two of intense enthusiasm and the careless way he would put it aside, his impulse exhausted. The contrast with Monet's deliberate, unresting, wearing-down application to a painting was piquant. Monet, too, painted quickly, but with a care that the careless Renoir knew nothing of. It was the hare and tortoise all over again; though Monet took pains undreamt of by his volatile friend, he painted incessantly and his canvases were often finished first.

Renoir was good company afloat, and many a day the three men went off in one of Caillebotte's yachts. Even the melancholy Sisley, on his rare visits from Louveciennes, appealed to Caillebotte's tender heart. For the condition of the painters could not be concealed from sympathetic eyes. Caillebotte, delicacy itself, did not like to offer them money. He was afraid of wrecking the new friendships he so much prized. He decided to make a collection of Impressionist pictures. Typically, the canvases he chose were not those he most liked but the ones he feared his friends would have most difficulty in selling elsewhere, the more advanced works.

This gesture delayed the destitution into which Monet and Sisley were falling, but could not obliterate it. The prices paid were moderate, the painters not wishing to ask much from a friend. Despite the appearance of Caillebotte as the first admirer of Impressionism, the remedy lay elsewhere. Somehow the attention of the public had to be gained. There were no funds for the holding of a second exhibition. Early in 1875 Renoir proposed that the three of them should put a collection of pictures up for auction at the Hotel Drouot.

Berthe Morisot, hearing of their decision, offered to put in a number of canvases. She admired the work and the courage of Monet and was indignant that a fine artist should have to beg for a living. She did not need money, though she could not afford to lend it, but she hoped that her presence in the auction would soften criticism. Her work, though Impressionist in theory, was nearer the conventional paintings approved by the public.

Manet also tried to help; he wrote to the most powerful critic of

the day, Albert Wolff of *Le Figaro,* who had shown little mercy for the Impressionists, asking him to notice the auction.

Phillippe Burty wrote an introduction to the catalogue, praising the work in general terms and trying to interest speculators by suggesting that for a modest price they could acquire canvases which would probably give a profitable return after a few years.

His "probably" was, as matters turned out, one of the understatements of the century. Unhappily neither he nor the collectors who attended the sale really believed for one moment that these despised daubs could ever become sought after. And Wolff, who obliged Manet with a notice, also added his "perhaps" which he immediately killed with a waspish: "The impression which the Impressionists manage to give is rather like that of a cat walking over the keyboard of a piano or of a monkey playing with a box of paints."

There was never much hope that the auction, held toward the end of March, would bring in much money. But no one suspected that it would arouse such high feeling. Duret was there, Caillebotte and Durand-Ruel, the first two in the hope of pushing up the prices a little by throwing in some bids, the last as watcher and well-wisher only, for to his chagrin he had not a sou to spend on his chosen painters.

It was he who afterwards described the chaos in the auction room. Most of the audience consisted of diehards prepared to go to any lengths to oppose modern painting—the forerunners of the mob who were to create the scenes at the Picasso-Matisse exhibition in London many years later. These men howled down every attempt of the few buyers to make a bid. When the bidders, determined not to be intimidated, moved closer to the auctioneer so that he could hear and see them above the uproar, they were set on. So rowdy did the spectators become and so threatening that the auctioneer had to send for the police.

All but the bravest of the painters' supporters were driven out of the room. Only Caillebotte and Duret and Durand-Ruel were left, with one other man, a man known to none of them. The auction became a farce, many of the bids not reaching the cost of the frames in which the canvases were fixed. At the painters' urgently whispered

request, Durand-Ruel bought back most of these low-bidded pictures. Monet, Sisley, and Renoir afterwards scraped the money together as best they could to repay him and take back their pictures. Not one picture fetched more than 480 francs, one as little as eighty. The average price bid was 163 francs. Monet's highest price was 325 francs.

The three painters made enough from the sale to keep themselves for a month or two, no more. But the pittance they had gained in cash was outweighed by the unfavourable publicity.

The riot in the sale room, largely reported in the papers, still further discredited the Impressionists. The future seemed hopeless. Yet none lost heart, and for Renoir, and soon for the others, a respite came quickly. The next morning he received a letter from that fourth, unknown supporter at the Hotel Drouot. His name was Victor Chocquet. He had bought canvases by all three painters but had been specially taken by Renoir in whom he saw something of the hand of Delacroix, the painter he worshipped. He asked if Renoir would make a portrait of his wife.

Renoir went off at once to see him. Chocquet turned out to be a customs officer who used the modest surplus from his salary to buy pictures. A gentle man, tall, with striking golden hair and beard, he showed unexpected firmness of mind when choosing pictures. He declined to be influenced by critics or by public taste. The demonstrations against Impressionist pictures left him indignant but unchanged.

Renoir, charmed, accepted the commission. He did more. The motto *all for one, one for all* might have been made for the Impressionists. Never before in the history of art had a group of men displayed such unselfishness. It was as if the communal happiness they delighted to portray—the crowds of lighthearted bathers, dancers, theatregoers, yachting parties—carried over into their lives. They were one and all determined to share pleasures as well as troubles. The penniless Renoir filling his pockets with bread for the Monet family was as typical of them all as his present gesture. For as a matter of course Renoir, as he came to know Chocquet during Madame Chocquet's sittings, took the opportunity to praise his friends. He took Chocquet to Père Tanguy, the paint and colour man in rue

Clauzel who often took canvases in exchange for paints from hard-pressed painters. There Chocquet saw and admired, a little fearfully, some Cézannes. He bought one, braving his wife's displeasure, asked to meet the painter and sat for a portrait.

Through Cézanne he met Monet. The two painters had a mutual respect for each other though they met seldom. Cézanne was to say of Monet: "He's only an eye, but what an eye!"—a saying which at the time Monet, fastening on the end of his remark, accepted with a certain pleasure. Compliments of any kind were hard to wring from Cézanne. For his part, Monet firmly maintained with Pissarro against the whole art world of Paris that Cézanne had it in him to be greater than them all.

So Cézanne brought Chocquet down to lunch to Argenteuil. Chocquet had bought a Monet river scene at the auction and was eager to meet the great landscapist. The two men got on famously. He had intended to go to the Impressionist exhibition at Nadar's studio the previous year, Chocquet told Monet. But he had for once listened to the advice of friends who reported that it was a farce. He regretted it bitterly and characteristically with a "Imagine how I feel, having lost a whole year!" And after going the rounds of Monet's canvases he burst out: "When I think that I might have known your work a year earlier! What bad luck, to have been robbed of such pleasure!"

Another admirer had appeared, one of the staunchest the Impressionists were ever to know. The outlook, however, had never seemed blacker. Their plans to hold a second exhibition that year with profits from the Drouot auction fell to the ground: there were no profits. They were instead still further in the black books of a public which refused to take their work seriously or, going to the other extreme, considered them as evils to be stamped out by whatever means. Despite the efforts of Caillebotte and Chocquet, the one limited by tact, the other by lack of fortune, all four landscape painters were faced by a year of near-starvation.

It was a question of who was worse off, Pissarro taking the unwilling

charity of his parents-in-law, or Monet who would not even ask his family for help. As with all the Impressionists, and more than most, Monet continued to defy fate with one ravishing canvas after another, always happy, always serene, always beautiful. That spring, when his hopes had never been lower, he painted what is perhaps his loveliest study of Camille sitting under a tree in the garden. She is reading a book and her flowered muslin dress billows over grass sprinkled with crocuses.

But the charming *Femme dans un Jardin, Printemps* seemed only to enrage the furies. By June he had to swallow his pride and write to Manet. "We have been without a sou for the last two days and neither butcher nor baker will give us more credit. I have faith in the future but as you see the present is utterly wretched. Could you possibly send me a twenty franc note by return? That would stave off disaster for a moment."

Manet sent the note and something more, but within a month, in July, Camille became ill—the strain had at last proved too great—and the Monets were immediately in desperate trouble. Monet tramped Paris with his canvases. The baritone Faure would occasionally do him the favour of a fifty franc note for a canvas worth ten times the price. Hoschedé listened favourably—he knew nothing of painting; his wife had spoken of Monet as a coming great man but money was tight, business not good. Everywhere else he was repulsed.

At Argenteuil, with Camille in bed and in pain, the situation rapidly grew worse. At his wit's end, Monet looked about for help. Caillebotte was away and had in any case put his hand in his pocket so often. He could not bring himself to ask Manet again. Yet Camille must get better, he must paint on. He neither saw nor looked further. And, if one of those two had to go, it would not be his work. This he knew, deplored, felt horribly guilty about, but was helpless to change. Camille accepted this dispensation of providence better than he. Like most women who live with genuine artists, she knew where his heart must be and accepted it.

Monet was soon faced with the prospect of a repetition of the scene

at the inn at Fécamp. The rent was months in arrears, the landlord adamant. It had to be paid. There was no longer any point in hawking his paintings around. Fifty francs or so—the kind of payment he got at best—would no longer help. Only a wealthy man could give the Monets a breathing space.

Degas had money, plenty of it, but Monet, even in desperation, could not bring himself to apply there. Degas did not like him. That he could accept. But Degas did not like his work; he had told Pissarro, and Pissarro had passed it on, that in his view Monet's work was no more than beautiful, clever but fundamentally shallow decoration. A decorator! Better go hungry, be thrown out of the house, even see Camille die than beg from the man who had said that.

Monet waited until the last minute, hoping that some stroke of fate would save them, then wrote to Zola. He had never been intimate with Zola who had long since dropped away from the Guerbois and art criticism. Nevertheless he believed that Zola liked his work, he knew him to have been a close boyhood friend of Cézanne, he had heard that he was making money hand over fist with his realistic novels.

He wrote: "Can you, will you help me? If I can't pay six hundred francs by tomorrow night, Tuesday, we shall be thrown into the street and our furniture and everything I own will be sold. I haven't a sou in my pocket at the moment. All the transactions I've been hoping to conclude and on which I've been counting have hung fire. It would give me great pain to have to tell my poor wife the true situation, so as a last effort I ask whether you could possibly lend me two hundred francs. Such an instalment might enable me to hold up the matter."

He explained significantly, excusing his pride: "I don't dare to ask you personally. I might very easily come to see you and never even mention the real cause of my call." He begged Zola not to comment publicly on his request, "for it is always a fault to be poor and needy."

"It is always a fault to be poor and needy." More truthful words and more damning ones had never been written. Zola knew all about

creditors knocking at the door and landlords threatening to evict. He sent the money.

Enormously encouraged, Monet worked on furiously with a view to another exhibition. Camille recovered slowly, though never regaining her strength, and somehow the year was seen through. Monet was tireless at his easel and in attempts to sell his canvases. He was more successful in this killing pursuit than Boudin, thanks to his manner, ability to bear rebuffs and the obvious strength of his work. He even found a new customer through Durand-Ruel—the rich Rumanian doctor De Bellio. But the sales were, as ever, for paltry sums, and it was hand to mouth all through the winter and into 1876 with the admiring Caillebotte rising to one crisis after another.

Monet detested dependence though he had had to endure years of it; he believed that his work was good and must sooner or later sell and sell well. He had absolute faith in it. Because of this he pressed his friends again and again to risk another exhibition. If they were once more belaboured by the press and mocked by the public, he argued, how would they be worse off? Only repetition was likely to stifle criticism; there was nothing like familiarity for bringing a public to heel.

Durand-Ruel, Pissarro and Caillebotte all agreed and the dealer and engineer both helped practically, the dealer by lending his gallery in rue Le Peletier, Caillebotte by paying a bigger entrance fee than was called for. Between them they carried their point.

The exhibition was held in April. The number of exhibitors had fallen to twenty, many of the original ones frightened off by the scandals of 1874. Boudin was one of these. One or two new ones came in, including Caillebotte, very proud to be with his great friends, and Legros whom Monet had met in London.

There were fewer scenes this time, partly because there were not so many visitors as to the first exhibition, but attacks in the press were scarcely less violent than before. La France declared that the Impressionists "are the people who choose to follow no rules, to do everything contrary to others without sparing the slightest glance at good sense or truth. They paint trees red or yellow, houses blue,

water carmine or bright red. Their figures resemble the occupants
of the morgue . . ."

In facetious vein *Le Soir* wrote: "We have been told that there is in
rue Le Peletier an asylum, a kind of successor to the clinic of Dr.
Blanche. There one meets painters mostly. Their madness is not
violent. It consists in turning out ceaselessly and at random, with a
feverish brush dipped in the sharpest and most incoherent colours,
a series of white canvases framed magnificently and at great cost."
It ended with a paragraph on Monet. "The public has stared at his
work, has laughed, has asked his name. It knows now that the man
who has had the astonishing idea of making knitted landscapes calls
himself Monet and Monsieur Monet is in a fair way to become as
celebrated as Monsieur Manet."

Le Soleil described an Impressionist as "a man who, without
knowing why, feels the need to consecrate himself to the palette;
and who, having neither talent nor the experience necessary to produce
anything serious, contents himself with beating the drum in support
of his school and in giving the public canvases which are scarcely
worth more than the wood they are framed in."

Two journals, *La Revue Politique et Littéraire* and *Le Constitutionnel*,
dealt gently but decidedly with Monet. The one began with: "It
is certain that some of these gentlemen weren't born without talent.
Monsieur Claude Monet has the strong hand and eye of the true
landscapist." It praised his *Printemps* and *Prairie* within reason, then
went on: "But the same Monsieur Monet is truly frightful in many
other canvases! He has an unhappy taste for blues and pinks which
it would be a good thing for him if he dodged. Many of his landscapes
are gaudy and flicker horribly."

The other journal said: "It would be unjust to deny that Monsieur
Claude Monet has a certain strength of colouring of which however
he makes the most regrettable use. He seems to go out of his way to
make himself disliked by all." *Le Petit Journal* said briefly: "His
seascapes are such bizarre fantasies that one wonders whether the
painter has ever seen the sea."

This kind of attack, on the group and on Monet a little more

persistently than the others—Cézanne did not exhibit this time—was summed up in the unconcealed venom of the formidable Albert Wolff. Manet's attempt to do a kindness by begging mercy from his friends' most bitter enemy merely made the enemy more virulent. "The rue Le Peletier is unlucky," wrote Wolff. "Following on the fire at the Opera a new disaster has fallen on this district. An exhibition of so-called painting has just opened at Durand-Ruel's. The inoffensive passer-by, attracted by the flags decorating the frontage, goes in, and a terrible spectacle meets his horrified eyes—five or six lunatics, one of them a woman, a group of wretched creatures seized by ambition, have gathered there to show their works. Some people burst out laughing before these things. They wring my heart. These would-be artists call themselves the intransigents, the impressionists; they take a canvas, paint and brush, throw some tones on it haphazard and sign it . . . Frightful spectacle of human vanity running wild to the point of insanity . . . One must pity these poor lost sheep; benevolent nature has endowed some of them with first-rate qualities which would have made them artists. Unhappily, in the mutual admiration of their common insanity, the members of this circle of noisy, vanity-ridden mediocrities have elevated to the height of principle the negation of everything that constitutes art; they have fixed an old paint rag to a broomstick and made a flag out of it. Knowing full well that the utter absence of all artistic training prevents them from ever crossing the gulf between an effort and a work of art, they barricade themselves behind an insufficiency which equals their self-satisfaction. Every year they come back before the opening of the Salon with their disgraceful oils and water colours as a protest against the magnificent French school which has been so rich in great artists."

This outpouring of bile from the foremost critic of the day fairly, or unfairly, states the case against the Impressionists. Voices were raised this time in favour of the rebel painters, but they were the voices of known sympathizers, Castagnary, Sylvestre, the poet Emile Blémont, and carried no weight. Of all the painters Monet suffered most. The fact that he had been repeatedly rejected at the Salon while his companions got in was commentary enough on the official and

public view. Today his pictures may seem the reverse of difficult.
But given the age-old fear of novelty, which the Impressionist painting
certainly represented, it is plain that Monet—always with the ex-
ception of the absent Cézanne—must arouse most bitterness. The
work of Renoir, Sisley, Pissarro possessed obvious appeal even to
an audience of that day. Degas' satirical eye was balanced by his
undeniable mastery of line. Monet alone was strong and uncom-
promising. "I paint as a bird sings," he once said; and he would paint
no other way. What that great eye saw he put down. No allowance
was or could be made for the man whose eye did not see so far or so
minutely. Monet demanded an imaginative effort of appreciation
and this none but a friendly critic or two would attempt to give. He
was condemned out of hand by the huge majority of men who looked
at pictures and, even more vital for him then, who bought them.

However, though the most abused painter of this Impressionist
exhibition, he was by a strange freak of justice the one man who sold
a canvas for a then very high price. It was Camille again who came
to the rescue. In his first study of her ten years earlier he had gained
his first enthusiastic Salon notice. Now he painted her in a kimono
holding a fan. Brilliantly coloured, the painting was called *Japonnerie*.
Even hostile critics paid it a grudging word of praise. The praise in
itself was worthless and, to Monet, ironical; of all his pictures this
least deserved it. The praise was in any case paid for the wrong reason;
it was not aroused by appreciation of composition, mastery of brush-
work, or even use of colour, but by the simple fact that Paris had been
swept by a craze for oriental art. Everywhere Japanese fans and trays
and kimonos were the rage, everywhere the new painters were caught
by the charm, the colouring, the unusual design of Japanese and
Chinese prints. Monet had succumbed less than most to this influence;
luckily for himself he succumbed far enough to paint this picture. He
was paid two thousand francs for it. For a moment he could breathe
again.

Chapter 15

Heights and Depths

1876 - 1879

Two thousand francs seemed a fortune, a fortune which Monet typically wished to use to press on with a third exhibition. He painted happily at Argenteuil with a Camille apparently well once more and the faithful Caillebotte, a splendid sailing companion and uninhibited enthusiast for everything Impressionist. They must show more and more, said Monet, and educate the public by regular exhibitions. Sooner or later good painting and truth of vision must win the day.

Caillebotte agreed, but elsewhere there were signs of dissension. The first stir was made by a man regarded as a firm supporter, the critic and Guerbois habitué, Duranty. After the exhibition he put out a booklet, *La Nouvelle Peinture*. His purpose was to analyze and defend the Impressionist way of painting and to a point he did so. He explained that the artists were expressing a new view of painting which rendered absurd the application of academic criticism. How, for example, criticize the Impressionists for lack of finish—one of the common jeers—when their declared purpose was to capture and reproduce the fleeting moment?

Duranty pointed out that the Impressionists "realized that full light

discolours the tones, that sunlight reflected by objects tends by force of its clarity to restore that luminous unity whose seven prismatic rays are dissolved into a single colourless brilliance—light. Proceeding from intuition to intuition they have little by little managed to split this solar light into its beams, its elements, and to restore its unity by the general harmony of its iridescence which they spread on their canvases. From the point of view of delicacy of the eye, of subtle penetration of colouring, this is an altogether extraordinary discovery."

But having paid tribute to the discoveries of Pissarro and Monet which had revolutionized painting, Duranty threw away all he wished to gain for the Impressionists. He launched into a tirade against some of them, Cézanne especially, and poured doubt on all by saying, "However, when I see these exhibitions, these attempts, I feel rather melancholy and I ask myself—these artists, almost all friends of mine, whom I have seen with much pleasure launch into unknown paths . . . where are they going?" He ended with, "The voyage is dangerous and they ought to have set out in larger, stronger ships; some of their vessels are very small, very shallow of draught, fit only for coasting."

This ending excited indignation in Impressionist circles and caused much heartburning at the Guerbois. It also led to a coolness between Pissarro and Monet. Duranty was the friend of Manet, and Monet had become friendly with Manet. Manet refused to exhibit with them. Why, then, asked Pissarro, did Monet allow himself this friendship, and what part had he played in the Duranty publication?

Pissarro's indignations could not long survive meetings with Monet, of whom he had seen little during his immurement with his parents-in-law. But he was a hasty man, rushing to extremes, and said enough to Cézanne, down in the south, to bring from the Provençal a fierce "I hope that our co-operative exhibition falls flat if we have to exhibit with Monet."

Before he and Pissarro could come together again on this point, Monet's life was once more disrupted. By the end of the summer, having paid his debts and set aside money for the next exhibition, he found himself penniless. He and Camille had to give up the house at Argenteuil. This was a sad break with a place both had loved in spite

of their sufferings there and which had turned Monet from a good to a masterly painter of landscape.

They took shelter with Hoschedé, the shop owner. He had a country house on the Seine south of Paris, at Montgéron. There they settled for the autumn, with Monet making study after study of this new river scenery. How much of the invitation came from Hoschedé and how much from his wife is not certain. In view of the future it is probable that Madame Hoschedé had the greater say. She was anxious that Monet should make her portrait.

All in all, despite the comfort of the house and the appeal of the fresh scene, it was with some relief that Camille, at least, returned to Paris for the winter. Nor was Monet far behind her. Like most men who have become familiar with privation, he felt uneasy in luxurious surroundings. He was not a woman's man; his hostess had to consider herself lucky if she could extract even the formal courtesies. This attitude also had an attraction, but he remained either unaware or scornful of it. He was besides so strongly moved by a sense of purpose that anything in the nature of frivolity quickly bored him. He was happy only in action.

And he had fresh action in view. He had managed to get together a little money from sales—to Caillebotte, to De Bellio, to Duret, and to Hoschedé himself—and was eager to do two things, to resume plans for another exhibition and to undertake a new series of paintings.

This series was a radical departure from all he had done so far and a notable example of his dour search for novelty in subject and treatment. His object was to use the Gare St. Lazare as motif. Only an Impressionist, with his belief that beauty was to be found everywhere in modern life, would have thought of a subject hitherto considered so unpainterly as never even to cross the mind of a painter. Yet why, he asked at the Café de la Nouvelle-Athènes, which had just taken over the role of the Guerbois, why should not a railway station provide a painter with satisfactory material and the purchaser of a picture with drama, colour, and beauty?

He soon stopped talking and got to work. He set up his easel in various parts of the station and made one study after another. He

used engines, passengers, porters, steam, smoke, the station roof, the buildings dimly seen beyond the station, anything and everything, to make canvases of fascinating interest.

Pissarro, filled with admiration at this bold assertion of Impressionist principles, lost the last remnant of what had always been an artificial coldness. The planning of a third exhibition went on. Let the Impressionists take their courage in both hands, they insisted, and show by themselves without attempt to weaken criticism or suggest apologetics by including outsiders.

They carried their point and became firm friends once more. But having done so they discovered, as Degas noticed with some pleasure, that their funds were insufficient. All very well to limit the number of exhibitors; this moral gesture led to a drain on the pocket which none of them could stand. And to further confuse counsel Renoir declared against another exhibition so soon. He felt it to be bad policy.

The dilemma was finally resolved by Caillebotte. The more he saw of them the more his admiration for Monet and affection for Renoir had grown. He was convinced that their painting was the painting of the future. Being a conscientious as well as kind young man and with a sort of mild passion for painting, he felt a duty to try to preserve it for a world which could not appreciate its own riches. Although not yet thirty, he had very strongly the sense of mortality so often given to those destined to die prematurely. Before the end of 1876 he made a will leaving his collection of Impressionist pictures —which he was charitably increasing every month—to the Louvre. He also made generous provision for a large and well-run exhibition of Impressionist paintings.

This last was because, convinced by Monet of the need for regular exhibitions until Impressionism was accepted, he was among the most eager supporters of his friend's call for a third in 1877. "The exhibition will be held," he was assuring a distressed Pissarro in the early months of that year. And when, despite every effort, the survivors of the first exhibition—the numbers had been cut from thirty to eighteen—were unable to raise the money for an exhibition hall, he came forward and paid for one.

This hall was unorthodox. It was the second floor apartment of a house in rue Le Peletier near Durand-Ruel's which Caillebotte discovered and rented. But it was well placed and fairly well lighted and the hanging committee—Caillebotte himself, Renoir, Monet, and Pissarro—did a good job of making the best of an ordinary set of living rooms.

The exhibition opened in April with more than two hundred works. Cézanne and Guillaumin returned after missing the second exhibition, and several non-Impressionists dropped out. It was so nearly an all-Impressionist show that all the leaders but Degas wished to give the exhibition this name. It was also a magnificent collection of pictures, but its fate was similar to the first two. The crowd at first showed signs of behaving itself, some people even looked seriously at the canvases. Then the press got to work with a series of attacks which rivalled anything that had gone before in vulgarity. A cartoon of a pregnant woman being warned away from the show by a policeman was typical of the journalistic attitude. For the press had discovered that Impressionism was a splendid target and they had no mercy. Nor did the joke rest there. It passed to the music hall, and to the stage proper with a comedy in which an Impressionist painter was prepared to sell his work either way up, as a cloud or a yacht in full sail. The Impressionists quickly became the latest Paris joke. For the first time the name really swept the city. It was not as the painters wished but it was fame of a kind.

Of all the painters exhibiting Cézanne was, as at the first show, the *bête noire*. Before his pictures the laughter was loudest, the jokes most revolting. But Monet ran him a close second as the critics made clear. For them Cézanne was simply a madman. Monet was even more dangerous, as sane in his madness and even with a certain attraction. Often they were linked, as in the review by Ballu, then Inspector at the Beaux-Arts and one of the foremost speakers for the official painters. "Messieurs Claude Monet and Cézanne," he wrote, "happily putting themselves forward, have shown, the first thirty, the second fourteen, canvases. They have to be seen to be believed. They provoke laughter and are altogether lamentable. They betray the

most profound ignorance of draughtsmanship, of composition, of colouring. Children amusing themselves with paper and paints would do better."

The critic's instinct for the strongest enemies of complacency was correct. Different though Monet and Cézanne were in the nature and value of their work, they provided, of all the painters then rated as Impressionists, the two most striking examples of men uncompromisingly devoted to their artistic principles. All and everything had to go before the one clear duty of their life, to express their sensation in front of nature.

They had defenders and none more loyal and impassioned than Chocquet. He was in the exhibition rooms from the opening to the closing minutes every day and, subduing a natural shyness, forced himself to intervene. "He became a sort of apostle," said Duret. "He received nothing but smiles and mockery but never lost heart ... I remember seeing him trying to convert famous critics and hostile artists who had come simply to run down the exhibition ... He was never at a loss for a word when defending his painter friends. He was specially indefatigable on the subject of Cézanne whom he placed on the highest level."

Nor did Chocquet confine his attentions to critics and painters. He would make a beeline for any visitor or group of visitors misbehaving themselves, "challenging the laughers, lashing them with irony, making them feel ashamed." And he would catch hold of a single disbeliever, "dragging him almost by force in front of the canvases of Renoir, Monet, Cézanne and trying to make him share his admiration."

His efforts were next to useless and were regarded, Chocquet being difficult to dislike, as "gentle insanity." He became known as an amusing butt. "He got nothing but smiles or mockery," wrote Duret. "Whenever he appeared people made a point of attacking him on his favourite subject." Nor did the other substantial effort, of Renoir's friend Georges Rivière, produce much greater effect. Rivière brought out a little pamphlet, *L'Impressionniste, Journal d'Art,* while the exhibition ran. He explained that the Impressionists differed

from other painters because they treated their subject in terms of colour and not of the subject itself. But his praise of the painters was in general too fulsome and too naïve to win acceptance; he was known to be a personal friend and this subtracted from any power the printed word might have had.

The third exhibition ended, like the second and first, in failure. Few pictures were sold and the Impressionists had become a city-wide joke. Duret, summing up, said that "most visitors considered the exhibiting painters as having talent and thought they might have painted good pictures if only they had been willing to paint like everyone else. They suspected that they were making a stunt out of art in order to attract attention."

This age-old charge was inevitable; no original artist has escaped it. The one point of satisfaction, negative though it was, consisted in the fact that at least, after three attempts, the Impressionists had succeeded in making themselves talked about in a big way.

To Monet, as to Pissarro, Sisley, and Renoir—though to Renoir rather less than the others—this thought was small comfort. Believing as he did in his mission as painter-originator Monet found the publicity painful. Ignorance was one thing, malice another. Cézanne, who had decided never again to exhibit with the Impressionists, spent the summer with Pissarro, back at Pontoise once more, and saw at first hand the trials of that hardly-tried man. "Profound desolation reigns in the Impressionist camp," he told Zola. "Gold isn't exactly flowing into their pockets and their pictures are rotting for lack of buyers."

Pissarro's despair was echoed by Monet. From the exhibition he had gained one fresh collector, a stock exchange broker named Paul Gauguin. He had not repeated his big sale of the second exhibition. He was soon out of money once more and hunting round for lenders.

Not the least evil of this continuous poverty of the Impressionist painters was its almost insufferable monotony. Every sou had to be counted, every expenditure was the subject of anxious discussion. There was no relief. Never could they get away from the scenes of their endurance, not even for a day or two. They dared not attempt

to cheer this cheerless existence. New clothes, a different dish, a visit to friends, all was forbidden. The grinding monotony was broken only by excitements they could have done without: how to heat their cottage, buy food, paints, canvases, appease landlord, butcher, baker, keep the broker's man at arm's length.

For Monet, whose lot was worse than any, this living from hand to mouth, varied by periods of actual starvation, had been going on almost without break for ten years. He was no longer a young man. He was in his thirty-seventh year. He had been painting masterly pictures for years. All he had gained was a few well-wishers. He was not known—rather, was known as a joke. To live, he had to eat his pride again and again and tramp round to his friends' or patrons' houses or write difficult begging letters. He knew that he did good work, original work. He believed that one day this work would be recognized and rewarded handsomely. But not, it seemed, in his day. He grew bitter.

In the autumn of 1877 the monotony was varied in a fresh way. Camille became pregnant. Monet had to think, not simply how to earn enough money to eat, but to pay for doctor, midwife, help in the home. And what home? They camped out in rooms, in tumble-down cottages, they no longer had even the certainty of a roof over their heads when Camille's time came.

Wherever Monet looked, he found cause for despair. Caillebotte was living in temporary retirement attending to his mortally ill mother. Faure the singer was thinking of selling his collection. Hoschedé, another victim of the slump, was on the verge of bank-ruptcy. He had no longer even the moral support of the old masters who approved of him. Diaz had died the year before, Courbet that year, and Daubigny was on his deathbed. Well might Cézanne say "profound desolation reigns." He spoke of Pissarro, but Monet's discouragement was as great. For once that brave spirit sank. He could not even raise the energy or the hope to plan for a future ex-hibition. All thought had to be given to the struggle to keep life in his family.

He went the dreary rounds, small enough in all conscience. His

letters begged without conviction. "Would you be kind enough to take one or two of my things?" he asked Chocquet—and the formula was the same for each of the tiny band of possible helpers, De Bellio, Zola, Manet, Duret—"You can have them for any price you care to give—fifty francs, forty francs, whatever you can afford. I simply can't wait any longer." He could not wait even to try to get a fair price as prices went then. And as none of his clients were rich men and had other struggling painters to think of, his giveaway prices were thankfully taken. Monets worth a fortune changed hands for the price of a week's wretched living.

There were no more visits to the Guerbois or Nouvelle-Athènes; he had neither the fare nor, when he tramped the streets, the price of a glass of wine or beer. Pissarro alone of the four walked heavily into the café from time to time. Thrust out by his irate wife to collect somehow a few francs in Paris, he presented a forlorn sight. His hair was quite white, his beard too, although he was no more than forty-seven years old. But his spirit flamed from time to time and his fiery sense of fellowship was as high as ever. He listened with indignation to the prosperous Degas and Manet debating the worth of official honours. He thought of Monet cadging a few francs, of Sisley short of every necessity, of Renoir forced to turn out portraits to live, and he burst out with a rush of hot words.

One day that autumn of 1877 Manet, in a fury after Degas had taunted him with his bourgeois ancestry, thought of Pissarro's words. His conscience struck him; he went to see Monet. The visit made him profoundly uncomfortable. It was one thing to talk about the poverty of painters—a foregone conclusion at the cafés—and quite another to see it. "I went to see Monet yesterday," he wrote to Duret. "I found him absolutely on the rocks and in despair. He asked me if I could find someone who would take at least ten or twenty pictures at one hundred francs apiece. Do you think we could arrange this business between us, each paying five hundred francs? Of course no one, he least of all, must know that we are doing it. I had thought of a dealer or collector but can foresee the likelihood of a refusal. In spite of a natural repugnance for acting in this way it is unhappily necessary for

someone to be as well informed as we are to carry out what is at once an excellent piece of business and a service to a talented man."

Duret declined. He was helping Renoir and was soon to help Sisley; he could do no more. Manet paid the money himself but had to cut the price by half. In the first days of the new year, 1878, he gave Monet one thousand francs for twenty canvases.

This manna from heaven enabled Monet to settle Camille before her confinement. He took a cottage at Vetheuil more than twenty miles down river from Argenteuil where rents were cheaper and the scenery wilder. And there he began immediately to paint a series of exquisite landscapes.

They were exquisite because for him as for all the Impressionist painters life had full meaning only when he gave himself to his work. When they took a brush in hand and sat before an easel they no longer felt cold or hunger, no longer worried how to get through the next day. Their whole being was fixed on the scene before them, they were absorbed by the problem of reproducing it truthfully. And one essential to truth of vision was a mind unclouded by anything outside that scene. They had to be, and were, artists before men; they had, one and all, the strength of purpose that art gives. Sisley at Louveciennes was painting some of his most successful canvases in these later seventies when nothing else would go right with him. At Pontoise, Pissarro was telling a friend, "I am passing through a dreadful crisis and can't see how to get out of it. I owe money to my butcher, my baker, on every side. My wife is expecting her fourth child." He even talked of "giving up art and trying something else." He did not exaggerate; he was desperately poor. Yet the next moment he was being the life and soul of a little group of painters who came from time to time to learn more under him. Cézanne had taken his first great step onward through him, Guillaumin was spending every spare moment with him when he could escape from his civil service job, Gauguin, the Sunday painter who had already had a picture in the Salon, was talking of giving up the Stock Exchange and taking to painting because of Pissarro's encouraging words and lessons. Pissarro himself was painting landscapes finer than any he had made.

At Vetheuil, too, Monet at once accepted the challenge of fresh river scenery and made studies as calm and beautiful as anything he had ever done. Some ice and snow effects were superlatively good and technically more advanced than ever before. Looking at them, no one could dream that the man who made them was harassed on every side and facing a future seemingly without hope. Yet by March, 1878, in the midst of this productive period, he was forced to stop work yet again and recommence the round of appeals. A second son, Michel, was born to him. Almost all the joy was swallowed by anxiety. He wrote to those he knew, he wrote to those he did not know. He tried at first to see, then to write to Charpentier, the well-to-do publisher of Daudet and Zola. Charpentier had commissioned several family portraits from Renoir who in turn had spoken of his friends. "I called at your house this morning," Monet now wrote, "in the hope of doing a little business, very little indeed, so that I should not have to go home without money. I wasn't able to see you and very much regret it. I shall send you a canvas which I hope will give you pleasure. I ask 150 francs for it or, if you think this too much, one hundred francs which I should be extremely grateful if you would send to me at Vetheuil. If the canvas doesn't please you I will change it for you when I come back." He ended with an explanation, naïve but typical. "I thought I might ask you because a long time ago you gave me the hope that you might buy something from me."

Uncertain of Charpentier's reply, he wrote to Zola. Here he let his defences drop. Zola was wealthy by this time, one of the most popular novelists in France. He had dropped all art criticism but not his friendships with artists. Monet could speak frankly, since Manet would have kept him informed. "Could you possibly help me? We haven't a single sou in the house, not even something to keep the pot boiling. And in addition my wife is not well and needs nursing. For as you may have heard she has given birth to a wonderful boy. Yesterday I tried everywhere without being able to get a sou. Could you lend me two or three louis—or even just one?"

Zola obliged and Monet, who could never receive a gift without thinking of the group, made a last attempt to arrange an exhibition

for that year. Pissarro, rising grandly above domestic tyranny and perpetual short commons, was all fervour. But plans had not got far before they were nipped in the bud. This time the trouble was not money only but a stab from their own circle. Renoir and Sisley gave up the fight and decided to join Manet and Cézanne in submitting their work to the Salon. Reproaches broke out. Sisley was spared, for his state was as painful as Monet's and he stuck grimly to landscape. But they did not spare Renoir who had the gift of picking up an odd commission here and there without caring too much what it was and where it came from. He defended himself with the humorous twist of the mouth and shrug that so many people found irresistible. "I doubt," he said, "whether there are a dozen collectors in the whole of Paris with the knowledge or the courage to appreciate a painting that hasn't received the blessing of the Salon. There are eighty thousand lovers of art who I know won't buy even a nose if the man who painted it has not had work hung in the Salon . . . My submitting to the Salon is entirely a matter of business. In any case it's like some medicines, if it does no good it can't do any harm." He was adamant, and Sisley too.

For a moment Monet's hopes were raised by a pamphlet published by Duret. This pamphlet, *Les Peintres Impressionnistes,* for the first time singled out the true Impressionists. Duret dealt only with Monet, Pissarro, Sisley, Renoir, and Berthe Morisot, each of whom was given a biographical notice and critical commentary. In his general argument Duret tried to reconcile the reader to Impressionism by pointing out that every artistic advance in history had at first been greeted with ridicule. He argued that, far from being a revolution, it was a logical evolution from painting of the past. He gave the list—pitifully small —of well-known men who owned Impressionist canvases (being careful not to say how little they had paid for them) and predicted a great future.

The great future was true enough, that was all. But not much was needed to cheer men who had gone singularly short of praise as well as money in their lifetime. Manet was able to assure Duret that he had given "fresh hope" to the four chief sufferers who, he added,

"need it badly, for the scales are weighted tremendously against them just now."

Just how much was soon seen. The auction of Faure's collection was a complete frost. Instead of making the handsome profit he had hoped, the famous singer had to buy back most of the pictures. The proceeds of the sale did not cover expenses. He was left out of pocket and with his faith in the Impressionists badly shaken (Durand-Ruel having encouraged him to buy with the confident prophecy of a spectacular rise in prices), and the painters themselves once more saw their chance of making a living receding into obscurity.

Any remaining hope they may have had of Duret's pamphlet doing them a tangible good was finally dashed in July, 1878, when another of their few buyers, Hoschedé, put up his collection for auction. This was a forced sale; the slump, though in fact nearing its end, had finally obliged him to close his shop. All the prices paid at the sale were depressingly low. Twelve of Monet's paintings averaged 184 francs each.

The news reached Vetheuil at an evil moment. Monet was entering a period so wretched that all the sufferings of the past thirteen years seemed as nothing to it. Then, however severe his trials, he had been supported by Camille's bright smile, her gay courage, her absolute faith in his work and eventual triumph. Now these were withdrawn with agonizing slowness, with a fearful inevitability against which he struggled helplessly. As summer passed into autumn and autumn into winter he could see that Camille was not recovering. He could not deceive himself any longer. The child, though sickly, showed faint signs of gathering strength; his mother did not.

Before his little money had gone he paid for help in the cottage while he made a last prolonged effort to sell some pictures or get a loan. He tramped the streets of Paris tirelessly in all weathers, knocked at the doors of every man he knew, pestered, implored, argued.

He did not succeed. Times were hard, he had no skill in the art of begging, no charm. A few years earlier his broad and handsome face with its mane of black hair, its full beard, its bright brown eyes, breathed confidence. But he had grown careworn, bitter, angry at

the need to continue to beg. He did it badly. He came away empty. "Please don't tell others," he had asked Zola years before. "It is considered a crime to borrow." Monet was then a novice in the art. He was also simply trusting. He believed that his moment of recognition must be near at hand and his manner reflected his certainty. Now all disguise was at an end. Men were "not in" when he called; answers, when he did catch them, were evasive. He was a marked man, the man who had joined the great army of beggars. And from this a simple conclusion was drawn: Monet the scrounger was inevitably Monet the failure. How could a man's work be good when after thirteen years he was still unable to sell it, would still accept any cut price one cared to place on it?

Home again, he sat down to write to the one man he had not managed to see, Renoir's patron Charpentier. The cottage was almost bare. Most of the furniture had been sold bit by bit to buy food or pay the rent. He could neither afford help nor the delicacies needed for Camille. He could not even pay for a doctor. "I must ask you," he wrote painfully, "if you could possibly lend or send me five or ten louis. I am terribly troubled just now. I have just spent ten days in Paris without being able to get hold of a single sou and have had to go back to the country where my wife is very ill. You would do me a great service by sending this sum. As soon as I can return to Paris I will come to see you to pay you back either in money or in pictures." He added—and there is a world of agonising humiliation behind the simple words—"I do hope that you won't refuse me."

Charpentier sent the money. But Monet had long since proved in one year after another of dragging poverty the truth of Bazille's warning long ago: "What's the use of a hundred francs? It won't get you out of your mess." True, yet what could one do? None of these small loans could solve anything, they merely postponed final disaster. For more than a decade he and his friends had been telling themselves that the neglect could not last, that they had only to hold on and all would be well. They had held on. Nothing had happened. Soon, as always, Charpentier's money had gone and he was crying frantically,

"I am literally without a sou, obliged to entreat, to beg for my very existence, not having a sou to buy canvases and paints."

For his last consolation had been taken away, the one thing that gave him strength to face Camille cheerfully. He could no longer work. "I have come too soon," he said grimly. It was his final word. What use to appeal further? He was a man before his time. He fell into the silence of absolute despair. A wife slowly fading away, a painter who had not the means to paint—what more could one endure?

But he had not touched the bottom of wretchedness. One further humiliation awaited him. Before that nightmare of a winter could draw into the spring of 1879 he was again forced to write to Paris. The local duns who pestered him week in, week out were joined by supposed friends in the city. The disagreeable history of Bazille years earlier was repeated even more unpleasantly. Not one man in a million is capable of lending money without expectation of return, not one is capable of giving money without feeling that the gift purchases proprietorial rights. Monet was never lucky enough to find the millionth man. Bazille had been no more than impatient or forgetful. At the time Monet had found this hard to bear. He now experienced treatment which made Bazille's lapses from true friendship seem minor pinpricks. The men who had lent or given him money were almost all kind, decent, undemanding. They felt sorry for him. At worst they hoped that the canvases they were given in exchange would cover the cost of their loans. At best they expected that the painter they had helped would prove himself worthy of it by making a name. In the one case it was a matter of business with them, in the other a matter of pride. All were disappointed: he neither justified their gifts by becoming well known nor did his canvases increase in value. And worse, as a final disappointment he began to fail to keep his promises, and did not always send canvases in exchange.

Charpentier, the successful publisher, was one of the first to take him up on this promise. Charpentier was well-meaning but unimaginative. Renoir had assured him that Monet was a fine painter. On that assurance he had given money against canvases. The canvases never arrived. All Charpentier's business instincts were outraged by

this failure to keep to a bargain. He wrote, once, again, and yet again, his opinion of painters falling to zero. "I know only too well that I can't tell you anything you won't know yourself," Monet replied at last to a particularly pressing letter, "which is that for a very long time I have been tormented by the impossibility of working, all my time being given to looking after my wife and our small child. You will surely know all this since I haven't been able to show anyone, or to try to exhibit, a single new canvas. You should know equally well that it has not been possible for me to leave here."

Charpentier wanted his money or the canvases. His last letter had been sharp though polite. "I am very much at fault," continued Monet, "and it has been very wrong of me not to reply to your letters, but I've had to endure such worry and anguish of mind that I've practically gone off my head."

He had searched the cottage, and "I shall send a parcel to your address by railway tomorrow. It is the only thing I have done for a very long time. I send it to you and hope that it pleases you. On the other hand Monsieur Caillebotte possesses a canvas of mine, a canvas which I slashed in a moment of despair and which I sent to him to be repaired. Ask him to show it to you and if it pleases you I shall owe you only one more canvas which I shall try to give you at the earliest possible moment."

Charpentier accepted what he offered. There was peace in that quarter, but a customer had been lost. So it was everywhere. But not all his creditors had Charpentier's politeness. Monet had been forced, like Pissarro, Sisley, and Renoir, to appeal to a friend of Guillaumin's, the pastrycook Murer. This rather vulgar young man had some time before opened a small but successful restaurant. He took canvases in exchange for meals and began an Impressionist collection. Pissarro and Renoir, on their beam ends, had decorated his restaurant for the price of meals. Later, he began to buy their work. He was a driver of hard bargains. He would refuse to pay the modest price they asked with an expressive, "I'm in no hurry." After a few weeks, desperate, back they would come: "Give me what you like." He gave them a pittance. His collection increased.

Monet, with no money and nothing to sell (for his few completed paintings in the cottage had been seized by creditors) had managed to persuade Murer to advance money for canvases he had planned but had not yet carried out. They remained unfinished or in his head; before he could get to work on them he ran out of materials and Camille took a turn for the worse and could not be left for more than a few minutes. He asked for time and, if possible, a small loan.

Murer began to write ugly, threatening letters. He would, he said, come down and take the canvases if they were not forthcoming immediately. Monet roused himself to reply with a noble dignity. "I am in the wrong most certainly," he said, "in not having sent you the canvases which you had already paid me for in advance. I have made my excuses to you on many occasions, and I believed, since you knew all about my situation, that you would sympathize with me in my difficulties which were obvious to all, knowing full well in any case that I should never allow you to lose the four hundred francs you had advanced. I was so convinced of all this that, when I fell into fresh trouble through no fault of my own, I had no hesitation in writing to you again. You could have replied to this appeal in a less unpleasant and hard manner, and though I may have been in error in the first place this does not excuse your letter which I find thoroughly nasty. There is a very simple way of getting your canvases if you are really afraid that I will never do them, and that is to take those now in the hands of the bailiff. I am surprised that you haven't already thought of this. But I will spare you all these boredoms and free myself as soon as possible. It is absolutely useless for you to take the trouble of calling at Vetheuil; as I shall not be at home I could not receive you and in any case, being in the thick of difficulties, I never know where I shall be tomorrow. The important thing being for you to have the canvases, it should be enough for you to know that I shall try by every possible means to let you have them at the earliest possible moment so that all intercourse between us can be brought to an end."

In the midst of these seemingly unending miseries Monet was approached by a Caillebotte determined that his favourite painter and

most respected man should not sink under his despair. "I occupied myself all day yesterday on your behalf," he explained cheerily, "so that I could send you some money sooner than I said. So don't be downhearted. When you can't work, come to Paris. Try to collect as many canvases as possible." Monet was unrousable. Even talk of a fourth exhibition failed to move him. "I think we shall have a superb exhibition," wrote Caillebotte, deliberately oblivious of his friend's troubles. "But you are always the same, you become dispirited in the most frightful manner. If you could only see how young Pissarro is! So come!"

He did not go, and the rump of the Impressionists was forced to make all arrangements without him. Renoir, Sisley and Cézanne had decided once more to try for the Salon (where Renoir had been a mild success the previous year) and were automatically excluded. Manet as usual went for the Salon. Berthe Morisot could not exhibit as she was pregnant. But inspired by the enthusiasm of Caillebotte and Pissarro—who showed himself, as Caillebotte said, younger than ever in heart—the reduced band decided to go ahead. Fifteen remained of whom only Pissarro, Monet, Caillebotte, Mary Cassatt, an American pupil of Degas, and, at a pinch, Degas himself could be regarded as Impressionists. Degas, as ever, fulminated against the name, and had his way, so they decided to give themselves another label. This was duly introduced by Sylvestre with a facetious note in *La Vie Moderne:* "You are invited to attend the funeral service, procession, and interment of the Impressionists. This painful invitation is sent out by the *Independents.* Shed no false tears, indulge in no false rejoicing. Let us keep calm. Only a word has died."

And not even that, as events were to show. The painters could call themselves what they pleased. They were fixed for life and for posterity with the name Impressionists.

In all this Monet played no part. Unwilling to leave Camille, unable to work, and with all his canvases sold for petty sums or seized by the bailiff, he remained mute, inconsolable at Vetheuil. Caillebotte worked hard for him at Paris, borrowing Monet canvases from the few collectors who possessed them, repairing others which Monet,

dissatisfied, had long since thrown aside or slit or smashed in a rage. When the exhibition opened in April, Caillebotte wrote daily, sending his own news and packets of newspaper notices.

The news was good. "We are saved," he wrote jubilantly on the first day. "This evening at five o'clock our receipts had exceeded four hundred francs. Two years ago on the opening day, which is the least good, we had less than 350. I do hope that you'll come here to Paris to see the end." He also enclosed a commission from Duranty.

Monet would not, could not move. Camille was no better, he had two small children to look after. He had no heart for Paris.

The exhibition made way. The critics were as cold as ever but the visitors showed signs of being able to look at the pictures without going into hysterics. Some even bought a canvas or two. Monet's twenty-nine paintings, which attracted most attention, were mainly early works, but three had been made that year: the serene, summerlike *Paysage, Vetheuil,* the strongly Impressionist *La Seine à Vetheuil, effet de soleil après la pluie,* and the most striking of all works in the exhibition, the winter scene *Eglise de Vetheuil.* Towards the end of April, Caillebotte sent for more canvases—the first time such a demand had ever been made. Monet sent all he had—two which he had thrown aside in disgust. On the first of May, Caillebotte acknowledged them and gave further good news. "I have received both your canvases, damaged both of them—by you? Anyway I am having them repaired. Tomorrow they will be at the exhibition. I have nearly sold one, the big one, to Miss Cassatt. She asked me to ask the price. I said I suppose you would let it go for 350 francs. The receipts increase daily. We now have something like 10,500 francs. As for the public, they are always cheerful. They have plenty of fun with us. I won't speak to you about the press, you can see that for yourself."

By the end of the exhibition there was profit enough, all expenses deducted, to pay something to all. In the second week in May, Caillebotte was reporting, "Our share has risen to 439 francs, 50 apiece . . . We have made a total of 15,400 francs plus a few entrance fees. In short, this is progress. I'm sorry you could not have been on

the spot to see it. But for painters and for the public we have done a great deal despite the ill feeling of the press. So take courage."

"Take courage." This to him who had spent his painting life leading the faint-hearted! But even this cruelly ironical turn of fate could not move him then. When he could paint he was a lion; without the means to work he was a lost man. Some eight hundred francs arrived at Vetheuil—his share of the exhibition profits plus the price of the picture bought by Mary Cassatt. Eight hundred francs: a fortune to the family besieged there. A fortune and even a certain hint of recognition. But at that moment the money and the hint of coming success were nothing to the man who walked distractedly about the cottage at Vetheuil. The success, such as it was, and the money were useful only to soothe the last days of Camille.

For there was now no doubt that she was dying. Nothing could arrest that slow falling away. Under the eyes of her husband she weakened daily. She had never put herself forward; in illness she remained equally self-effacing. By the end of the summer she was dead.

Chapter 16

The Missing Link

1879 - 1883

"I CAN SEE YOU STILL," WROTE BOUDIN, "WITH YOUR POOR CAMILLE in the Tivoli Hotel. I have kept a drawing you made on the beach then . . . In it your small Jean is playing on the sands and his father sits by, a piece of drawing paper in his hand . . . but does nothing. It is a memory of those times which I preserve piously."

Boudin's tone of gentle reminiscence was intolerably out of key with his old pupil's mood. Monet did not see a happy Camille on the sands of Trouville, he saw a hollow-eyed Camille facing a table without food, a fireplace without fuel, braving insolent tradesmen and overbearing bailiffs, a Camille trying to smile, trying to smother her cough, above all a Camille cruelly defrauded of certain triumph.

Physically he was utterly wretched, moving from one poor room to another, unable to paint. For thirteen years, ever since that day they met in 1866, she had shared his lot. She had been proud of the stand he took. She had abided by it and had never begged to be spared the severity of life with a man who would look neither left nor right. He had refused to compromise and she had died. Had she rebelled, complained, he would have felt less furious with fate, less guilty in

178

himself. For he had not only told her that he must paint as he believed, he had predicted success, reputation, a fair life for them all. And each year life had become sterner, with growing insecurity and, in Camille, growing fragility. He had to watch her slipping away and, being what he was, had no power to keep her.

With him the struggle between principle and personal emotion could have only one end, but it was to leave an unexpected and disastrous mark. For even at the height of grief he did not suspect the full content of his loss. He saw Camille's death as a frightful irony. The real irony—that his wonderful eye had lost its most powerful creative influence—was beyond his imagination. So far was he from connecting her with his work that he turned against all that he had spent so many years to build up. Could even the struggle for a true art be worth the life of such a woman? he demanded passionately. At first he could not believe it. He abandoned the Impressionists and went back to the Salon.

His decision caused much ill feeling among his old allies whose 1880 exhibition without him appeared like a headless horse. There were bitter words. Monet complained to Duret that he was being treated "like a renegade." As he was, by Degas specially. Degas had never liked him. In the old Guerbois days his sarcasms had rolled unheeded off Monet's broad back. He disliked his work and did not hesitate to say so. Now he accused him of "a piece of disgusting log-rolling" and cut him. Pissarro, the one man beside Monet to whom the exhibitions were a matter of life and death, kept silent. He understood what Monet left unsaid. This was seen clearly by Caillebotte. He pleaded with Pissarro to drop Degas from the group shows. "If there is anyone in the world who has the right not to forgive Renoir, Monet, Sisley, and Cézanne, it is you because you have been up against the same practical troubles as they and have not weakened. But truly you are less complicated and more just than Degas . . . As a human being he has gone so far as to say to me, speaking of Monet and Renoir, 'Do you ask such people to your house?' "

Monet's Salon entry, like Renoir's, was badly hung. Both men wrote a letter of complaint to the Minister of Fine Arts and asked

Cézanne to send it to Zola with a request for newspaper comment. This Zola did but in a manner which shocked all his old companions except Cézanne. For Zola had moved far from the men he used to praise and sit with nightly at the Guerbois. His interest had shifted to the kind of realism of which, happily for them, they were incapable. If he agreed to the request to publish the Renoir-Monet letter it was more from the power-complex of the successful man than from sympathy with them.

As he demonstrated. For having struck at his old enemy the Salon he went on to play the art critic with the unhappiest results. He spoke of Impressionism as "the only possible evolution" painting could take—an unfortunate judgment when the Post-Impressionists were just about to demonstrate its falsity. Then, like Duranty with his "larger, stronger boats are needed," he crabbed all the help he had given by stating publicly and with all the prestige of a successful novelist that "not a single painter in the group has managed to apply the new formula powerfully and definitely . . . all remain unequal to their self-appointed task."

Disappointed, Monet followed Manet with a one-man show in June at the office of Charpentier's new review *La Vie Moderne* off the Boulevard des Italiens. The exhibition was not a success in sales, but as a draw it surpassed all expectations. The office was jammed day after day by curious crowds, well-behaved crowds too. The critics were cautious. They were beginning to suspect, as even the stupidest and most biased must do in time, that perhaps there was more in this much-belaboured art of Claude Monet than they had imagined. They began to temporize, to sit on the fence. Duret no longer doubted. "Claude Monet," he wrote, "is the one artist since Corot who has brought inventiveness and originality into landscape painting. If one judges painters by the amount of novelty and unexpectedness in their work, one can't hesitate to place him among the masters."

The young Paul Signac, tremendously impressed, begged to be taken as pupil. Monet's answer to him was the answer he was to give to all young worshippers. "I don't teach painting, I try to do it, and I can tell you that I haven't time enough for that. However, since the

world is what it is, and being what it is it will have a teacher, I tell you, ignoring all our aesthetics, that your teacher is there." He pointed to the sky, river, trees, with a, "Ask it, ask them and listen to what you are told. If you hear nothing, the best thing you can do is to study law." For Monet regarded grimly this prelude to the success which had evaded him when he really wanted it. His face was impassive but his heart was bitter and he returned short answers to the curious. "I am and always shall be an Impressionist," he told an impertinent journalist who was trying to stir further trouble between the painters. "If I don't often see my old colleagues now it is because the little group has swollen into a large club which opens its doors to the first dauber who knocks."

In the next year, 1881, he repeated his refusal to exhibit with the Impressionists. He also sent nothing to the Salon. The whole year he worked along the Seine, worked with the kind of dumb desperation known only to the bereaved and the bitter. What, after all, could he do but work? He was not, that one uncharacteristic attempt excepted, the kind of man to kill himself. He was a painter. His life was possessed and controlled by painting. He could not see a new country-side or a sudden change of light on a familiar one without wishing to record it. Sometimes he despised himself for this native curiosity. More often he surrendered with a sigh; while the brush was in his hand and his eyes laid bare the secrets of the scene before him he could think of nothing else. An automaton? Perhaps he was. A prisoner of his eye certainly, as he was to say many times.

He painted up and down the river, oblivious of heat and cold and rain. Madame Hoschedé had taken charge of the two children—he had no fears there. Nor had he further worries about food and drink and a bed for the night. In the first few months after Camille's death he had been as poor as ever in his life. He had enjoyed savagely and with a kind of masochism the discomfort, the hunger, the street tramps, all the familiar routine of poverty. Let him suffer! But nothing he could do would fend off the inevitable. Those months over, the slump suddenly lifted, Durand-Ruel, with money behind him once more, began to buy. Monet had money in his pocket without asking for it,

without wanting it. It was not a fortune, he was not famous, but the exhibition at *La Vie Moderne* was a pointer. Fame and fortune were advancing remorselessly.

But at least while he painted he could not think of that, only of getting a little closer each time to his goal. But was he? In the months after Camille had gone came the first doubts. He was painting better than ever—who could question it? And yet? Bewildered, furious, he would wreck a group of canvases, try again. The technical mastery was there as never before, the dissection of the motif seemed without fault, he was clear in his mind what he wanted to do. And yet, and yet . . .

In 1882 after long discussions he joined the Impressionists again. When Camille lived he had felt himself obliged to agree to Degas and his horde of respectable painters who cut down the cost of exhibiting. Camille gone he could dispense with this one departure from a lifetime of non-compromise. He insisted that only Impressionists be admitted.

Such was his prestige that he got his way. The seventh Impressionist exhibition was the only one in which none but Impressionist painters took part. There were nine of them. Degas stayed out in pique at the rejection of his friends. Caillebotte was there, Renoir, Sisley, Berthe Morisot, Pissarro, Gauguin, Guillaumin, and the now forgotten Vignon, protégé of Pissarro.

The exhibition was a success. At last Monet and Pissarro had proved their point, argued out over eight years, that there should be frequent exhibitions and that they should be confined to men whose work practised the theories of Impressionism. No more was there an unruly mob of people but serious crowds looking carefully at this much-maligned painting. The critics also became serious, the diehards realizing that cheap gibes would no longer unseat these modern painters, the favourable ones gaining courage to say what they really thought. Many pictures were sold, most of them the work of Monet —who showed the greatest number—Renoir, and Pissarro.

Impressionism had arrived. Impossible to say that it had come to

stay. One of those nine exhibitors, Gauguin, with Cézanne and Van Gogh, was to unseat it. But it had become accepted and was soon to pass by way of the indefatigable Durand-Ruel to America where the public proved wiser than the supposed art lovers of France and England. There was to be one more Impressionist exhibition four years later, but Monet had done his work and would exhibit no more. In future he went his own way.

In March of the next year, 1883, he was the first in order of one-man shows arranged by Durand-Ruel at his new gallery. He was also shown in London. No picture was priced at less than one thousand francs or one hundred pounds. His study of the thaw at Vetheuil, *La Débâcle,* was sold for 1,500 francs. There were more interested crowds and a press that was beginning to be respectful. "An exhibition of the work of Monsieur Claude Monet is now open at 9 Boulevard des Capucines," said *Le Chronique des Arts.* "This exhibition is very interesting. Monsieur Claude Monet is one of the few innovators of our times who knows how to express himself boldly and in a manner comprehensible to all. He has long since replaced the tendencies and intentions of the school called Impressionist by real painting in the sense in which one cannot misunderstand him and which has the incontestable merit of originality."

That was typical of the comments. Monet read without pleasure. His answer was, on the face of it, a strange one; he destroyed several canvases in a fit of despair and began to rework others which he had with an effort spared from the holocaust. Still he was not satisfied. The months went on with no improvement. At last he wrote of his dilemma to Durand-Ruel. "I begin to wonder," he said, "whether I'm going out of my mind. I have more and more trouble in satisfying myself. I've reached the point when I simply can't tell whether what I do now is better or worse than what I used to do. But this much is clear—what I used to do easily now gives me a great deal of trouble."

This is the letter of an old or failing man. Yet Monet was only just forty-three when he wrote it and was within a year or two of world triumph.

13

Chapter 17

Triumph and After

1883 - 1916

MONET WAS NOT THE KIND OF ROMANTIC FIGURE WHOSE WORK GOES
to pieces when a beloved wife dies. There was nothing romantic
about Monet except his appearance in youth. Even his pictures, which
to modern eyes appear the essence of romance, were to him scienti-
fically exact reproductions of the effect of light on nature at any given
moment—the sort of photograph his old Guerbois acquaintance Nadar
would have taken if such a camera had ever been invented.

The effect on Monet of the loss of Camille was quite another thing,
altogether more subtle. In the months after her death he had reacted
conventionally to the premature death of a wife who had patiently
endured so much suffering with so little reward. Like most people
whose reactions, however sincere and strong, are conventional, he
exaggerated the wrong thing. He tormented himself by the thought
not so much of her sufferings as of the lack of reward. The effect
on himself was, he believed, the effect on any loving man who lost
before time, and in tragic circumstances, his life's companion. He
was mistaken. Camille's reward had been all about her—in children,
husband, and above all in the husband's work. For she was more

than the perfect model, she provided his eyes—those wonderful organs of minute perception—with a heart. All the warmth, the humanity, the feeling in his pictures came from her.

This he did not see and could not be expected to understand. His reactions, stronger than most people's as he was stronger, followed accustomed paths. And like most men's his grief and bitterness grew less with the passing of time.

In the late spring of 1883 he seemed to have thrown off the last remnants of active sorrow and to have transferred it, as the habit is, to pious memory. For at the beginning of May he set up house at Giverny, some ten miles down river from Vetheuil, with Madame Hoschedé. Hoschedé had long since fled the country to escape his creditors and the two little Monet children had come to accept his wife as their mother. The ménage was not unexpected, allowing the children of both husbands to be brought up together, and it was eminently sensible—just the kind of action one would expect from Monet. Later, as soon as Hoschedé died, he married Madame Hoschedé and regularized the union.

From that moment all went well for Monet. It was as though the fates, relenting, tried to do all they could to make up for the long years of wretchedness. Wherever he looked he found cause for satisfaction. The house at Giverny was delightful, the garden, bordered by the Seine and the ravishing little Epte, was a dream of beauty, the scenery all around was varied, attractive, precisely the type of scene to stir his wish to paint. He saw his children well cared for, contented. His every wish was anticipated by Madame Hoschedé, who made him a dutiful wife and competent housekeeper and provided a perpetual chorus of admiration for his work.

And this work was no longer abused. He could paint what he pleased, sure of approval and, soon, of acclamation. For here too all went smoothly. In 1885 he decided to join the Exposition Internationale of the great rival of Durand-Ruel, Georges Petit, who had opened magnificent galleries in rue de Sèze three years earlier. He did this with the approval of Pissarro, Renoir, and Sisley, to demonstrate publicly that Impressionism was not a prerogative of

Durand-Ruel but the kind of painting fit to head the list in any gallery in the world. Petit's had become the fashionable Paris rendezvous for those who prided themselves on being too advanced for the Salon. They provided the perfect customers for the work of Monet. They bought largely and paid high prices, higher than he had ever received.

Durand-Ruel had held out for a long time against the temptations of Petit. But he found himself in an impossible position; he could not afford to give Monet all the money he demanded. In the event, he gave way with a good grace. His restraint—for he feared to lose the reward of years of championship—was to pay him handsomely. Monet, relieved, wrote after the show: "I am very pleased to find you so satisfied with the result of my exhibition at Petit's. What made me so content to enter this new field was above all the certainty that it would be in the interest of every one of us and would lead to the happiest conclusions in the future." And so it proved, for Durand-Ruel as for Monet, Renoir, and Petit. Stirred by the success of the exhibition, Durand-Ruel showed the Impressionists in New York the following year. Monet, as always, provided the strongest entry. Despite the doubts of certain critics the general response was favourable and the way made clear for good sales and high prices in the near future. Monet was singled out for special mention.

One year later, in 1887, Monet repeated his showing with Petit, this time accompanied by Renoir, who had retired to the south of France. He charged as much as 1,200 francs for his canvases and was paid without a murmur. By way of Belgium came the first of European compliments from outside France; he was invited to show at Brussels by Les Vingt, a society of advanced artists. His work was acclaimed.

On July 14, 1888, came the first sign of official approval. He was offered the cross of the Légion d'Honneur. Unlike Renoir, who was to accept it with many apologies to his old friend, he refused it brusquely and to the great joy of the critic Octave Mirbeau. "The minister isn't used to replies of that kind. I love the stand you take, that nothing will make you change your mind."

Monet had not seen Boudin since the death of Camille, and was not to see him again, but he wrote a last letter early the next year, 1889, when he heard of the death of his old friend's wife. He wrote from the depth of the country: "It was here, in a lost land, that I heard of the terrible blow you have suffered, and this will explain why you have not seen me. Believe that I share your wretchedness. I have been through it and I know the emptiness such a loss leaves behind. Be strong and courageous, that's the only advice I can give you."

Then came the final word. "I have much to reproach myself with on your account and I do reproach myself often. Don't harbour resentment, my dear friend. I am always in the country, often travelling, forever going to Paris. But don't think any the less of the friendship I feel for you or of my gratitude for the first advice I ever had from you, advice which has made me what I am."

Boudin did not bear malice. Soon afterwards he came up to Paris to see the latest Monet show—a joint exhibition with Rodin—in which his former pupil showed a full range of his work from 1864 onward. He did not see Monet and did not attempt to renew a thing that was dead. He regarded the audience, now highly fashionable, with awe and the great collection of pictures with amazement and some sadness too. The canvases of 1864 took him back twenty-five years, to the waterfronts of Honfleur and Le Havre, to Jongkind lumbering by their side and sketching divinely, to the young Monet who saw and painted so freshly. These canvases he understood with all their faults. But these latest efforts about which the crowds clustered . . . Boudin shook a gray head and wrote home simply that the exhibition was "making a great stir. That chap has become so daring in the use of tones that one simply can't look at anything after him."

The show was, as Boudin said, "making a great stir." It was an enormous success. Money poured in. Never had Monet pictures fetched so much. Monet would have been fêted—all houses were open to him—had he not refused to be, as brusquely as he had refused all efforts to bring him out of retirement. New business offered itself on every hand. He rejected every commission contemptuously, but

made no objection when a third dealer, Boussod and Valadon, asked him for canvases. Durand-Ruel had been handsomely repaid for his long years of support. Petit had profited enormously. He felt free to allow his pictures to be distributed by another reputable house. He felt, above all, uninterested.

Fame, wealth—there they were at last in full measure. But Monet could not enjoy them. He was no longer thinking only of all Camille had missed. Camille had been dead ten years and ten years is a long time. His response to that thought had long since moved from an agony of regret into a kind of settled cynicism.

His deep and lively dissatisfaction with Monet the great and rich painter came from another source. It was expressed perfectly by an invitation he received during the exhibition. The invitation was from Albert Wolff, the lifelong enemy of Impressionism. Wolff effusively invited Monet and Rodin to lunch. Rodin went, Monet stayed away.

But the invitation had been given. One could refuse it as brutally as one chose, the implications remained. Albert Wolff, the man who had condemned the Monet of 1874, approved the Monet of 1889. And that was fame. Had Wolff changed his opinions or Monet his painting? The question gave Monet many bad moments.

The next year, 1890, Monet showed his dissatisfaction by beginning work on what was to become the first of his famous "series." This was of a haystack seen under different lights, times of day, and seasons of the year. He wrote to Geffroy the critic in the midst of his struggle, "I'm working hard. I persist with this series of different effects, but at this season the sun goes down so quickly that I can't follow it. I work so slowly that I despair, but the more I do the more I see that it needs a great deal of work to get to the point of reproducing what I'm after—the 'instantaneity' above all enveloping it, the same light spread all over it. More and more I'm disgusted with things coming to me easily, in a flash . . ."

The *Meules* were shown at Durand-Ruel's the next year. There were fifteen canvases—a haystack at the end of summer, at sunset, in

snow, in mist, under clouded skies, on a stormy day. Fifteen of them. They became the talk of Paris. Instantaneity was the catchword of the day, obligatory in every salon. Within three days the canvases had all been sold. Monet got from three to four thousand francs for each one.

The following year, 1892, he showed his second Instantaneity series —of poplars. There was even louder acclamation, everything was sold at once, the prices rose still higher.

Two years later, while Monet was still at work on his third series— of Rouen Cathedral—Duret gathered that the time was ripe to sell his collection. He had paid from fifty to a hundred francs for each canvas during the hard years, and the starving and desperate Monet had been glad of the money. Now Duret was handsomely repaid for his kindness and shrewdness. The pictures fetched prices unheard of in those days, ranging from four to twelve thousand francs.

From 1883 Monet had no more money worries. He could do what he wished, go where he wanted. And he did go. He who had spent his twenties and thirties contentedly painting by the river suddenly, in middle age and in sight of greater success than he had ever dreamed of, began to move about restlessly. He had not been settled six months in his house at Giverny, where he had every comfort, affection, and fresh river scenery crying aloud to be painted, than he was off.

"I am always in the country, often travelling, forever going to Paris," he had told Boudin. He used the fact as an excuse, but it was a fact; he could not keep still for more than a month or two at a time, he the most stolid and home-loving of men. The south of France, Italy, Holland, Belle-Isle, La Creuse, Norway, England—the restless march went on through the years. Restless and useless too. From one place after another came cries of frustration. 1883: "I'm having the devil's own difficulties. I've destroyed six since coming here. I've only done one that pleases me. I'm tired of it all." 1885: "A week of helpless fury has driven me almost insane, beginning a canvas again and again, scraping off and eventually ripping up the whole thing." 1888: "I work hard and make myself ill with wretchedness; I'm

horribly worried by everything I do." 1889: "I am heartbroken, completely discouraged, and feel sick with fatigue." 1890: "I work so slowly that I despair." 1892: "I have scraped off all my latest canvases. I suffer anguish."

In the autumn of 1894 the run of travels, success, and scientific painting was interrupted by a strange visitor to Giverny. Cézanne was still struggling, still the wild man of French painting, a legendary figure. Rumours, usually exaggerated, came through the years from Aix where he worked furiously and alone. He had long since abandoned Impressionism, having "made up my mind to work in silence until the day when I felt able to defend my attempts in theory as well as act."

Such a stand appealed to Monet. The two men, so far apart in their art, had a strong link, their simplicity and sincerity, their determination to paint, their absolute refusal to let anything or anybody come between them and their work. This was enough to ensure mutual respect. They had met once only since Cézanne's last Impressionist exhibition, in 1877. In the last three years Cézanne had wandered up and down France painting, always alone, in a frenzy of determination to discover the "sensation" which had so long eluded him. He was then fifty-five and virtually as unknown as when he first began to paint in his twenties. Chance took him close to Giverny. He felt a wish to paint the river scenery. On impulse he wrote to say that he would put up at the inn there for a few days.

Monet warned Geffroy, who was due to visit Giverny: "I hope Cézanne will be here then and will be one of us, but he is peculiar and so fearful of seeing a new face that I'm afraid he may not turn up in spite of his wish to know you. What bad luck that this man has not had more help in his life! He is a true artist too greatly tormented by self-doubts. He needs a helping hand."

Cézanne arrived and survived acquaintance with the three friends of Monet's middle age, Geffroy, Mirbeau, and Clemenceau, though he was alarmed by the politician's digs at his religious faith. He met Rodin and Mary Cassatt calmly.

Monet was silent as ever. When he spoke it was with a sort of weary irony. But he paid tactful attention to Cézanne when he could be induced to leave the inn or his painting round about the village. And he conceived the idea of honouring him by a dinner to which he invited Renoir and Sisley, both of whom happened to be near at the time.

Cézanne was not warned. He arrived one evening to find his old Impressionist companions at table and Monet with an uncharacteristic speech of welcome. "Here we are all together again and happy to have this chance of telling you how fond we are of you and how much we admire your work."

Monet had mistaken his man. This was not the kind of thing one could say to Cézanne. He dropped his head, his eyes filled with tears, he murmured, "Ah, Monet, even you make fun of me!" went back to his inn and took the next train to Aix.

Monet had his things packed and sent after him. In his haste to be gone from formality Cézanne had left everything lying about the room. Later Cézanne thanked his host by letter for his "moral support which has stimulated my painting." He meant what he said. But when the story was told at Giverny, as it often was in the next months, Monet did not join in the laughter. He was famous, Cézanne a joke; he had only to paint what he pleased and it would sell for any price he demanded, Cézanne sold a canvas with immense difficulty and for a song. Nevertheless he was uneasy.

He threw himself into his work. The Rouen Cathedral series of twenty canvases made a new Paris sensation the next year, in 1895. His technical virtuosity was hailed in every newspaper as the miracle of the age. Art critics tumbled over one another to produce superlatives. Hostesses fought to capture this greatest and most elusive prize, but the prize remained uncaptured. Unmoved, the greying Monet retired without a word to Giverny, put up his easel before his great garden pool and began the water lilies series.

The new century came and his sixtieth birthday: he was still painting his water lilies. What mastery, breathed the few who found their

way into that silent garden and watched him, grown heavy and long-bearded, bending over his canvas. Then: What perseverance!

No response. No sign of pleasure. Application was all, stertorous breathing, the great hand wielding the brush, touching in, brushing out, always working.

War came. For the second time the Prussians marched into France. Paris was threatened. Indifferent, uncaring, the old man painted on by his water lily pool. Quite alone now. He had made forty studies of the lilies since 1895. Twenty-one years! Still he was not satisfied. He worked on . . .

As the years rolled on his ineffectual rages and moans stopped at last, like his journeying. Giverny came into its own. By 1916 he had become resigned to his fate. He kept as closely to house and studio and garden as he had formerly seemed anxious to escape from them. He was never seen in the village, he was never seen outside it. Paris might have been a thousand miles away and he might have been dead for all that Paris thought of him. Geffroy called from time to time. Clemenceau, suddenly elevated to world fame, gave him an occasional thought. Vuillard and Bonnard, remembering their origins, praised him. But the cafés would not listen, the young painters had other gods: "Claude Monet? What, is he still alive!"

Epilogue
Giverny
1916 - 1926

CURIOUS EYES PEEP INTO THE GARDEN. IN THAT LITTLE-USED STUDIO with its great north light overhanging the water he has made a last self-portrait, hair shorn to white stubble, eyes apathetic. He rarely goes to the lily pool. His hand is often without its brush.

December, 1919. He walks, sighs, cannot be still. In the far south, at Cagnes, Renoir has died, paralyzed but working to the end, the brush strapped to his wrist.

He is the last. 1891, Jongkind; 1893, Caillebotte; 1898, Boudin; 1899, Sisley; 1903, Pissarro; 1906, Cézanne; 1917, Degas. And now Renoir. All gone. He alone lives on.

Yet what is life, what is death? Is Degas dead? Is Cézanne? Their words will not leave him. "Monet is a clever but shallow decorator." "Monet is only an eye." And has not some critic written that his *chef d'oeuvre*, his water lilies, twenty-one years of his painting life, are only "the most exquisite decoration?"

A decoration. An eye. Is that all? He walks in his garden, takes up a brush, puts it down, walks again, sits, stares. Is he alive, then? He is famous, rich, his paintings in every well-to-do house in Paris.

193

In America, in Europe, his fame is secure. Those who had mocked now take him for granted. He is the pride of the official critics, the Beaux-Arts, the Academy.

He moves restlessly. But the young painters—that is another matter. His famous series have been dismissed in the cafés as cerebral painting. Instantaneity has driven away spontaneity, they have said. His very claim to have overcome "easy things that come in a flash" has been held against him as proof that he has become a mere painting machine, marvellous, but meaningless too.

How laugh youth away? The young men are merely repeating the words of their elders. In these last thirty years, ever since he showed his *Meules,* have not his old friends spoken as if he were a lost man, as if he were dead? They, at least, have spoken regretfully, but the young painters brush him aside impatiently. Why waste time on has-beens, however famous in their day? These are the Twenties. On, on, with Cézanne, Gauguin, Van Gogh, the great Post-Impressionists!

Is he alive, then? In the eyes of all he cared about he is dead. How can he foresee that another generation will hail him as the great modern, the precursor of the great schools of contemporary art?

Now he cannot take his mind further than Camille. Again and again he thinks of her. She had gaiety, she had warmth, she was spontaneous in every action, every flash of mood. That was why Renoir, Manet, Sisley, Pissarro, Caillebotte, all of them, had loved to be with her, to paint her. That was why he had painted—ah, how he had painted!

He is drawn irresistibly to those last days. Sorrow, yes, of course he had felt sorrow. But what he remembers, what haunts him, what he cannot drive from his head, is the curiosity he had felt. He had watched that dear face on its deathbed as man, as husband, but still more as painter. Not one change of colour escaped that all-seeing eye—the fading of the reds and pinks, the oncoming of the blues, the yellows, the greys. And when he had taken palette and brush to make a final likeness, how much of his resolve had been the wish to preserve what he loved, how much the fascination of an unusual model, a dead person?

He shifts his huge bulk wearily along the paths. He mutters. "I'm like a beast on the treadmill!" the listeners hear from the other side of the hedge. "I am the prisoner of my eye!"

* * *

Somehow the years drag away. His step is heavier, slower. He shuffles. He sits more often. He shuns the lily pool. He has one thought only, and it dogs him relentlessly. "Only an eye! Only an eye! Only an eye!"

At the last comes a sort of peace. The words stop clanging, they recede, he can hear them no more. Courbet's roar, Jongkind's great fist deftly sketching, Boudin's gentle insistence, become hazy, are gone. Camille's face blurs. He is a school-boy at Le Havre, his parents call him Oscar, everyone thinks him very clever, he makes caricatures and sells them at twenty francs apiece, he cheeks the drawing master Ochard, takes French leave, runs by the sea filling his lungs, the wind blows through his hair, he strips, plunges . . .

"I wish I could die on a buoy!"

* * *

Curious eyes peep into the garden. The gates open and two peasants appear. They are drawing the village hearse, and on it rests a large, plain coffin. Four men follow: the painters Bonnard, Vuillard, Roussel, the politician Clemenceau.

In the small cemetery within view of the Seine the coffin is lowered in silence. He has said, "No words—a burial as simple as a peasant's."

The mourners walk away. The gravediggers begin to shovel earth into the grave. They are not silent. They talk of the dead man. The whole village has been discussing that last "I wish I could die on a buoy!"

On a buoy! It was true, one had heard that he had lived and worked by the sea. But how long ago! Forty-three years he had lived at Giverny. Half his lifetime.

The coffin is covered; the earth falls without sound. And how seldom the gates of his house had been opened in those last years! He was a silent one, was Monsieur Monet, walking slowly, heavily in his garden, sighing as he sat or, more often, simply standing, staring, staring . . .

For they had peeped, as who did not, into that wonderful garden by the river. And there he would be, the huge old man, bushy white beard to the chest, pacing the paths, sitting on his favourite seat, standing motionless.

Who had ever seen him leave house or garden? He would walk, sit, stand, day after day, month after month, year after year. Always silent, always staring.

The grave is filled, trodden down. After a last approving look, they shoulder tools, turn away, out of the cemetery, down the road to the village. A mystery, the old man. It was said he was the most famous painter in the world. He had money. His house was envied by all. Yet his silence, his stare . . . It was strange. His fame had not done him much good, it seemed.

The winter sun shines low across the river, that river he had painted so often. The peasants reach their cottages, shrug shoulders, shake hands, part.

Bibliography

Letters in private collections at Sorel, Montpellier, Méric, Béziers, Le Havre, Honfleur, Bourg-la-Reine and in Paris.

Manuscript Sources at:

Archives de la Seine
Bibliothèque d'Art et d'Archéologie, Paris
Bibliothèque Doucet, Paris
Bibliothèque Nationale, Paris
Musée du Louvre, Paris
Musée Fabre de Montpellier
Musée Rodin, Paris
Musée du Havre

Books and Journals:

Anonymous, "La Grande Misère des Impressionnistes," *Le Populaire*, Paris, March 1, 1924
Cahiers d'Aujourd'hui, Paris, November 29, 1922
Aubry, G.-J., *Eugène Boudin*, Paris, 1922

Baudelaire, Charles Pierre, *Variétés Critiques*, Paris, 1924

Baudot, J., *Renoir*, Paris, 1949

Cahen, G., *Eugène Boudin*, Paris, 1900

Cézanne, Paul, *Correspondance*, Paris, 1937

Chavance, R., "Claude Monet," *Le Figaro Illustré*, Paris, December 16, 1936

Clemenceau, G., *Claude Monet*, Paris, 1928

Clement, C., *Gleyre*, Paris, 1878

Daulte, F., *Frédéric Bazille et Son Temps*, Paris, 1952

Delvau, A., *Histoire Anecdotique des Cafés et Cabarets de Paris*, Paris, 1852

Duret, T., *Histoire des Peintres Impressionnistes*, Paris, 1906
 Manet and the French Impressionists, London, 1910

Elder, M., *Chez Claude Monet à Giverny*, Paris, 1924

Fels, F., *Claude Monet*, Paris, 1925

Fels, M. de, *La Vie de Claude Monet*, Paris, 1929

Geffroy, G., *Claude Monet*, Paris, 1922
 Histoire de l'Impressionnisme, Paris, 1894

Gimpel, R., "At Giverny With Claude Monet," *Art in America*, June, 1927

Guillemot, M., "Claude Monet," *Revue Illustrée*, March 15, 1892

Huysmans, J. K., *Certains*, Paris, 1889

Joets, J., "Les Impressionnistes et Chocquet," *L'Amour de l'Art*, Paris, April, 1935
 "Lettres Inédites de Pissarro à Claude Monet," *L'Amour de l'Art*, Paris, 1946

Maus, M.-O., *Trente Années de Lutte pour l'Art*, Brussels, 1926

Moreau-Nelaton, E., *Daubigny*, Paris, 1926
 Jongkind, Paris, 1926
 Manet raconté par lui-même, Paris, 1926

Pissarro, Camille, *Lettres à son Fils*, Paris, 1947

Poulain, C., *Bazille et ses Amis*, Paris, 1932

Régamey, R., "La Formation de Claude Monet," *Gazette des Beaux-Arts*, Paris, February, 1927

Renoir, E., "Claude Monet," *La Vie Moderne*, 1879

Rewald, John, *The History of Impressionism*, New York, 1946
 Cézanne, Paris, 1939

Riat, G., *Gustave Courbet*, Paris, 1906

Rivière, Georges, *Renoir et ses Amis*, Paris, 1921

Rouart, D., *Correspondance de Berthe Morisot*, Paris, 1950

Signac, Paul, *Jongkind*, Paris, 1928

Tabarant, A., "Autour de Manet," *L'Art Vivant*, Paris, May 4, 1928
 Pissarro, Paris, 1924

Tabouroux, E., "Claude Monet," *La Vie Moderne*, 1880

Thiebault-Sisson, "Claude Monet," *Le Temps*, November 27, 1900

Vauxcelles, L., "Un après-midi chez Claude Monet," *L'Art et les Artistes*, December, 1905

Venturi, L., *Les Archives de l'Impressionnisme*, Paris, 1939

Zola, E., *Correspondance: Les Lettres et les Arts*, Paris, 1908
 Mon Salon, Paris, 1866
 "Peinture," *Le Figaro*, May, 1896

14

Index

INDEX

INDEX